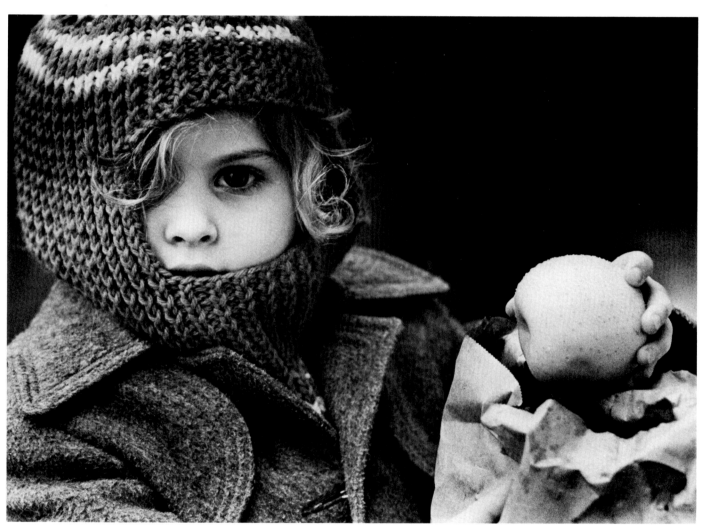

THE EYES
OF THE
GLOBE

THE EYES
OF THE
GLOBE

Twenty-Five Years of Photography from
The Boston Globe

**written and edited by
Stan Grossfeld**

with an introduction by Thomas Winship

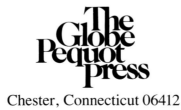

The Globe Pequot Press

Chester, Connecticut 06412

Library of Congress Cataloging-in-Publication Data
Main entry under title:
Eyes of the Globe.

Includes index.
1. Photography, Journalistic — Massachusetts —
Boston. 2. News photographers — Massachusetts —
Boston — Biography. 3. Boston globe. I. Grossfeld,
Stan. II. Boston globe.
TR820.E844 1985 779'.990982 85-17549
ISBN 0-87106-861-3

Manufactured in the United States of America
First Edition
First Printing

Jacket photography by David L. Ryan
Layout by Stan Grossfeld
Designed by Tom Goddard
Mechanicals by Wendy Walden
Composition by Comp-One, New Haven, Connecticut
Printed by Eastern Press, New Haven, Connecticut
Bound by Book Press, Brattleboro, Vermont
Produced by Kevin Lynch

Contents

for Ollie

. . . Though death bells toll
They can bomb the land
But not the soul.
— OLLIE NOONAN, JR.

Preface

John F. Kennedy — the negative, not the person — was lying on the floor between two file cabinets gathering dust. Nobody noticed. Ten years of other *Globe* negatives were gone, thrown out thanks to someone's thoughtlessness.

News photographers are masters at preserving a moment in time, rushing back to the darkroom, and meticulously editing and printing their films, often under extreme deadline pressure.

But, sadly for many photographers, then comes the contradiction. They preserve moments in history, then carelessly lose or scratch negatives. In some cases, the only print disappears to an anonymous admirer with a penchant for theft.

A photographer at the *Boston Herald American*, Dennis Brearley, was walking through that paper's hallways one day when he found janitors throwing out barrels of old 4x5-inch, 2¼-inch, and 35-mm negatives.

"If you don't want 'em, I'll take 'em," he said. They didn't want them. Brearley drew up a contract and bought the rights to the pictures for a dollar. He now makes a living selling enlargements of these photos at The Negative Side in Quincy Market. Babe Ruth, Ted Williams, F.D.R., the Beatles, the Hindenburg flying the Nazi swastika over Boston's Custom House Tower; all were headed for the final solution, until Brearley interceded.

This book is an attempt to preserve some of the memories of the last quarter century; to entertain; and to teach a little about photography in a way that doesn't show up in the slick photo magazines with all the camera ads. The fractions of seconds frozen on these pages are unique.

You may not have stopped to think about it, but you remember still photographs longer than you remember television clips. It is easier to recall a still photo, to bring it up in your mind's eye, than a television sequence. The frozen picture stays in the mind longer than the moving picture. It can be inspected, and studied, and hung on your living room wall. Try doing that with the seven o'clock news.

This book is the collected work of some of the most versatile photographers in New England. In an age of pack journalism, the *Globe* photographer has tried to be the freethinker, trying to serve up something different for the readers at breakfast. Too many newspapers stick with tried-and-true, grip-and-grins of local honchos shaking hands and mugging it up for the local paper. You won't find any photographs like that here.

A few of the prints are not of the quality we would have liked. They are extra prints found in cellars and attics of now-retired photographers. They are flawed, as we in the news business are flawed.

The newspaper business has gone through a revolution in the last twenty-five years. In the panoramic photograph of Jack Kennedy speaking at the Boston Garden on the eve of the 1960 Presidential election, only two film cameramen from television stations and barely a dozen still photographers are visible.

Globe photographer Ed Kelley wanted more than a head shot of a candidate speaking. He went behind the speaker's platform, one level up in the loge seats. With a 4x5 Speed Graphic, he captured this classic photograph of the light bearing down on the young man about to become President, in front of a rapturous hometown crowd.

There's a line in Kennedy's favorite musical, *Camelot*, about ". . . one brief shining moment, that was known as Camelot."

Like the target of the beam of light, the negative deserved a better fate.

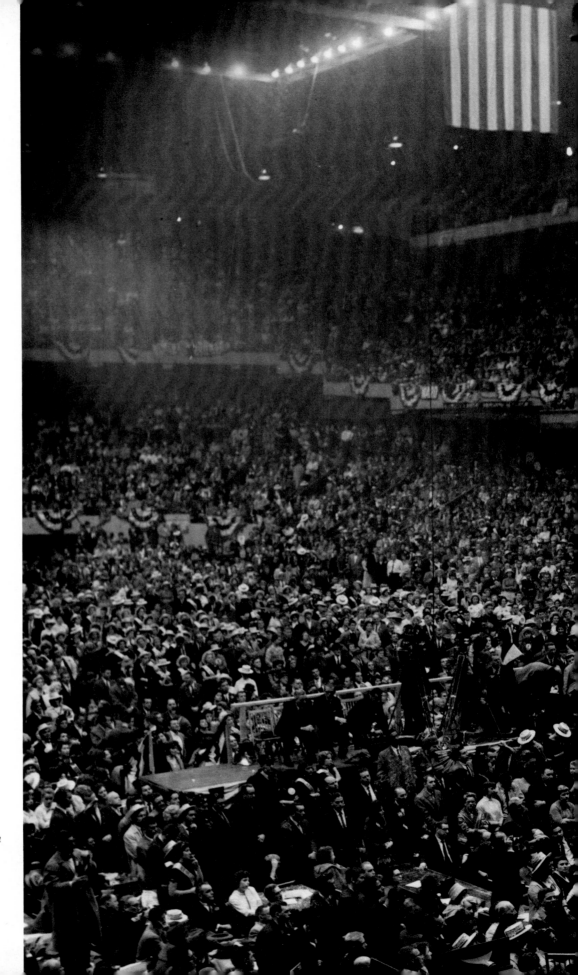

John F. Kennedy at the Boston Garden. Election eve. 1960.
ED KELLEY

8

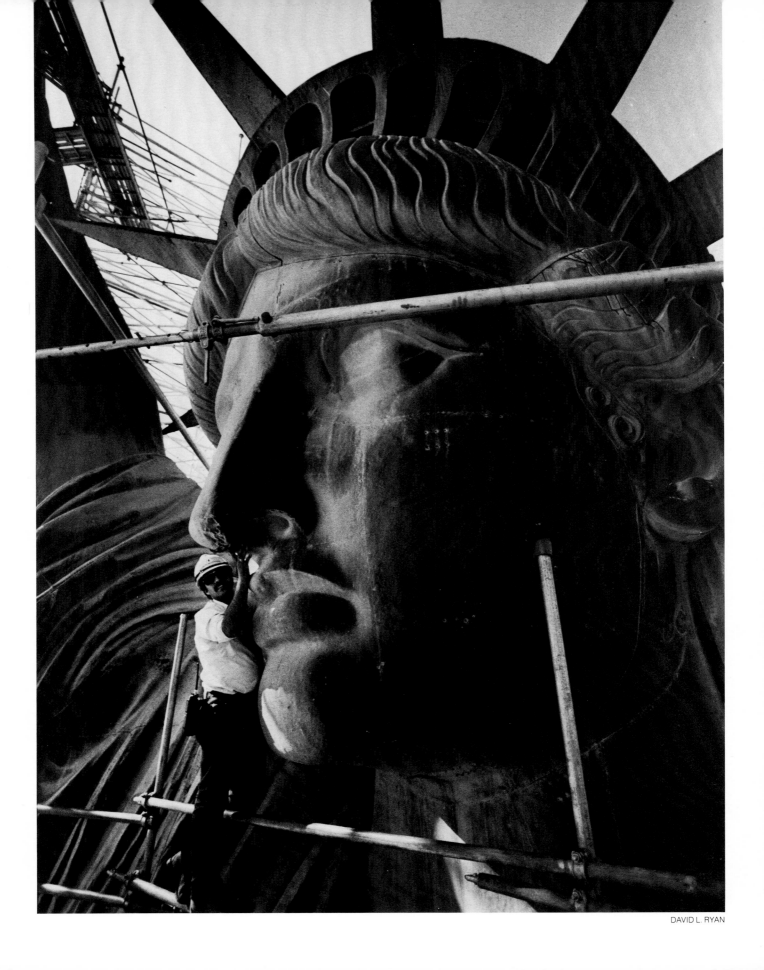

Introduction

Readers of *The Eyes of the Globe* are in for a very special emotional experience, a sweep through the past twenty-five years that reflects great and tiny events — the mood of New England and almost every other part of the world.

In this book the *Boston Globe* photographers, a creative and feisty band of artists, have preserved their favorite photographic memories — the serious and cosmic stuff of recent history, and the minutiae of daily living since the early 1960s. This book pulls no punches. The mix of subjects is a staggering and unusual blend of sights and feelings that is fascinating to pore over.

Nostalgia is an uncontrollable emotion for most of us. It is for me. I remember that steamy night in Boston Garden (November 8, 1960) when John F. Kennedy gave his homecoming speech to a raucous crowd, so classically recorded by Ed Kelley. What a night! What a tableau of vintage Boston pols, most notably Representative Peter Cloherty of Brighton, leading the "Up, up, here comes the President" cheers. And no history of the Sixties would be complete without a recording of the student peace rally on Boston Common, that jam of humanity shouting its anti-Vietnam message to the world.

No newspaper in America covered that war more intensely, in words and in pictures, nor involved itself more on the editorial pages than did *The Boston Globe*. Its coverage of the Vietnam War marked a significant point in *Globe* history because it earned the newspaper the respect of the youth of New England; it helped to explain the jarring differences in outlook between youth and parents;

and, finally, it led directly to the *Globe's* becoming one of three newspapers to obtain and print the Pentagon Papers.

However, *The Eyes of the Globe* makes no pretense of being only a record of the seriously significant events of the last quarter century. Part of its basic appeal is that interspersed with wars and other disasters are such wonderful pictorial reminders as the Beatles in Boston . . . Ted Kennedy triumphantly dodging snowflakes the size of quarters as he grinned his way through a South Boston parade at age thirty-two . . . a contented pig escaping a record heat by wallowing in the cool New England mud . . . the Celtics' Bill Russell with his feet flailing in mid-air . . . New Englanders braving the history-book blizzard of '78.

How can we stop remembering? Yaz takes one last trot around his Fenway playground, waving farewells . . . Bobby Orr and Phil Esposito embrace in remembrance of that golden age of Boston sporting life.

Let's not forget, either, the scores of non-news, pretty pictures *Globe* editors have insisted on publishing on the front page to give readers a break from the daily cascade of disaster. Who will forget Ulrike Welsch's mood studies of tall ships, Pope John Paul II deep in prayer, or children candidly caught at play? Ditto Paul Connell's wonderful shots. Every member of this roster of talented photographers has earned great praise for contributions to this book of recaptured visual memories. We salute them all — John Blanding, Bill Brett, Jim Bulman, Charlie Carey, Paul Connell, Bill Curtis, Bob Dean, Joe Dennehy, Charles Dixon, Ted Dully, Gil Friedberg, Dan Goshtigian,

Stan Grossfeld, John Ioven, Ed Jenner, Ed Kelley, Janet Knott, Tom Landers, Wendy Maeda, Sam Masotta, Ollie Noonan, Jr., Frank O'Brien, Jack O'Connell, George Rizer, Joe Runci, David Ryan, Bill Ryerson, Jack Sheahan, Danny Sheehan, John Tlumacki, Ulrike Welsch, and Jim Wilson.

The Eyes of the Globe is much more than a "coffee table" picture book, laced as it is with marvelous tales of the struggles and perils of *Globe* photographers — the risks they took, their lucky breaks, their misses and near-misses. Chief photographer Stan Grossfeld wrote most of those tales, and the writing makes you wonder whether he is wasting his time concentrating on cameras instead of typewriters and terminals.

The fact is, I don't think Stan ever wasted a moment of his young life. He writes and "shoots" day and night for *The Globe,* which is the main reason why he closes out 1985 as a five-time New England photographer of the year, two-time winner of the Overseas Press Club Award , and, best of all, winner of two Pulitzer Prizes, back to back, for spot news photography for his series of awesome portraits from Lebanon and his tragic shots of mass famine in Ethiopia that earned him the overwhelming votes of the Pulitzer board.

Yes, publication of *The Eyes of the Globe* comes about through the persistence of the insatiable Grossfeld, who wants everyone to savor the work of his talented colleagues, too.

TOM WINSHIP
Editor, 1965–1984
The Boston Globe

11

Ollie

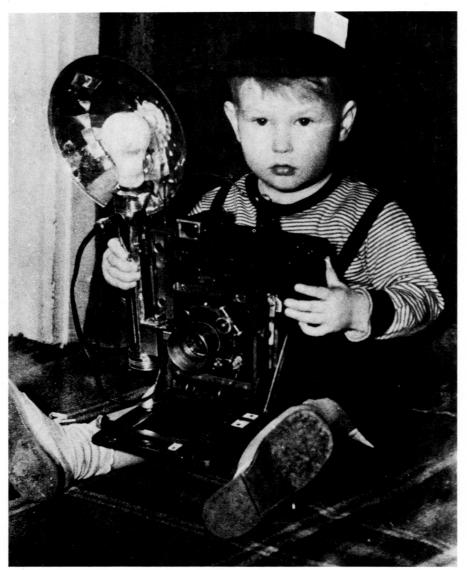

Ollie Noonan, Jr., 4, with his father's 4x5 Speed Graphic. OLLIE NOONAN, SR.

Ollie Noonan, Jr., didn't have to go.

He couldn't be drafted. He had asthma. "He knew there was a chance he'd die in Vietnam," says his sister Lori. "But he wrote that he'd rather spend one day experiencing the most-photographed war in history and die, than be stagnant in Boston."

At home Ollie had been a natural leader. He had won the presidency of his senior class at the Norwell, Massachusetts, high school, on the slogan: "It's Ollie, by golly." But leadership in Vietnam was not a question of rank. He led by doing. He died the same way.

His last day on earth, August 19, 1969, he put his camera down and helped carry wounded American servicemen to evacuation helicopters in the steamy jungle 31 miles southwest of Da Nang. Press cards don't keep you from getting shot in war zones. No picture is worth an arm, or leg, or life. "Every step is earned here," he wrote home from Vietnam. "Nothing is free . . ."

He had written some bylined stories for the Associated Press. One came after President Nixon, with great fanfare, announced the withdrawal of the first American infantry battalion from Vietnam. Men with a few months left to serve were quietly transferred to other outfits, and the men sent home were those who had completed their terms, many of them hastily transferred in from other units.

Ollie's lead: "The first American infantry battalion scheduled to be withdrawn from Vietnam is going home in name only, and the men are angry and bitter."

It had been six months since Ollie walked out of the *Globe* on a leave of absence. Just "I want to be where the

action is," and see you later. He struggled with his asthma. One of his photos made the cover of *Time*.

Boarding his final helicopter, Ollie lugged a large metal can. "If they shoot at the helicopter, I'll just hide behind this," he told a colleague at the time.

For several days, more than a thousand North Vietnamese troops blocked American efforts to reach the wreckage of the helicopter that took Ollie and seven others, including a battalion commander, to their deaths.

Horst Faas, the Associated Press' Pulitzer Prize–winning photographer, wrote the Noonans: "The machine guns that shot Ollie's helicopter down were located only days later during five days of bitter fighting, which claimed sixty Americans dead and brought the whole company Ollie had been with to a breaking point when it refused to go out again."

George Esper, the Associated Press Saigon bureau chief from 1973 until the end of the war in 1975, called Ollie "one of the very best. He put his life on the line to show people what the war was really like."

"Ollie went to Vietnam to learn the truth" is the way his father puts it, staring out at the Bay of Fundy, which surrounds Campobello Island. The hard truth is that people die in war, creating a domino effect on their families. To this day Ollie Sr. cannot go into the nearby cemetery where his son rests. As a boy, Ollie played among those same headstones. Now the family has the memories. And the long letters he wrote home to his sisters, Lori and Judy, his mother, Lorene, and his father.

He loved rock and roll. He went to England in 1963 and came back talking about this new group, the Beatles. They had energy. Ollie knew energy. Once he and *Globe* photographer Bob Dean left work in Boston, drove to New York City, and Twisted the night away in the Peppermint Lounge. Ollie was tall and loose, bundled with nerves that erupted in a dance contest. He scooped up the prize, then he and Dean turned around and drove back to Boston to be at work the next day.

Ollie was with the old *Boston Traveler* when the Beatles held their first news conference in Boston, at the Madison Hotel on September 12, 1964. Security was fierce. Two thousand crazed teenagers clogged Causeway Street for a glimpse of their heroes. The *Globe's* Bob Anglin wrote, "Anyone older than 20 who ventured into the area of Boston Garden Saturday night was a madman." A man with long hair had to be rescued by police after mobs of teenaged and preteen girls ripped the clothes from his back.

One teenaged girl managed to sneak in. Debbie Chase asked Paul McCartney if she could kiss him. She got her kiss, and Ollie got his Beatle pictures. He also got some autographs, and fought his way out to get back to the office.

The next day's *Globe* served up the Sixties on page one. There was a bloodless coup in Saigon with the new premier saying, "This is nothing to worry about, just a little operation against some politicians." Bobby Kennedy, campaigning for New York's Senate seat, was described as "a political hurricane." The six-column headline called the Beatles the center of "an astonishing human storm."

Twenty years later the storm has settled. The Saigon coup that was "nothing to worry about" to the South Vietnamese premier turned into something to worry about for 58,000 Americans who were to die there. Including Ollie.

John Lennon was gunned down outside his New York apartment in 1980, ending any remote hope of a Beatle reunion. Bobby Kennedy was assassinated in Los Angeles in 1968. The hotel where Ollie photographed the Beatles in 1964 was demolished on May 15, 1983. It took all of 9.7 seconds.

Not everything from the Sixties disappeared as quickly as the Madison. Twenty years after her Beatle kiss, Debbie Chase told *Globe* columnist Jack Thomas that "nothing in my life before or since will ever touch that night."

Ollie covered Dr. Martin Luther King, Jr., and the civil rights marches of the South, through hostile crowds where a white photographer from a paper up North was sometimes considered as much of a troublemaker as King and his followers. Ollie admired King; when the black leader was killed, Ollie wept unabashedly.

"Ollie was one of the first photojournalists, in the strictest sense of the word—someone who thought pictures and story ideas," said Bob Dean. Even on vacation in Rome, Ollie managed to borrow a camera to make a color portrait of newly installed Pope Paul VI with Boston's legendary Richard Cardinal Cushing.

The boy learned the trade from the man. Ollie Jr. learned from Ollie Sr., who had forty years in the business. They worked on competing dailies, but kept an eye out for each other in the Roxbury

riots of the late Sixties. On occasion the old man could scoop the kid. Once both Noonans found themselves at the right place at the right time, outside a Cambridge courthouse. A witness in a criminal case tried to climb out of a window. "When she started putting one leg out, I fired. Then, startled, she jumped back in," Ollie Sr. said. "I got the only picture because I fired early."

Ollie Jr. never drank, rarely smoked. Other cameramen mimicked his distinctive shooting stance. "He'd get real jiggly lining up his angle, always moving, shaking, you'd swear he'd get [camera] movement, then at the moment he takes the picture he just stops shaking," recalls *Globe* photographer Sam Masotta.

To deal with his fears, Ollie wrote poetry.

On landing in Vietnam, Ollie wrote home, "I am where I want to be." Six months later he radioed in to the Associated Press that he had "good combat stuff." It was the third battle of the day. The helicopter took off and banked left. At 2000 feet, the chopper was hit by heavy enemy ground fire and exploded in flame. His family has the memories. We have the pictures. And this poem.

ON THE SIDE THAT'S WINNING

by Ollie Noonan, Jr.

The moon hangs like a tear
And I, sensing immortality
But afraid of tomorrow, rush to greet it
Afraid to die
And keep running.
Afraid to realize it may be hopeless
To carry tears on my sleeve
While right behind me, in cloak and gown
The man's juggling bombs
Like a circus clown.

. . . Though death bells toll
They can bomb the land
But not the soul.

Ollie Noonan, Jr. AP

Vietnam.

14

15

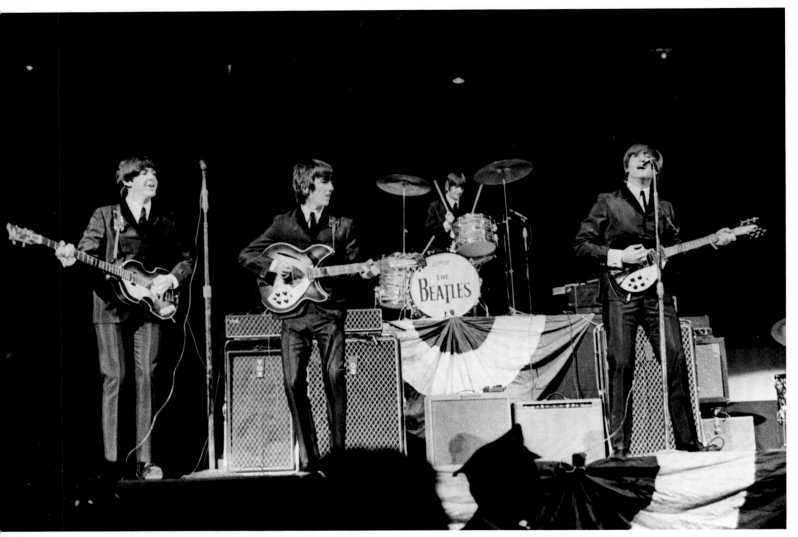

Beatlemania at Boston Garden. 1964.

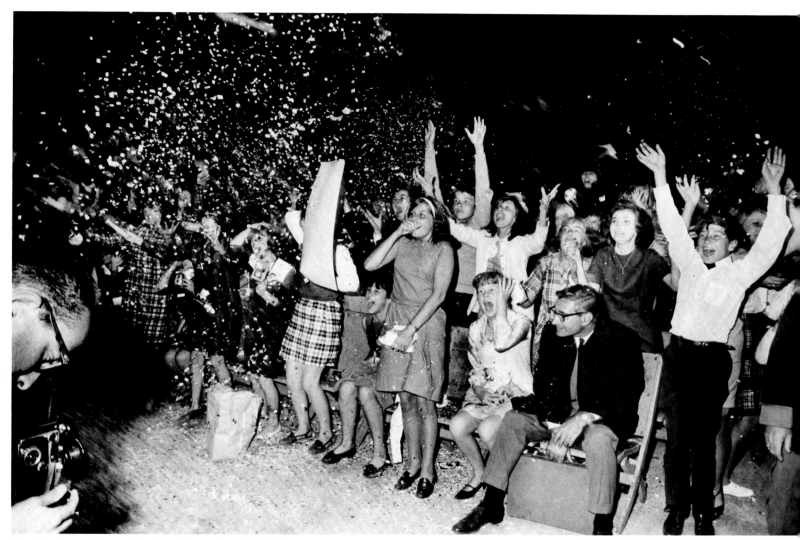

The Beatles at Boston Garden. September 12, 1964.

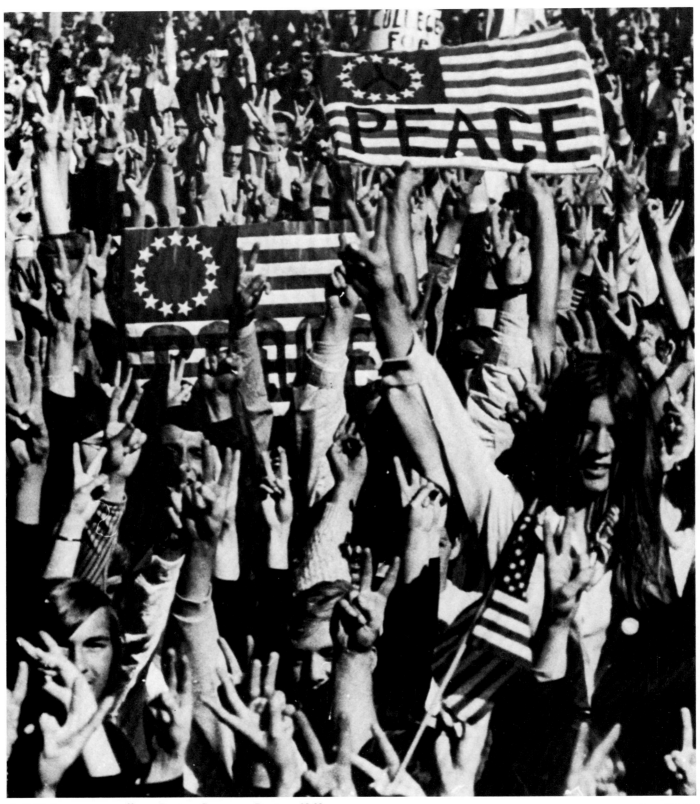

Anti-Vietnam peace rally on Boston Common. Boston, 1969.

PAUL CONNELL

18

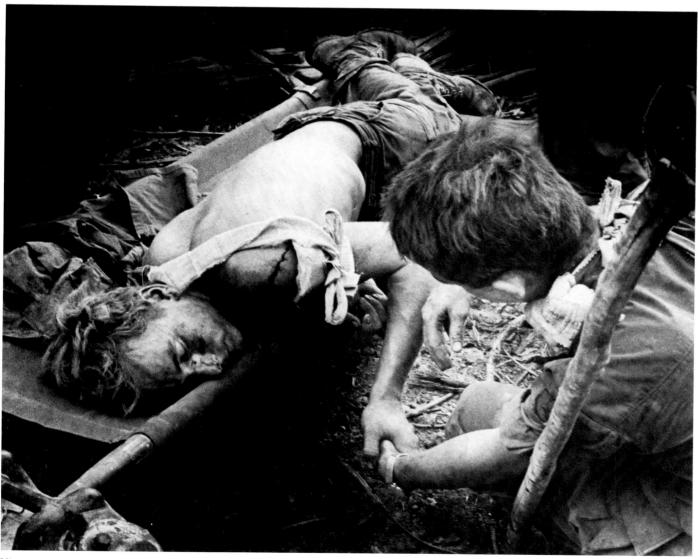

Vietnam

19

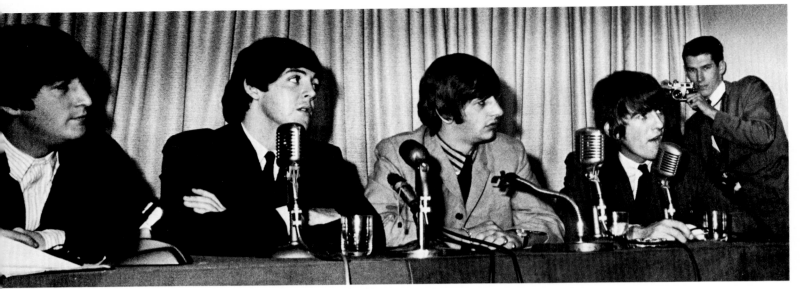

Ollie Noonan, Jr., photographs a Beatles press conference. 1964.

September 13, 1964

"The youngsters galloped back and forth along Causeway and Nashua streets like herds of temperamental sheep.

"Any hint that a Beatle might be nearing a window set up a mass scream heard for blocks and powerful enough to penetrate the hotel from basement to rooftop.

"The Beatles slept soundly, apparently accustomed to the stormy atmosphere. But for the great rushing, swaying stream of teen-age Beatle addicts, Mecca had come to them. In this case it was the Hotel Madison, and they started assembling at dawn to pay homage with a rising crescendo of screams and hysteria."

—RICHARD CONNOLLY,
The Boston Globe

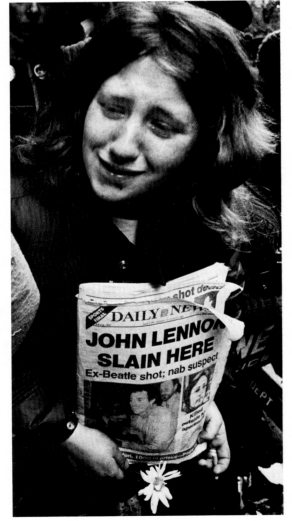

Woman weeps in front of the Dakota Apartments the morning after a gunman shot and killed John Lennon. New York City, December 1980.

May 16, 1983

"The crowd which gathered on rooftops, streets, bridges and in parking garages and peered from apartment windows cheered loudly as a 10-second countdown bellowed through a loudspeaker. Then, at exactly 7:41 a.m. rapid fire blasts of plastic explosives rippled through the 19-story building. Suddenly, the once proud art deco structure collapsed to earth, forming a pile of mangled steel, bricks and concrete. The ground vibrated. Some windows shattered and damage was reported at Boston Garden. A mushroom-shaped cloud shot upward and outward, spreading brown dust and soot onto cars, people and buildings."

—MICHAEL K. FRISBY,
The Boston Globe

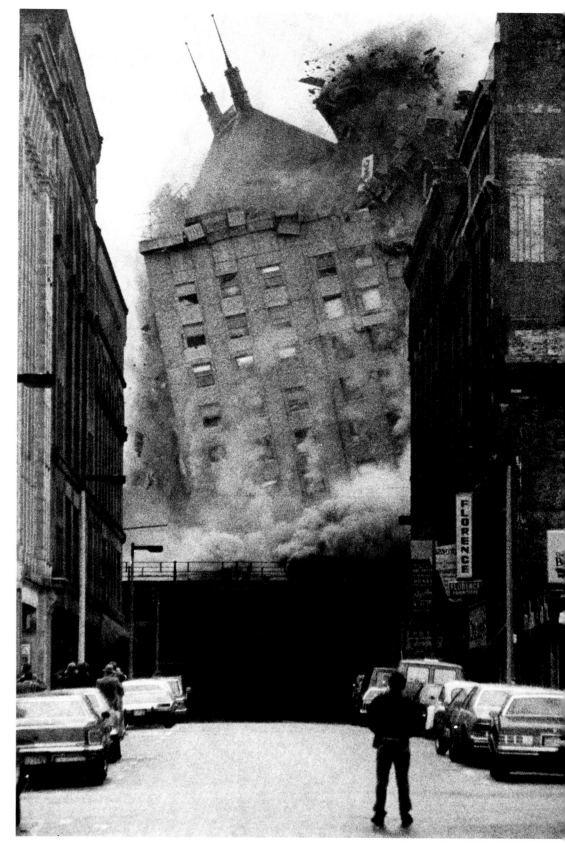

Madison Hotel implosion as viewed from Portland Street. Boston, May 1983.

JIM WILSON

Features

Portuguese Tall Ship, Sagres, *during the Bermuda-Newport race. June 1976.*

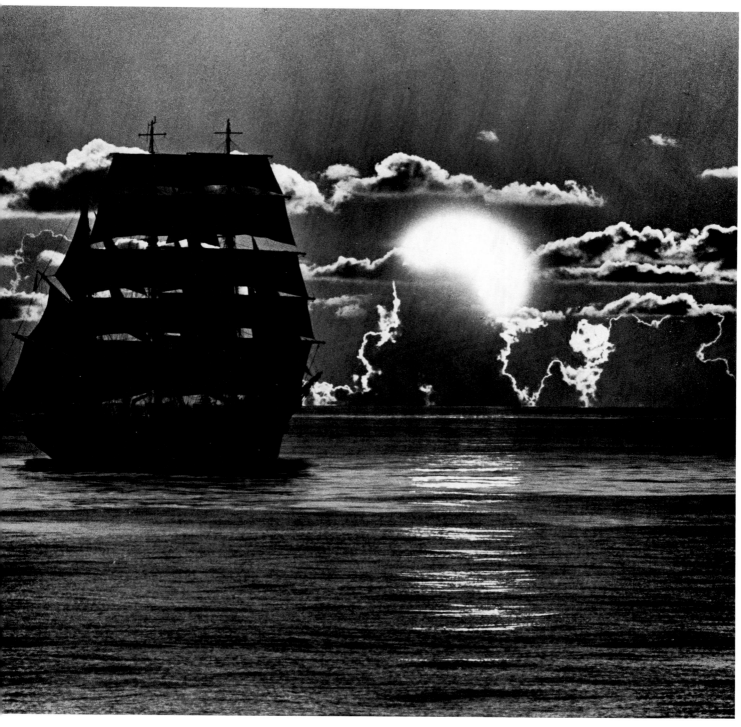

ULRIKE WELSCH

23

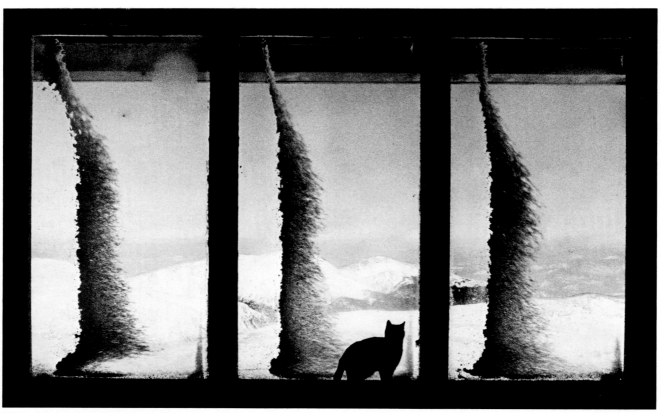

White Mountains, New Hampshire.

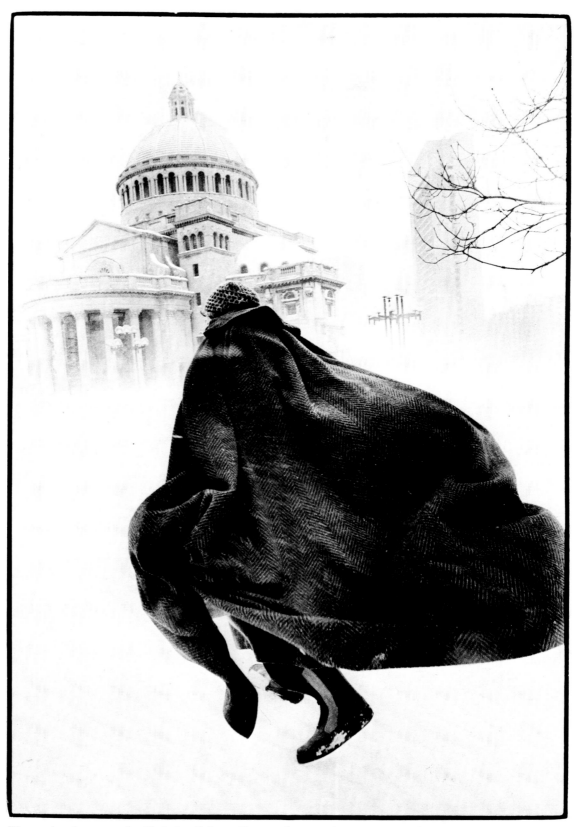

Woman heads across the Christian Science Center after a spring snowstorm. Boston. TED DULLY

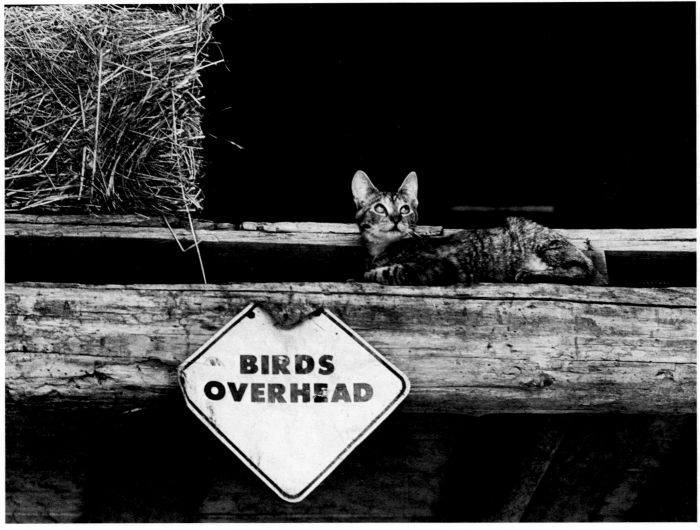

Sherborn, Massachusetts.
Opposite: Seagulls looking for food follow the Martha's Vineyard ferry. JOHN BLANDING

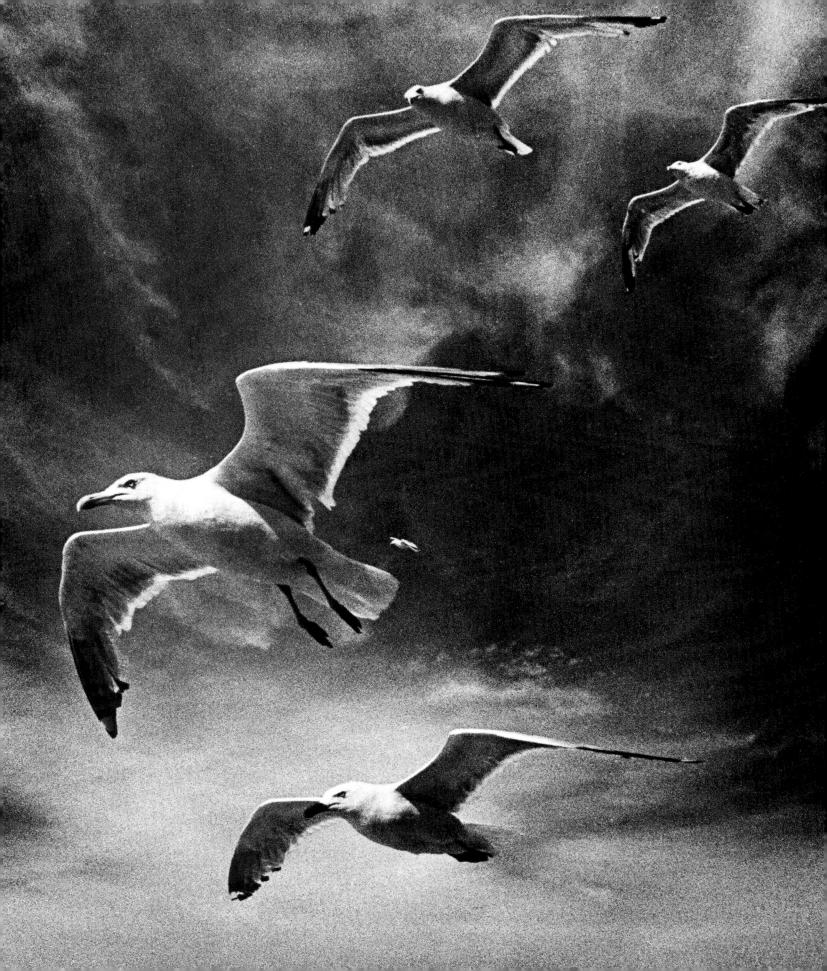

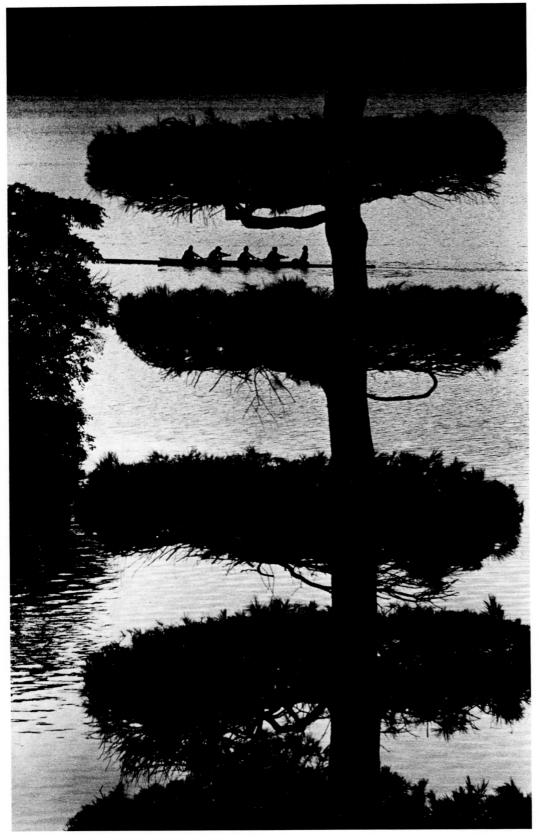

*Wellesley College crew members are framed by
sculptured trees, Wellesley, Massachusetts.*

STAN GROSSFELD

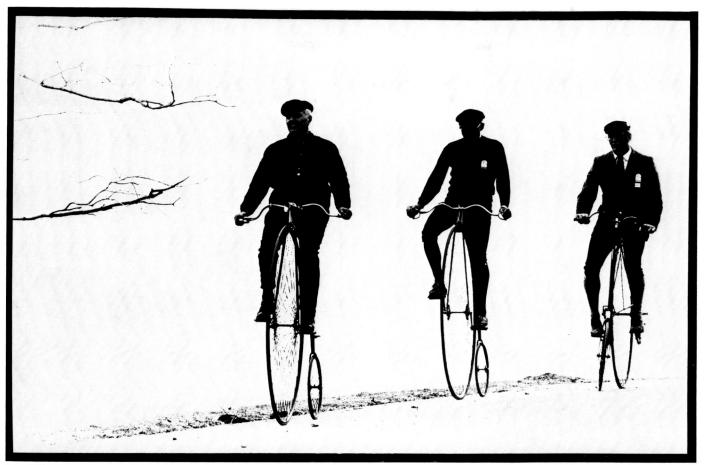

The Wheelmen cruise through Larz-Anderson Park, Brookline, Massachusetts.

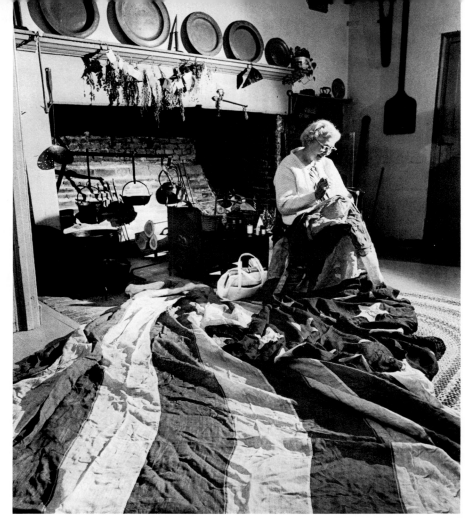

Flag day at the John Quincy Adams birthplace. Quincy, Massachusetts.

British troops advance toward Minutemen in Breed's Hill reenactment. Newbury, Massachusetts.

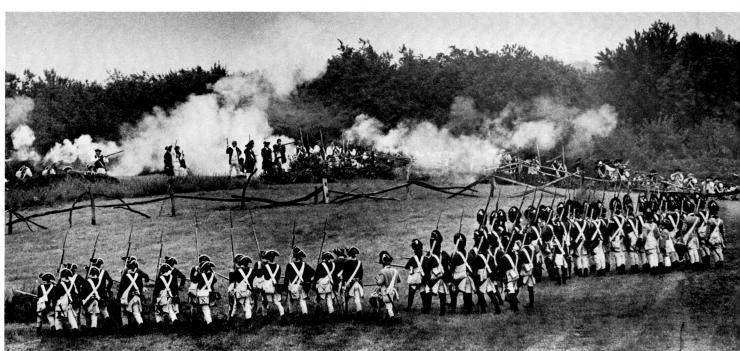

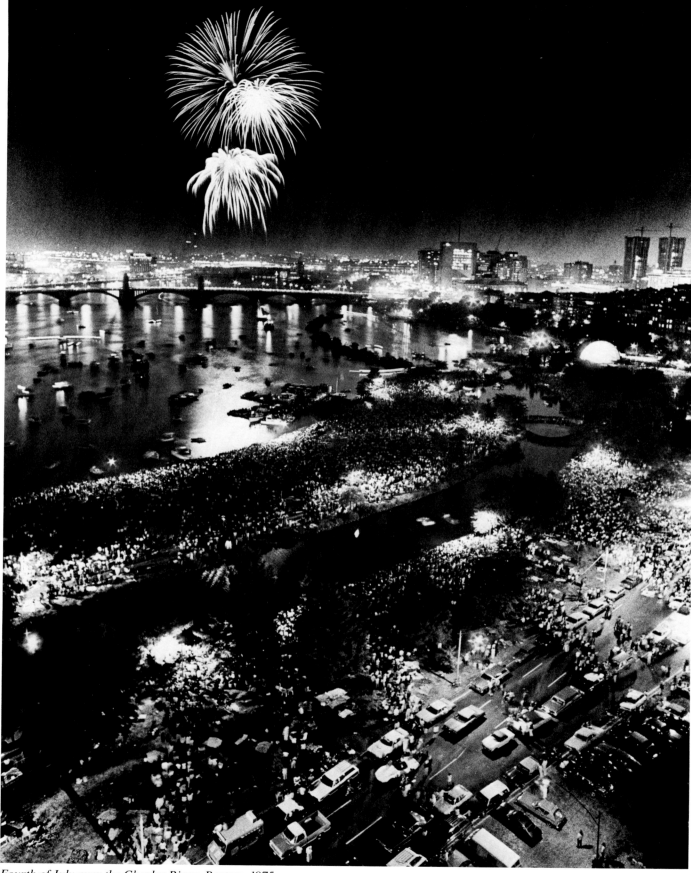

Fourth of July over the Charles River, Boston, 1975.

TED DULLY

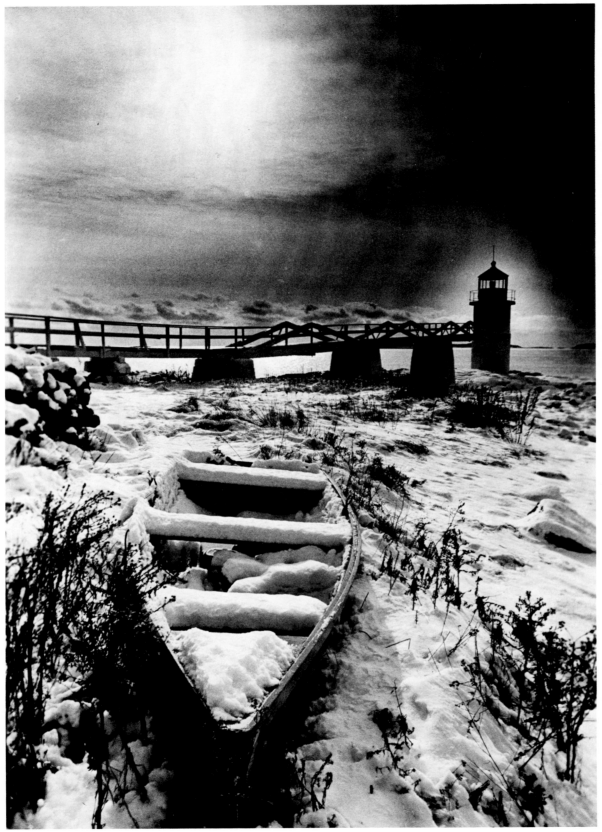

Port Clyde lighthouse, Maine.

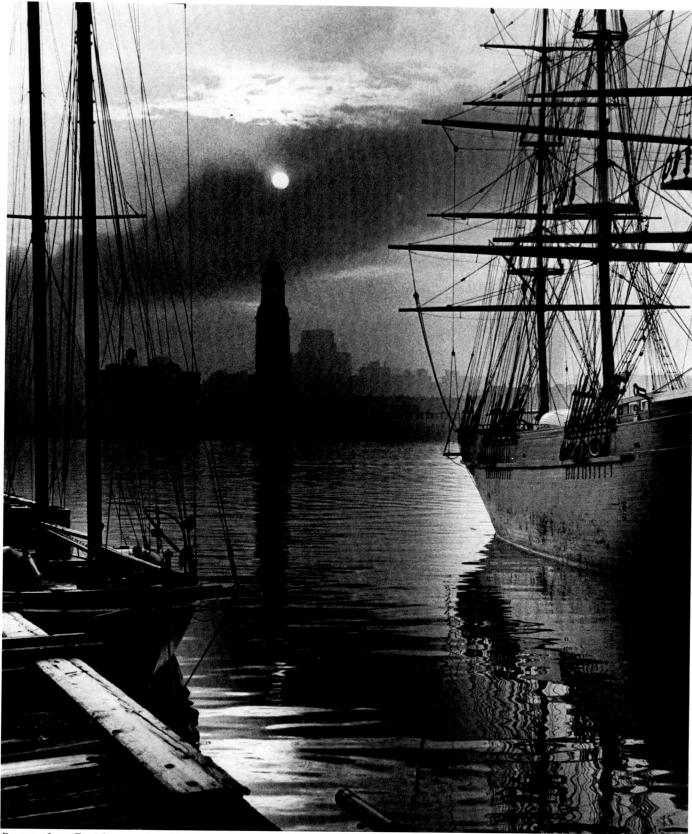

Boston, from East Boston pier. 1967.

JOE DENNEHY

33

Logan International Airport, Boston.

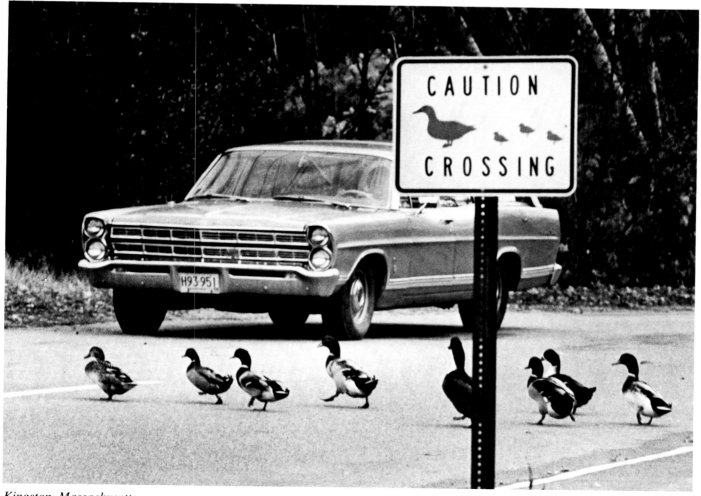

Kingston, Massachusetts.

The Museum of Fine Arts, Boston.

The Louvre, Paris.

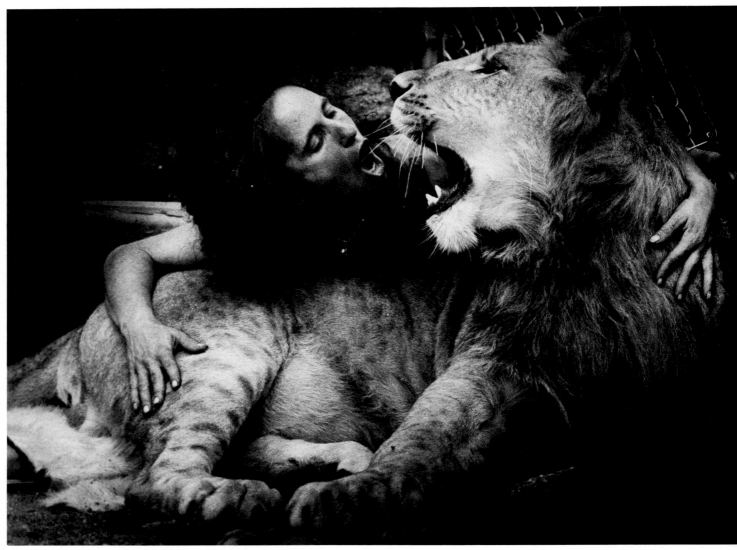

Mount Wachusset Wild Animal Farm. Hubbardston, Massachusetts.

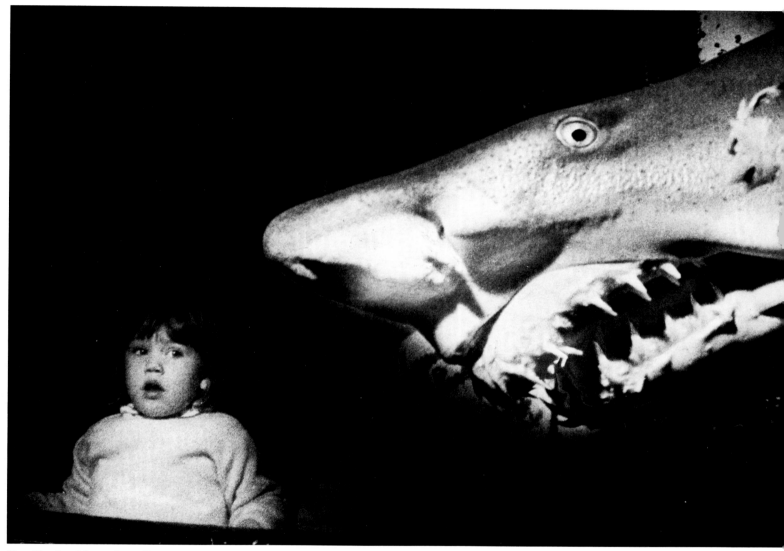

New England Aquarium, Boston.

Following: Skyline dive. Boston. DAVID L. RYAN

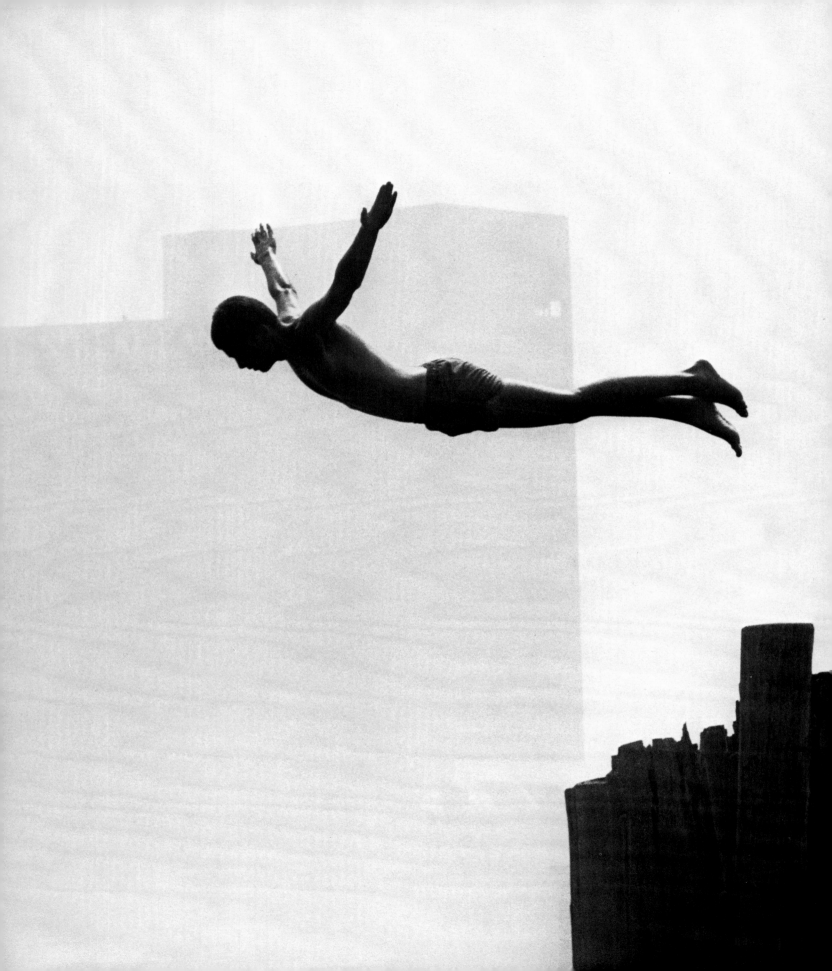

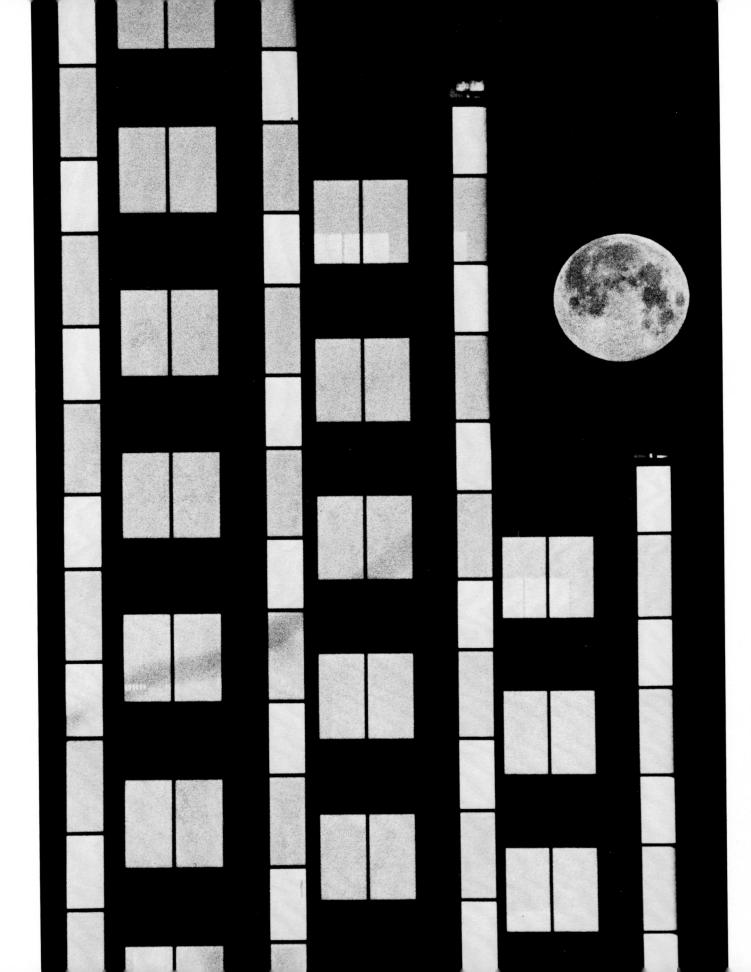

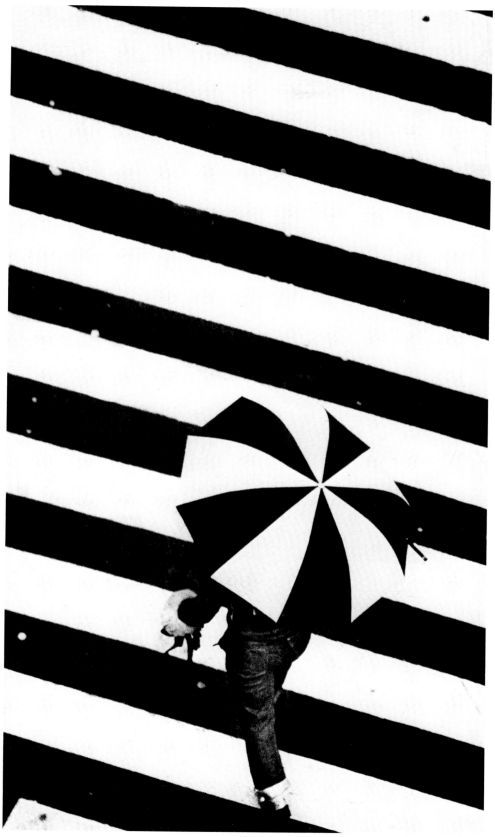

Old Downtown Crossing. Boston.

Opposite: Moon over modern high-rise. Cambridge, Massachusetts. JOHN TLUMACKI 43

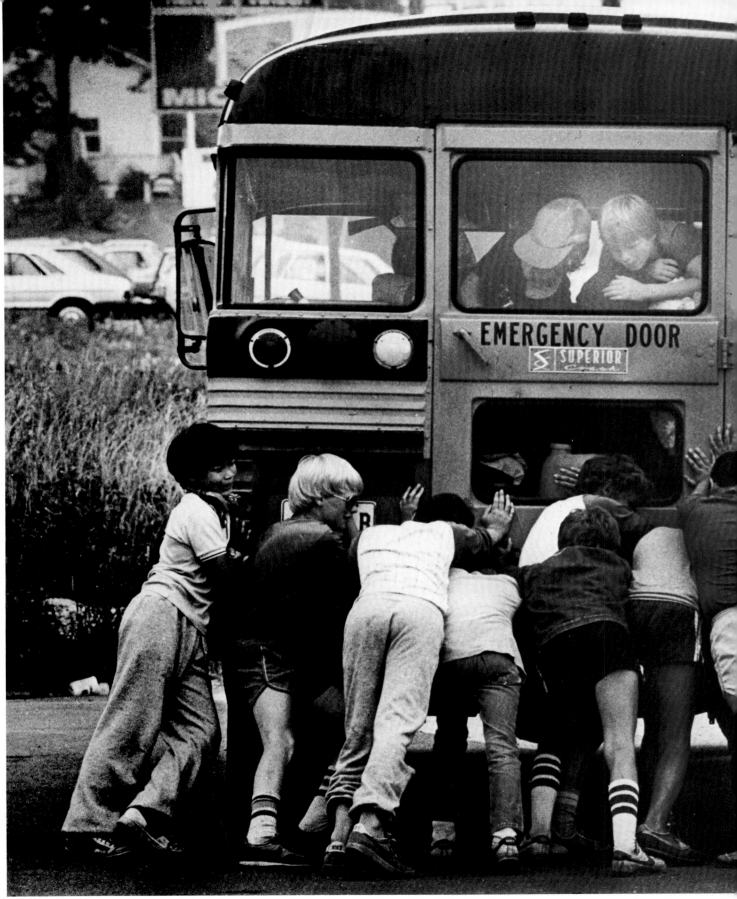

Route 1, Wiscasset, Maine.

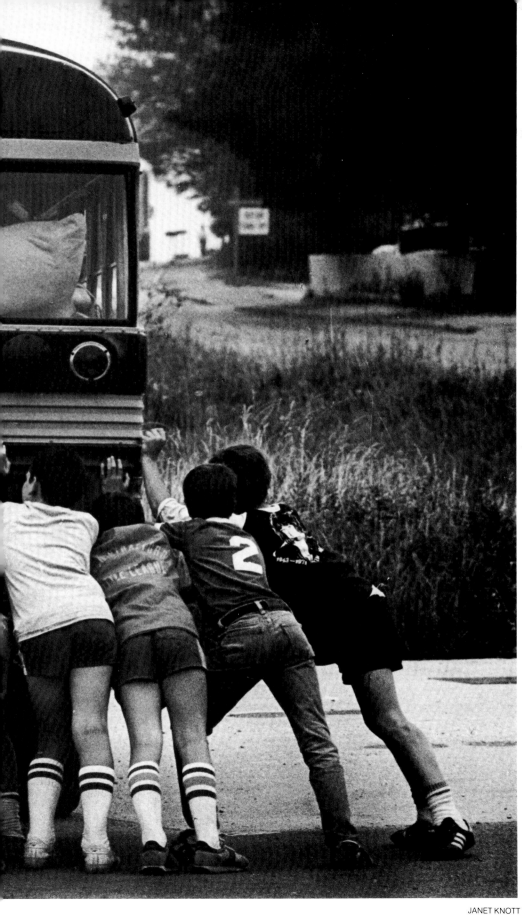

45

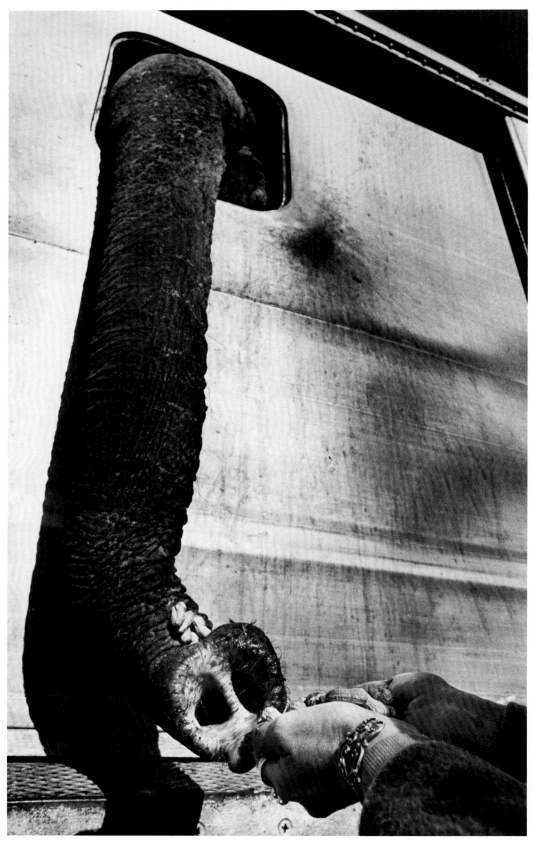

A Ringling Brothers elephant scoops some peanuts as the circus train pulls into town. Boston.

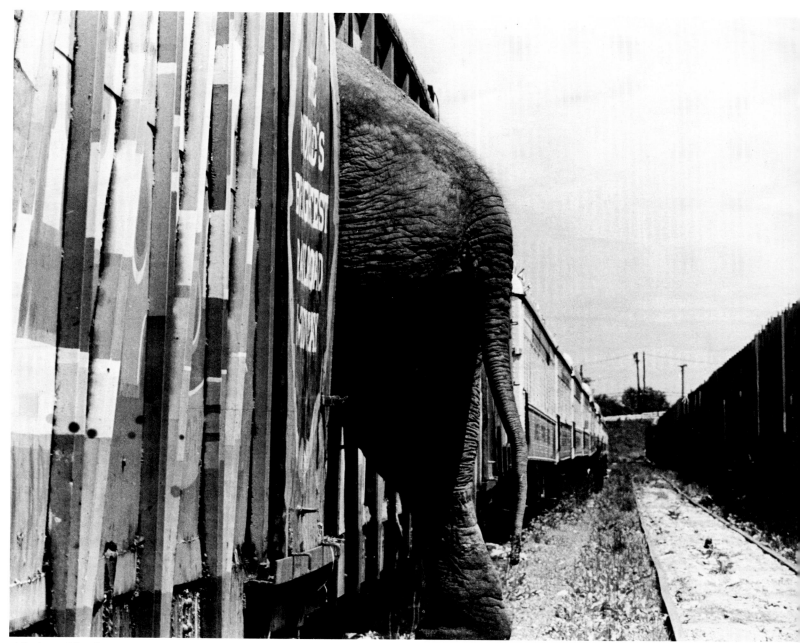

All aboard for the circus. Framingham, Massachusetts.

JOE DENNEHY

47

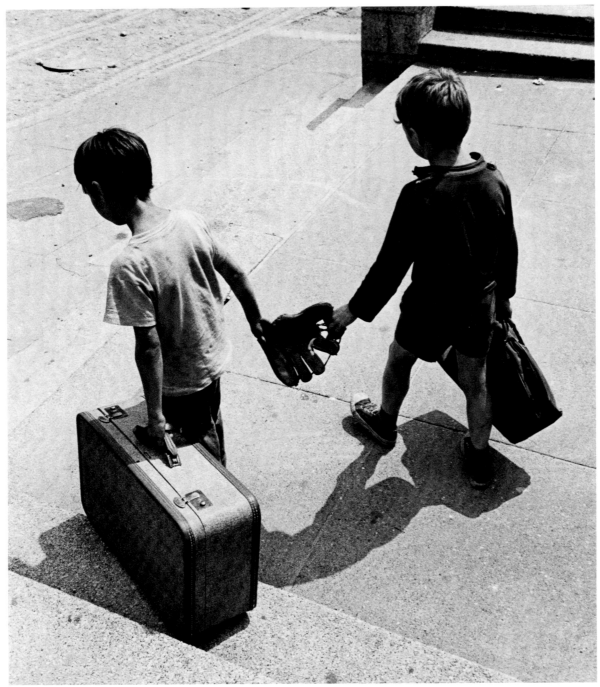

Two youngsters head for summer camp. Charlestown, Massachusetts.

48

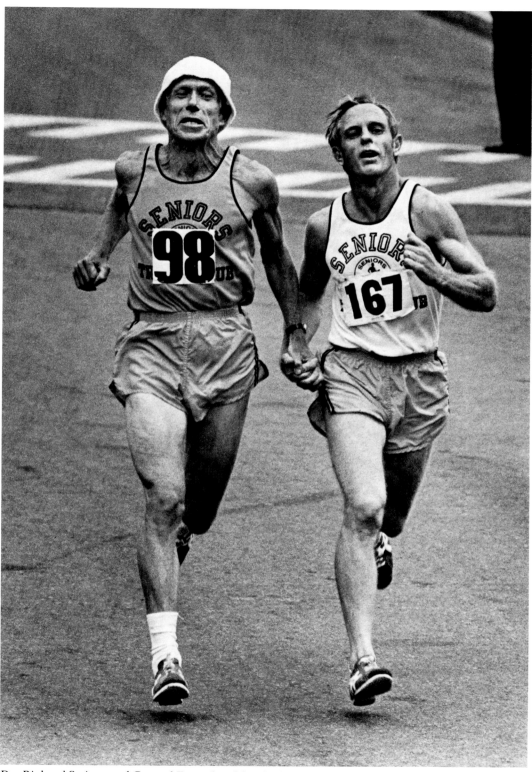

*Dr. Richard Steiner and Conrad Eroen head for the finish line
of the Boston Marathon. Boston, 1972.*

ULRIKE WELSCH

49

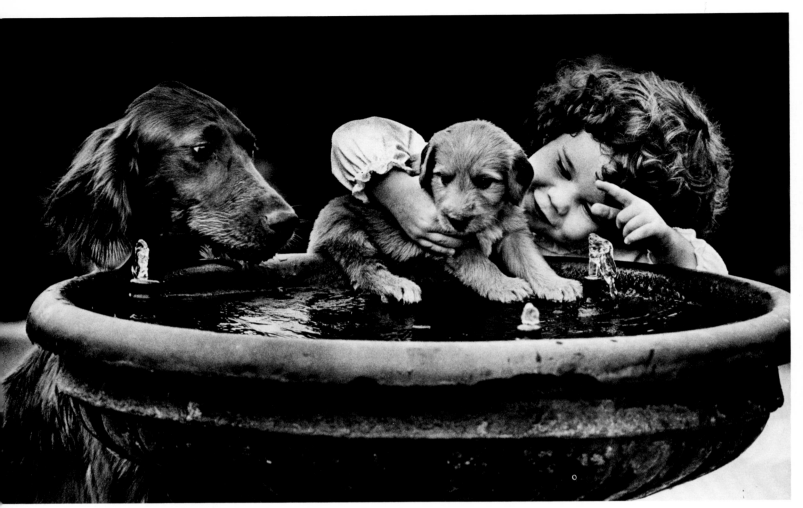

Jamaica Pond, Boston.

Opposite: Frog Pond, Boston Common. STAN GROSSFELD

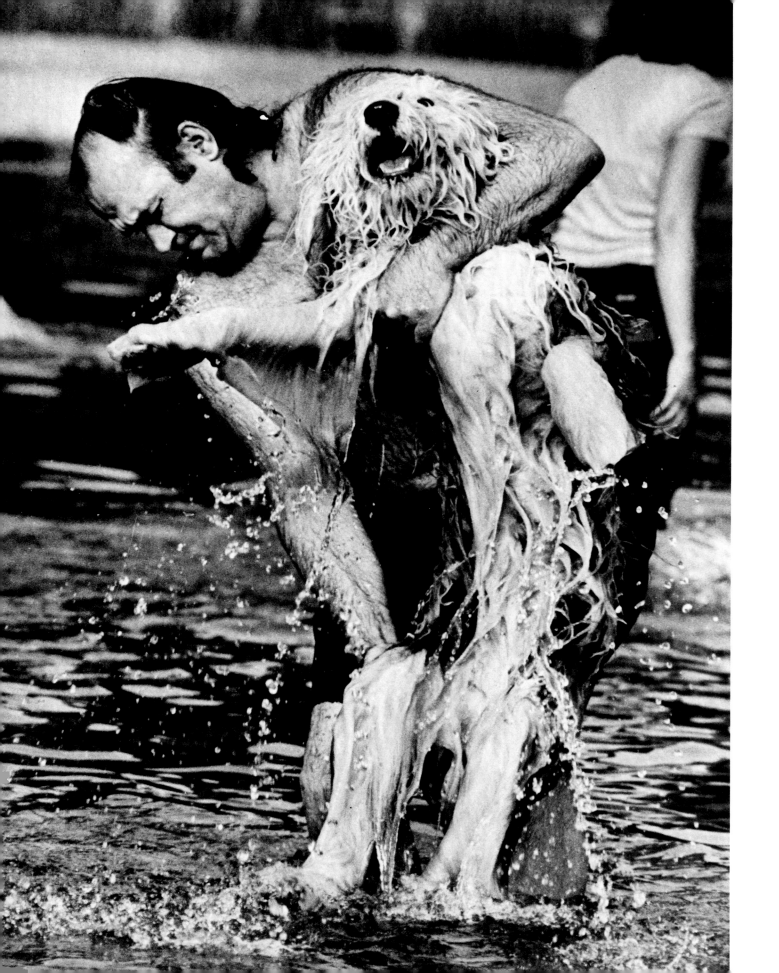

Sandwich, Cape Cod, Massachusetts.

52

Double dogs. Boston Common.

Following: Chimney sweeps. Beacon Hill, Boston. DAVID L. RYAN

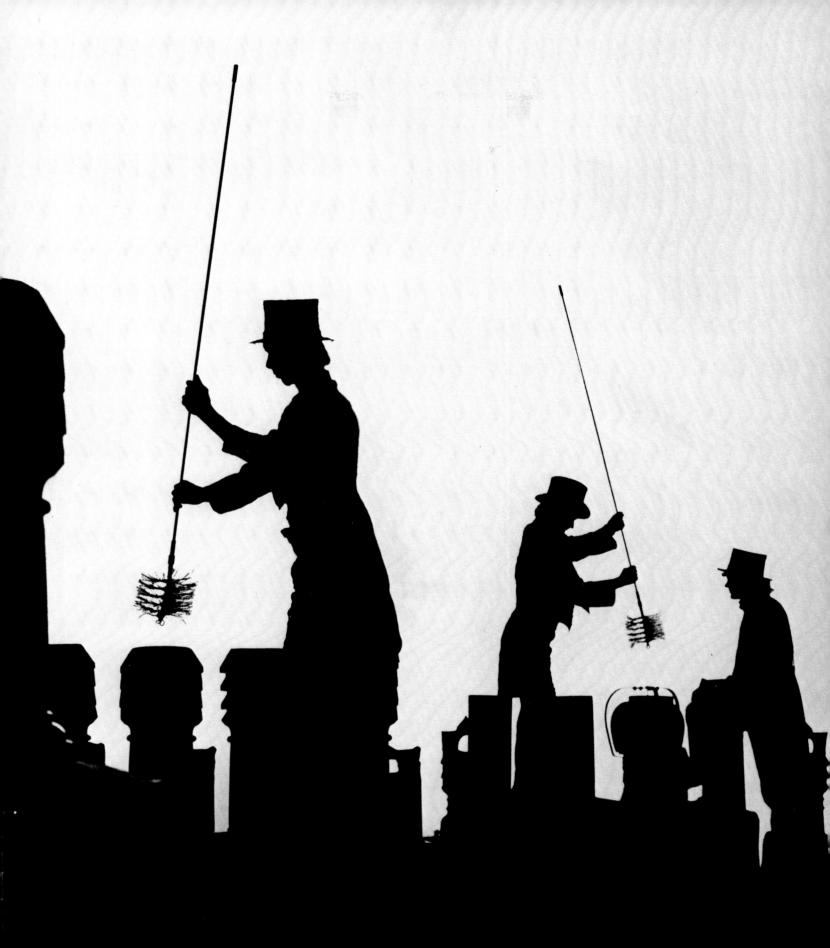

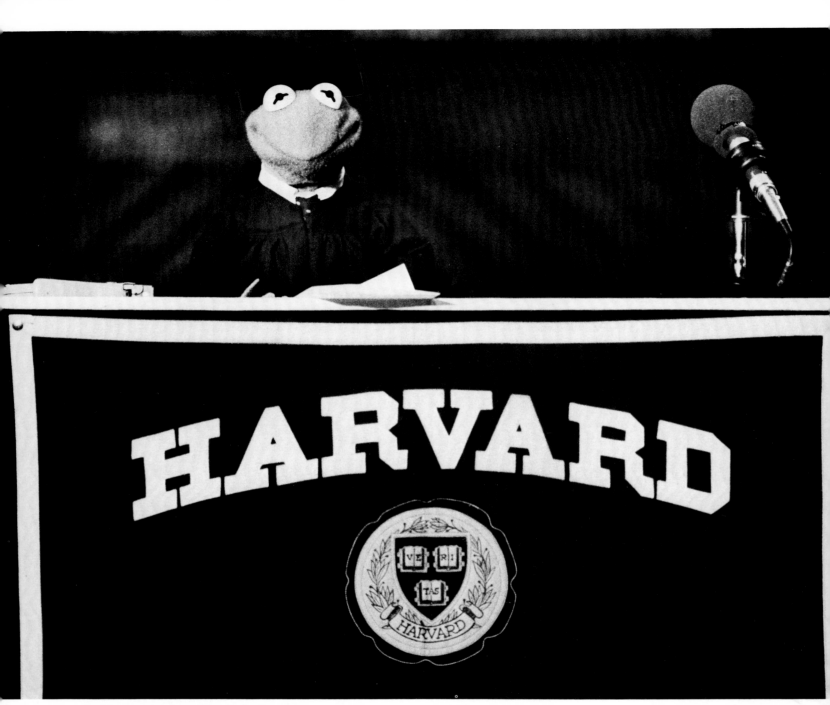

Muppet character Kermit the Frog appears at commencement activities
at Harvard University. Cambridge, Massachusetts, 1982.

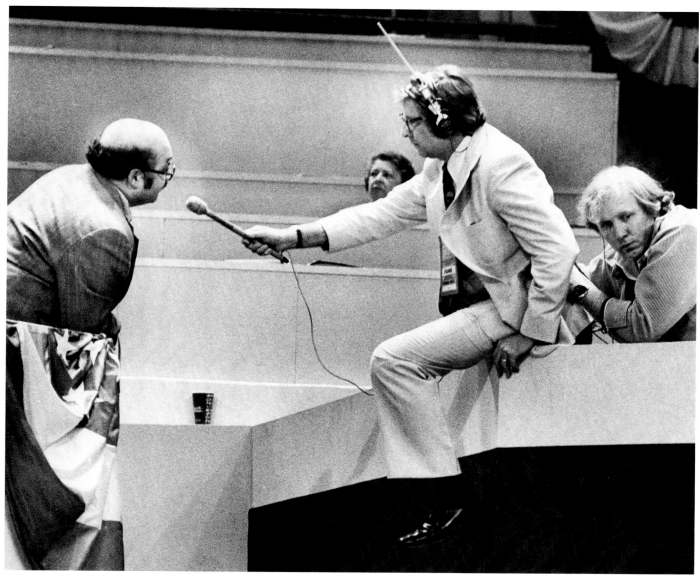

*NBC's Tom Pettit stretches for interview
at the Democratic National Convention.
New York, July 1976.*

Workman installs windows in 57th floor of the John Hancock Tower. Boston. TED DULLY

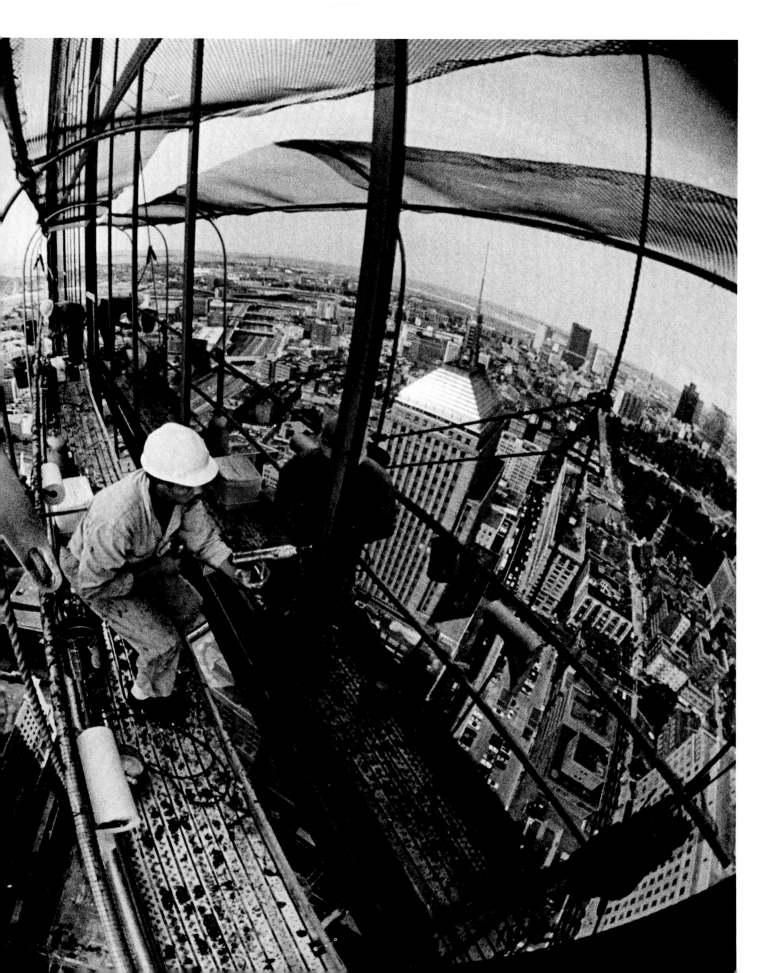

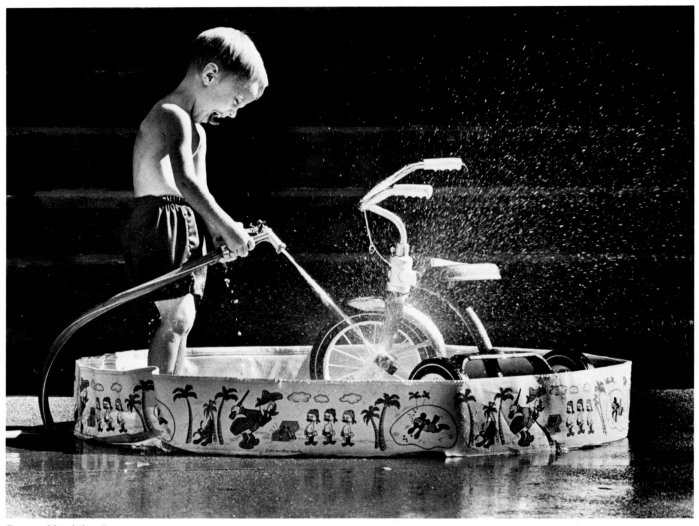

Boy and his bike. Boston.

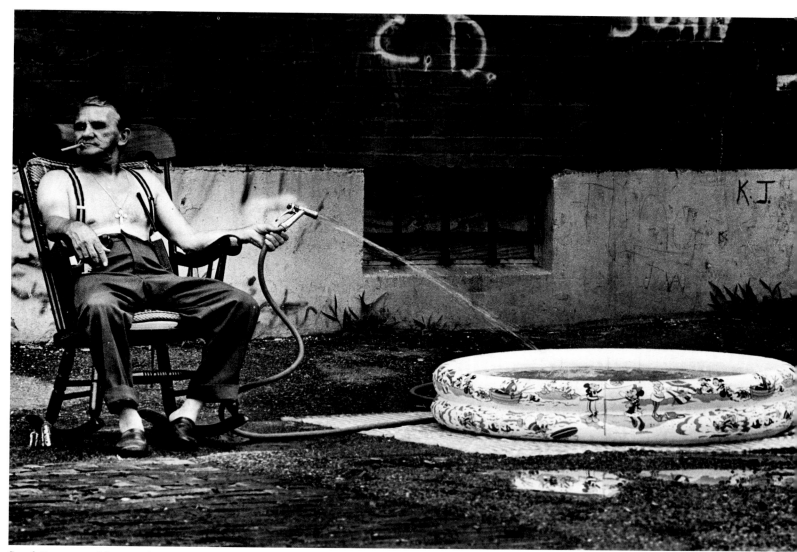

South Boston resident cools off by filling a kiddie pool during summer heat wave.

JANET KNOTT

61

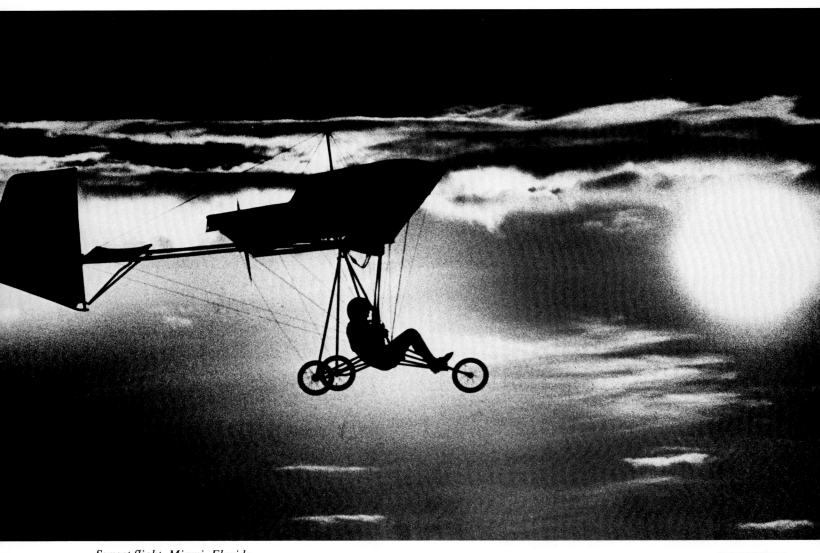

Sunset flight. Miami, Florida.

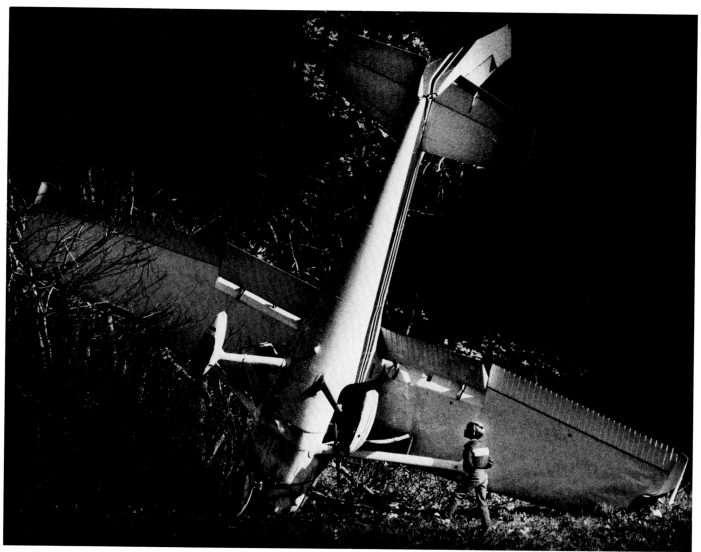

A boy inspects a downed aircraft, from which two passengers escaped without injuries. Marlboro, Massachusetts.

WENDY MAEDA

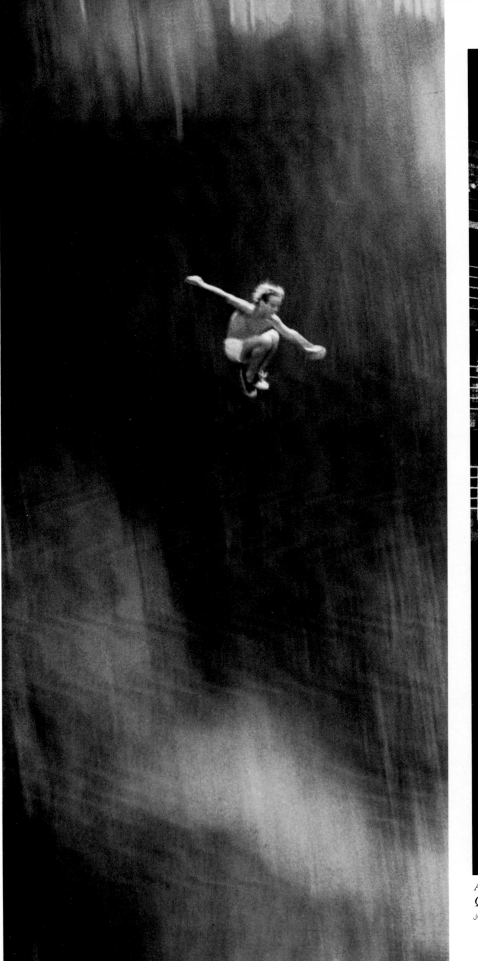

A free fall into the quarry.
Quincy, Massachusetts.

JOE DENNEHY

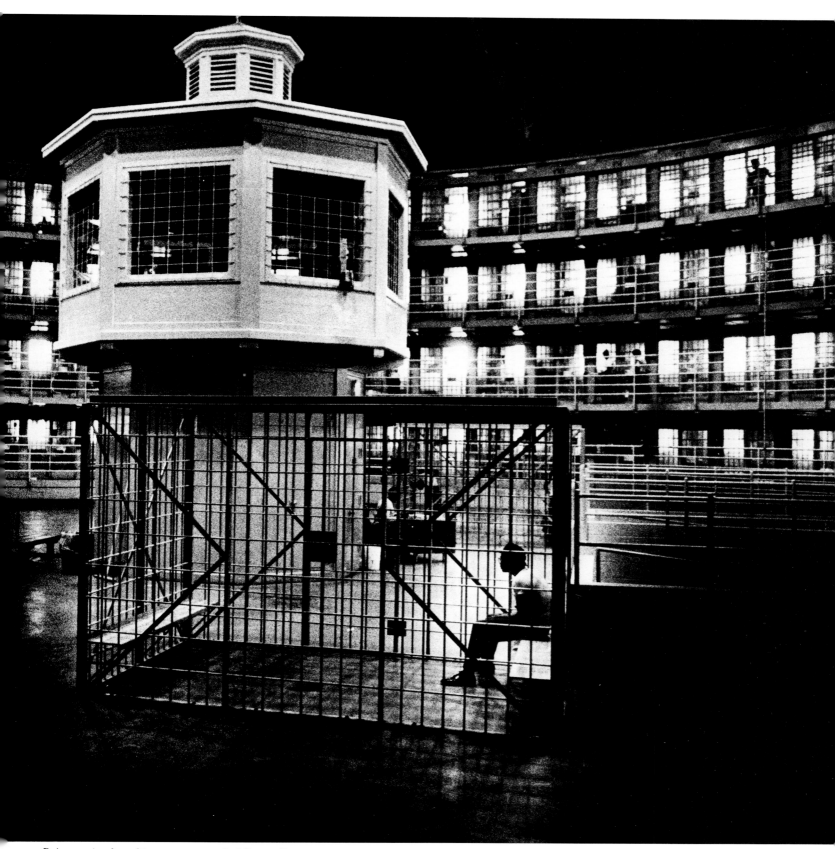

*Prisoner is placed in a temporary holding cell
in a prison in Joliet, Illinois.*

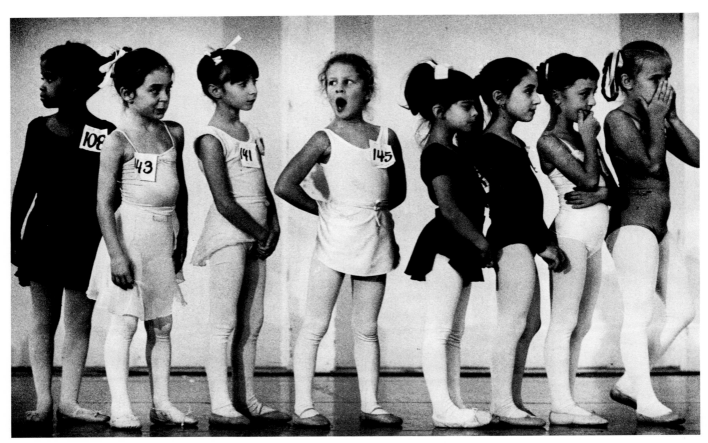

Miniature ballerinas line up to audition for a part in the Boston Ballet's annual performance of "The Nutcracker Suite." Boston.

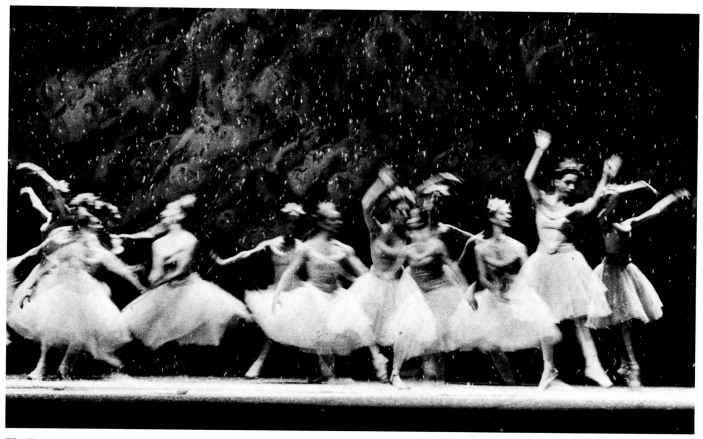

The Boston Ballet performs ''The Nutcracker Suite.'' Boston.

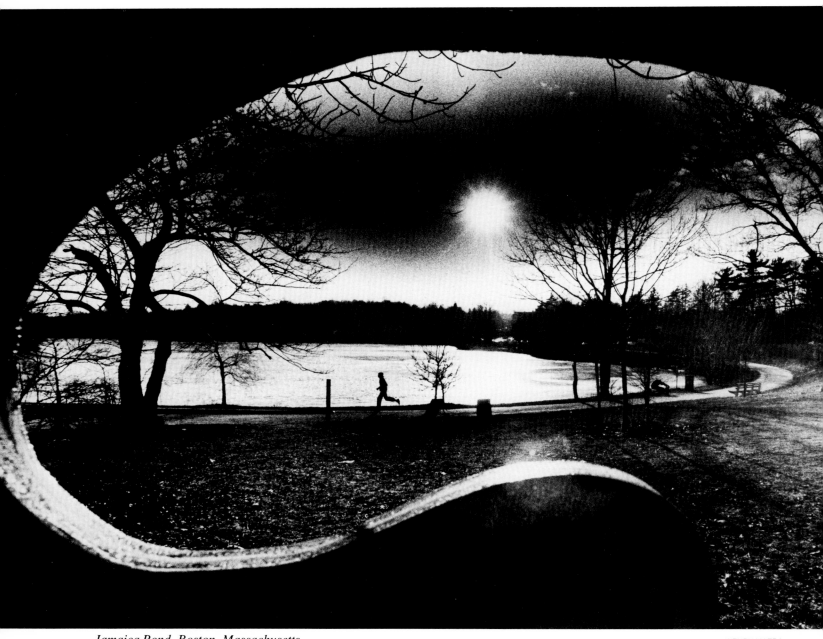

Jamaica Pond, Boston, Massachusetts.

WENDY MAEDA

Marblehead Harbor, Marblehead, Massachusetts.

TED DULLY

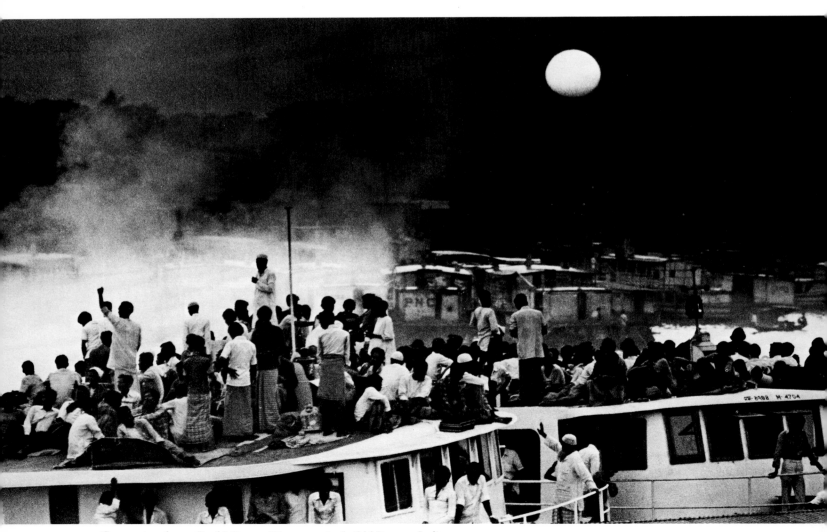

Commuters leave Burhi Ganga River terminal. Old Dacca, India.

JANET KNOTT

70

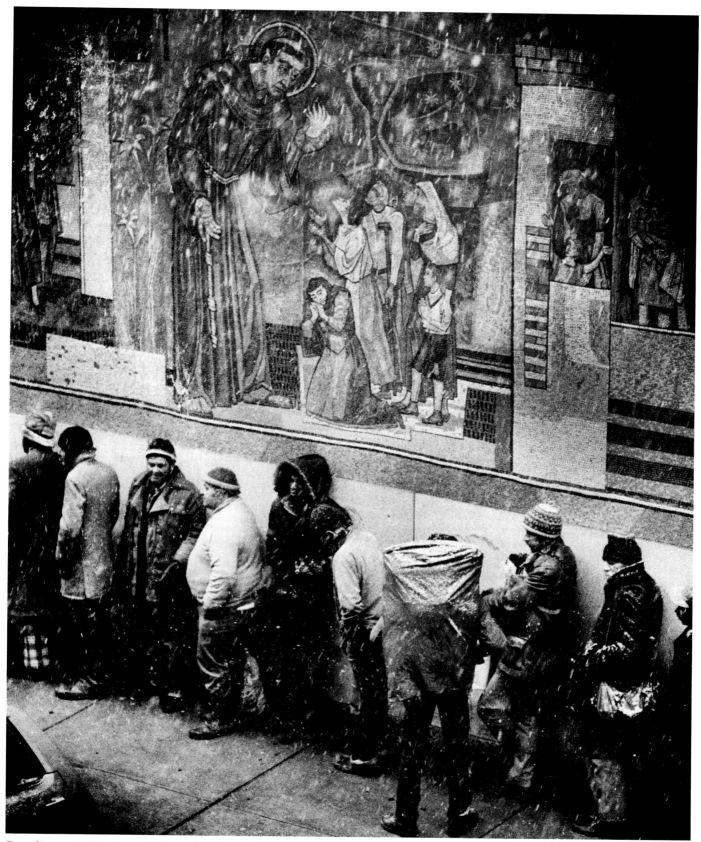

Soup line outside St. Anthony's Shrine on Christmas Day. Boston.

Tiny Tim, the entertainer, was in Peabody, Massachusetts, playing the Holiday Inn on August 6, 1971. Timothy Leary, the high priest of LSD, was in Lausanne, Switzerland, that same day, having been released on $18,500 bail. Tommy Agee, the New York Met center fielder, was in Shea Stadium going 0-for-8 in a seventeen-inning 2-1 loss to the Atlanta Braves. Richard Nixon, the President, arrived on Minot's Island, Maine, for a vacation. Alfred Worden, the *Apollo* astronaut, viewed a spectacular lunar eclipse from outer space.

John Tlumacki, the sixteen-year-old, was in Beverly, Massachusetts, bagging groceries at the corner store. Eleven years later he would painstakingly photograph the next lunar eclipse, using multiple exposure techniques on a single frame of film.

The page-one picture would become one of the photos most requested by *Globe* readers. Here's how he did it.

"First I did my homework and watched the moon rise over Boston a few times. Early that night I went to Faneuil Hall, because it's such a symbol of the city. I put the camera on a tripod and made a picture of the whole building, leaving plenty of room in the sky. I used a 35-mm lens and an exposure of f/2.8 at 1/15 second," Tlumacki said.

Then he returned to the darkroom, developed his film, and placed the negative directly under the groundglass, which was removed from the camera viewfinder. With a crayon, Tlumacki traced the image of Faneuil Hall on the groundglass. He also drew circles across the sky, to help him line up the various stages of the moon's eclipse. Because the sky area was black, the upper portion of the negative was, in effect, unexposed.

With a fresh roll of film in his camera, and his tripod exactly in the same spot—wedged in between a traffic light and a fire hydrant—Tlumacki reshot Faneuil Hall using the marked groundglass. Then he packed up and stopped for coffee and an Italian sub to go, "with plenty of onions and hot peppers so I would stay awake."

In the next three hours he made six more exposures on the same frame of film. Using a spot meter that reads only one percent of the angle of view, Tlumacki was able to get an accurate reading of the moon's surface: f/5.6 at 1/125 second.

"People don't realize how bright the moon's surface is. They think you have to make a long time exposure; you don't."

He lined up the full moon against the crayon mark he'd made on the upper left-hand corner of the frame, and exposed the same frame again. Each successive phase of the eclipse was photographed at precise half-hour intervals, using multiple exposures, in exactly the spot Tlumacki had drawn for the moons on his groundglass.

As the shadow covered more of the moon's surface, Tlumacki had to increase his exposure by a full two f-stops for his last exposure.

"I had to keep adjusting the camera because with the 300-mm telephoto lens the moon would actually travel across the viewfinder in about ten seconds."

Back in the darkroom, he developed the film normally. It was the first 36-exposure roll of film he'd ever developed where only one frame was exposed. Hard work and planning paid off. Frame 7-a was right on the money.

"I never tried a multiple exposure shot like this before, so I prayed a lot out there. I prayed for no clouds. And I prayed that after shooting the thing for three hours I wouldn't accidentally bump the tripod on my last exposure."

He didn't.

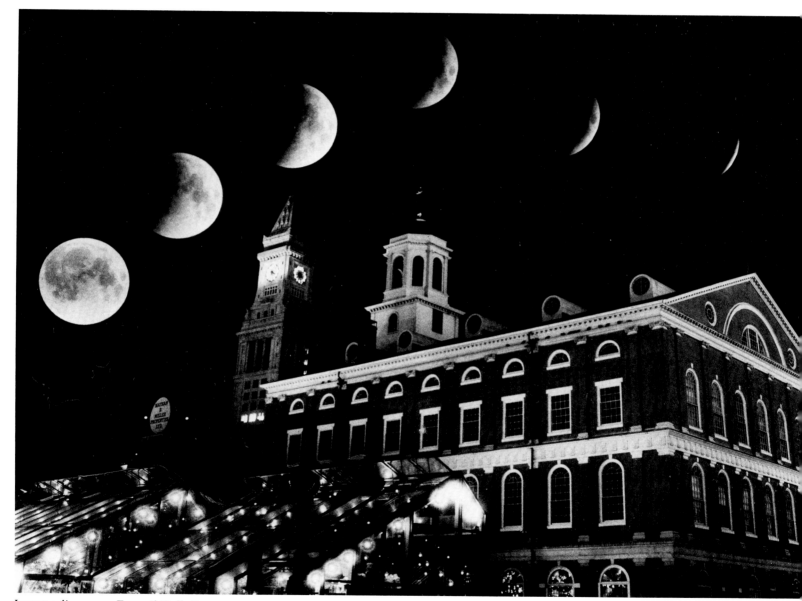

Lunar eclipse over Faneuil Hall. Boston.

The light was lousy in the hotel chapel.

Ulrike "Uli" Welsch was in the Sheraton Boston to cover a religious rite conducted by His Beatitude Patriarch Elias IV of Antioch and All the East.

Certain rules were set up by the Antiochian Orthodox Church. No shooting in front of the altar, no motor-driven cameras, and no flashes. Another photographer, too aggressive and disrespectful, had fired off several flashes and had been thrown out. "I hated the other photographer's behavior," said Uli. "There is no reason for it, and it gives all photographers a bad name." Photographers should be sensitive and patient in situations like this. "You will find if you seek," says Uli.

Uli noticed a small tear in a black curtain that served as a backdrop to the altar. She crept behind the curtain. Out of sight of the congregation, she separated the threads with her fingers just enough to view the bishop through her 28-mm lens.

A single spotlight illuminated the bishop as he turned to face the altar. Because of the low light she rated her ASA 400 film at 1600. The effect was to deliberately underexpose and overdevelop the picture. The way it turned out, light from the spotlight illuminated the loose threads that hung over her lens.

"It turned out very lucky," Uli says. "The spotlight hit the threads at just the right angle and made him 'holy.'"

His Beatitude Patriarch Elias IV of Antioch and All the East.

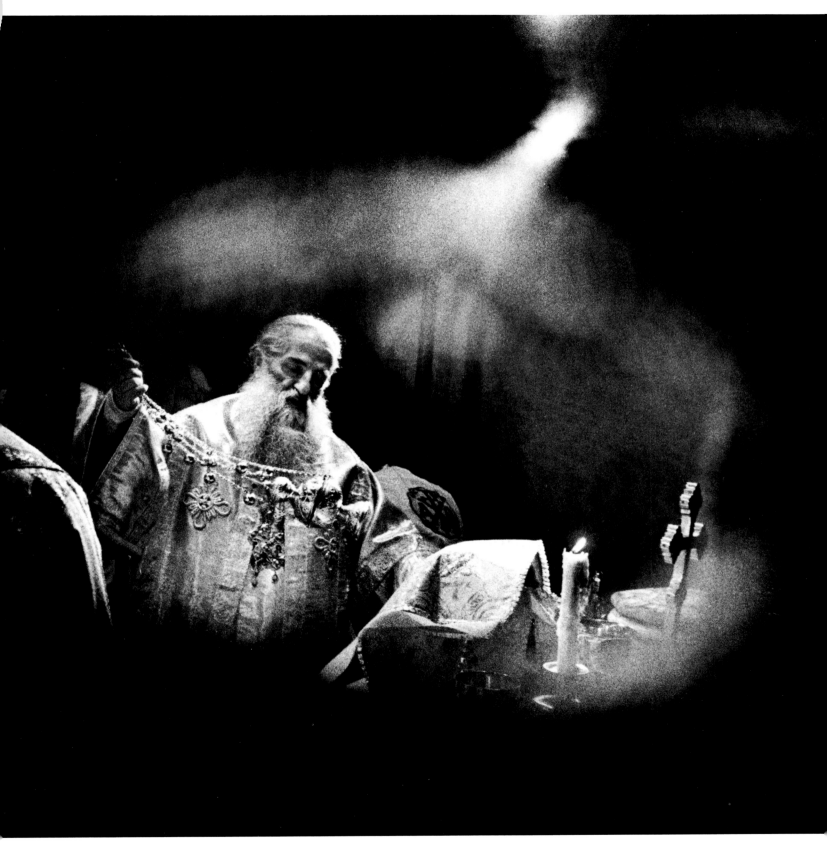

Faces

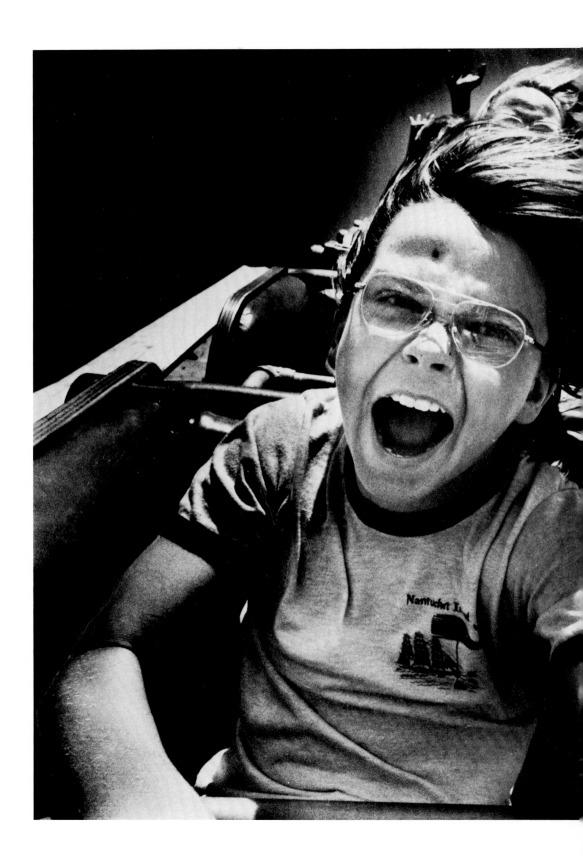

*Paragon Park
roller coaster.
Hull, Massachusetts.*

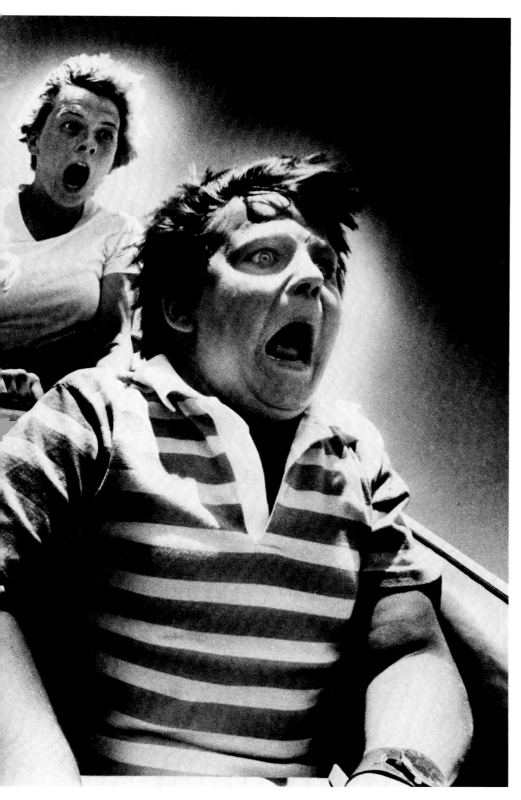

STAN GROSSFELD

Bob Dylan

JANET KNOTT

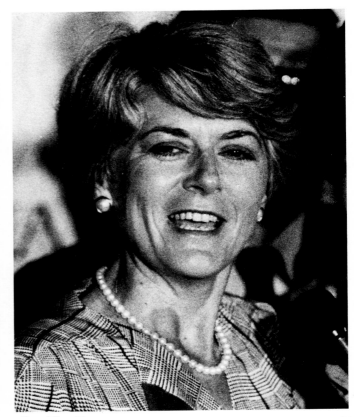

Geraldine Ferraro

DAVID L. RYAN

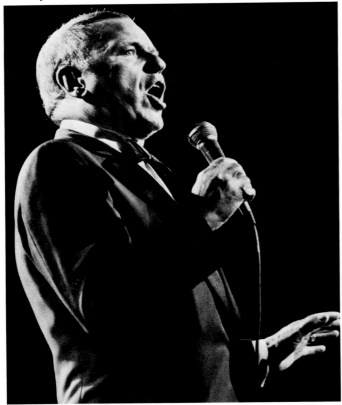

Frank Sinatra

JOHN TLUMACKI

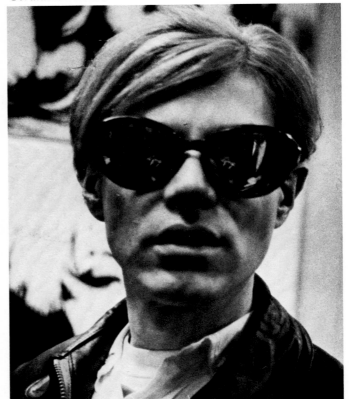

Andy Warhol

GIL FRIEDBERG

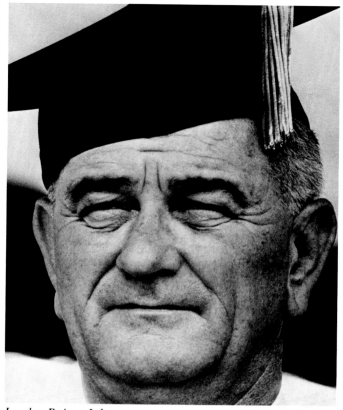

Lyndon Baines Johnson OLLIE NOONAN, JR.

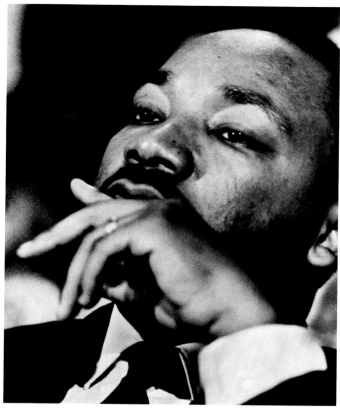

Martin Luther King, Jr. BOB DEAN

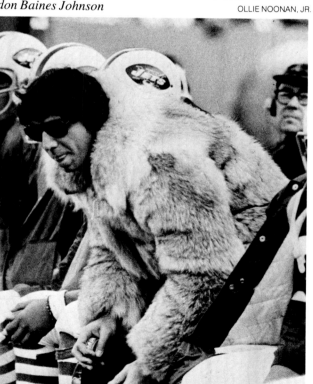

Joe Namath FRANK O'BRIEN

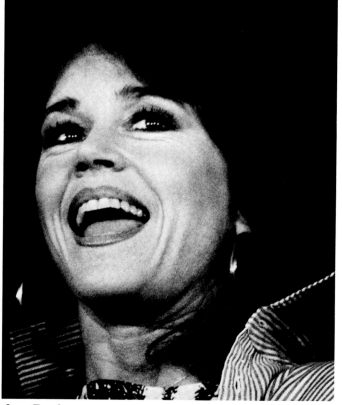

Jane Fonda JANET KNOTT

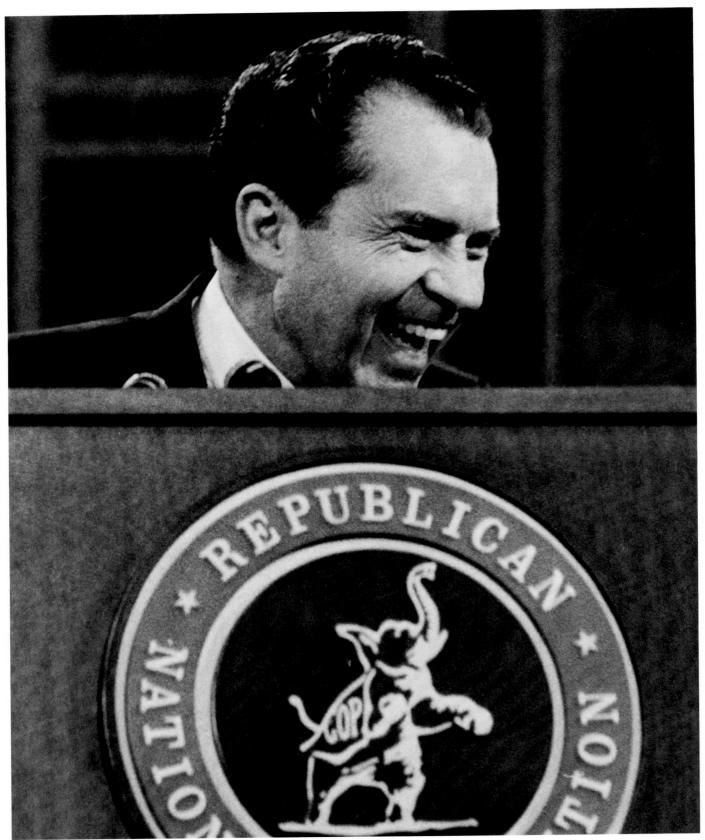

Richard Nixon accepts Republican nomination for President at the Miami convention. August 1968.

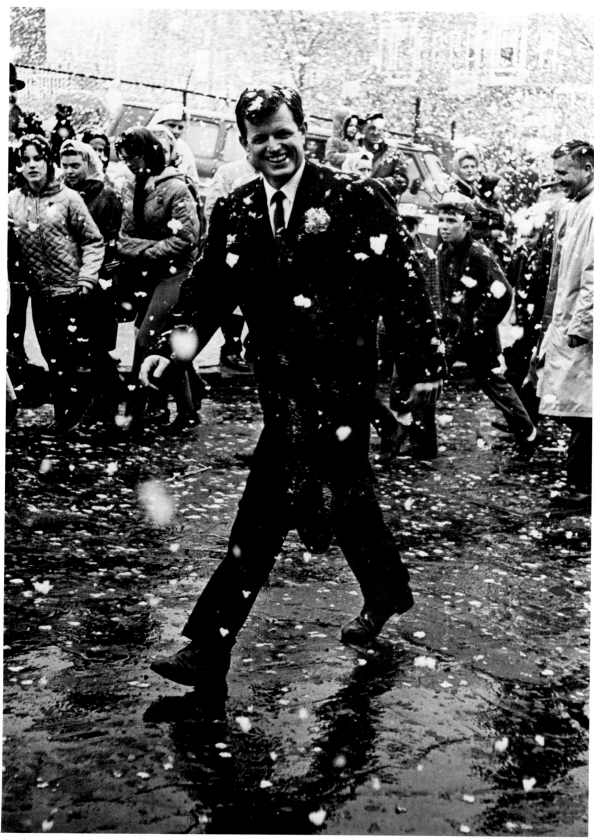

Undaunted by giant snowflakes, Senator Edward M. Kennedy marches in Southie's annual St. Patrick's Day parade. South Boston, March 1964.

Golden delicious. Watertown, Masssachusetts.

Opposite: Woman peers out frosted window near Faneuil Hall. Boston.

Winner of the Ugly Dog contest.

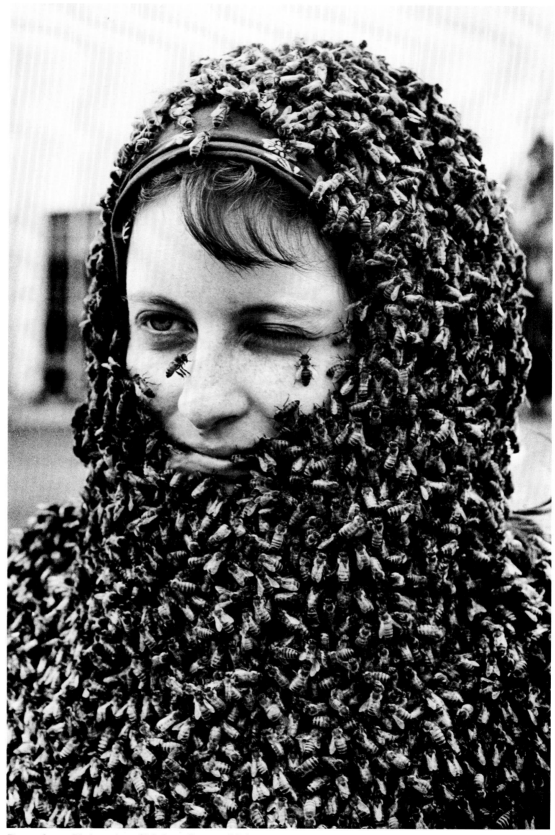

Bee colony, University of Maine, Orono, Maine.

Former heavyweight champion Muhammad Ali greets a very special fighter. Boston. GEORGE RIZER

Opposite: Elma Lewis and little girl rehearse for the upcoming black nativity. Boston. JIM WILSON

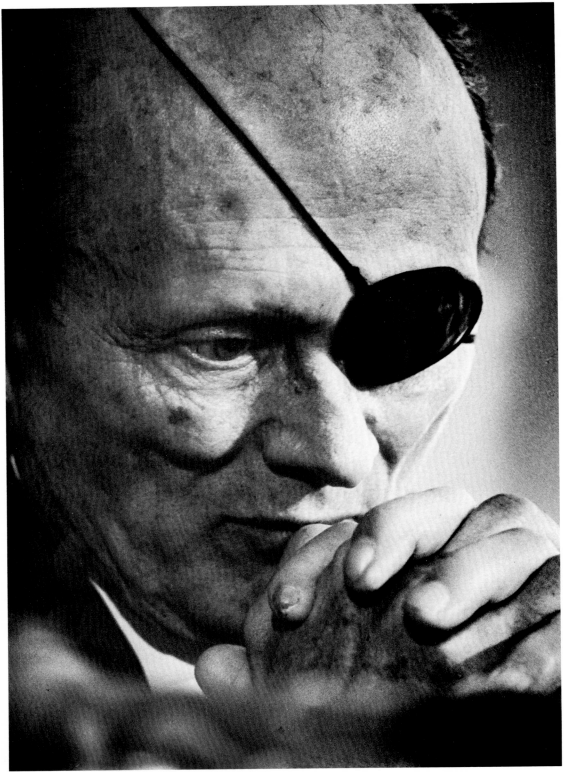

Moshe Dayan. April 1980.

GEORGE RIZER

88

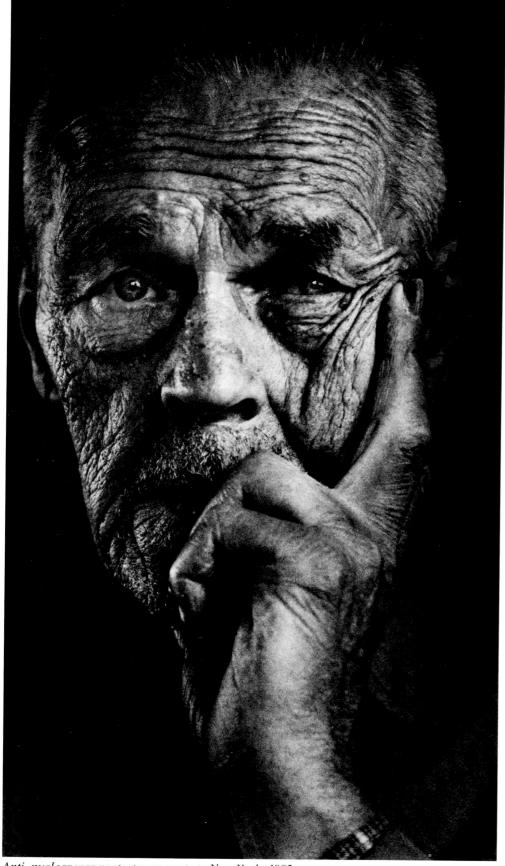

Anti–nuclear war protester en route to New York. 1982.

JANET KNOTT

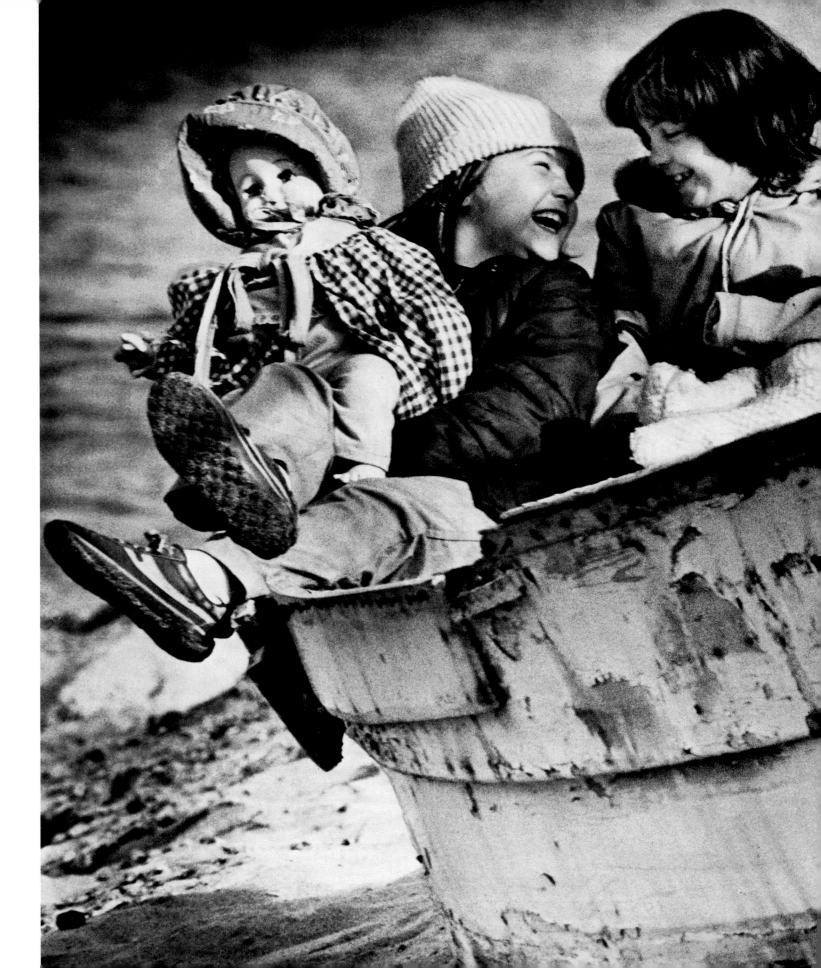

Imaginary cruise.
Provincetown, Massachusetts.
STAN GROSSFELD

91

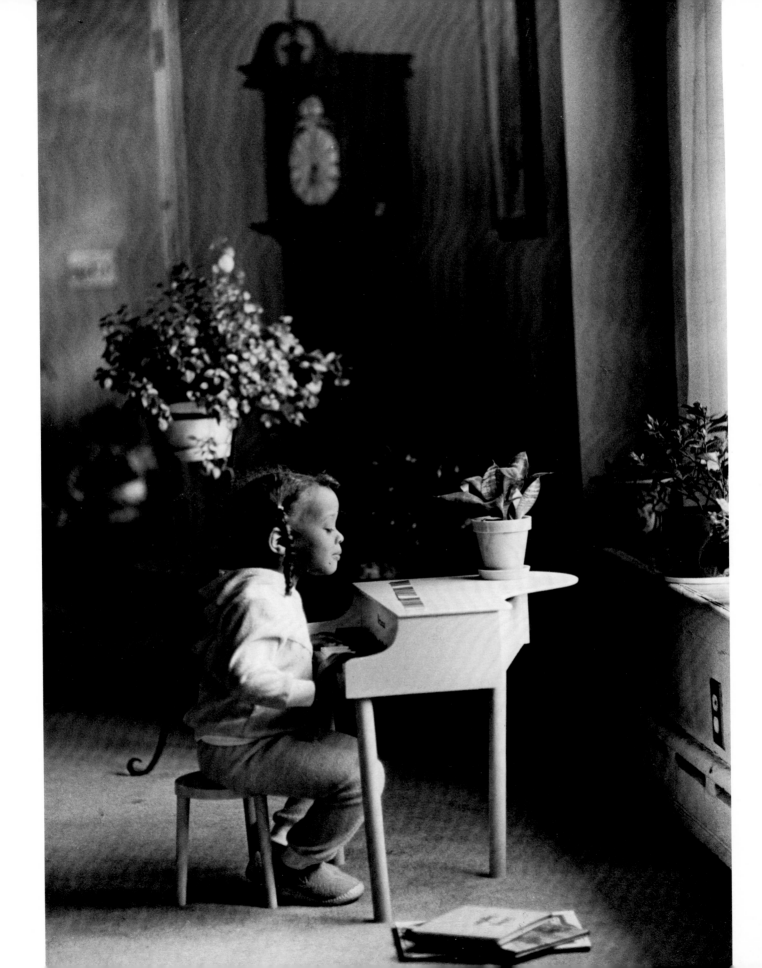

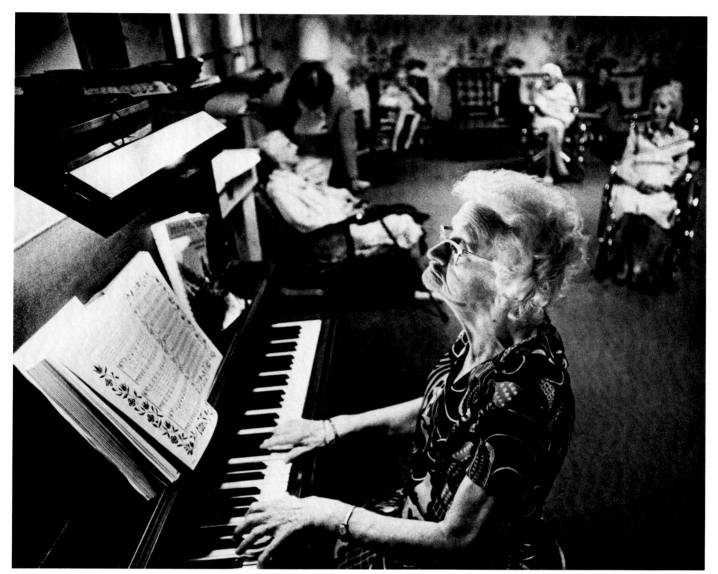

Music to rock by. Weston, Massachusetts.

Opposite: Piano player. Mattapan, Massachusetts. DAVID L. RYAN

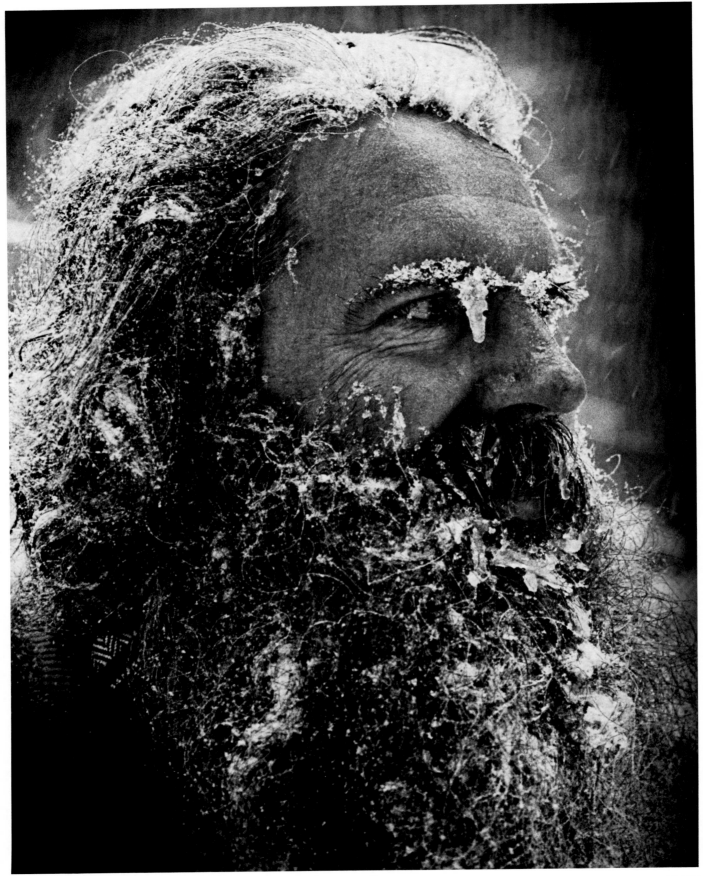

John Procter of Beacon Hill after a winter walk on Charles Street. Boston.

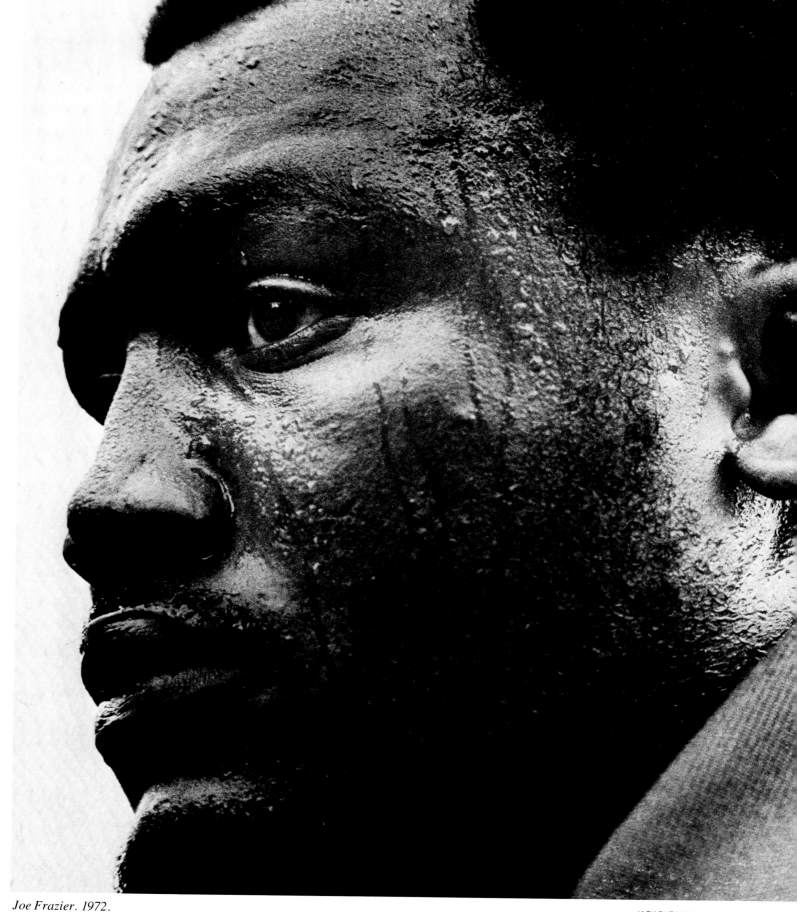

Joe Frazier. 1972.

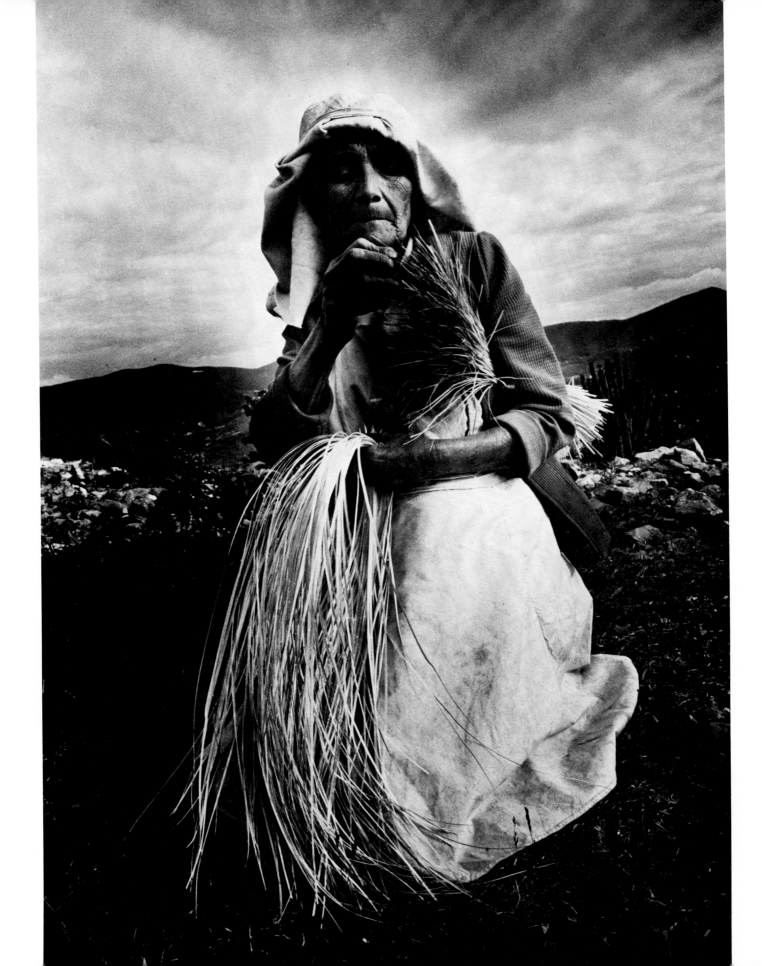

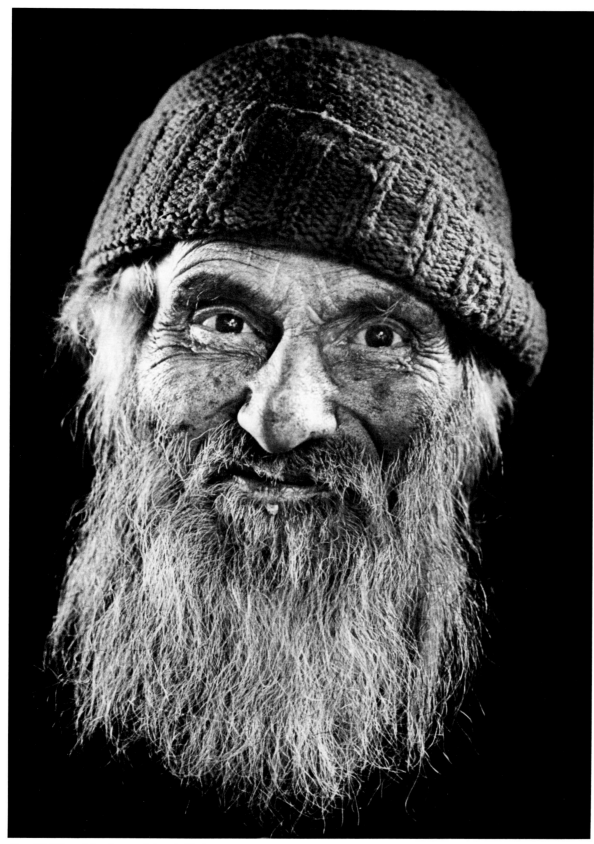

Ray Phillips. Monhegan Island, Maine. ULRIKE WELSCH

Opposite: Mexican basket weaver. JANET KNOTT

97

Outdoor sculpture at the Museum of Fine Arts. Boston.

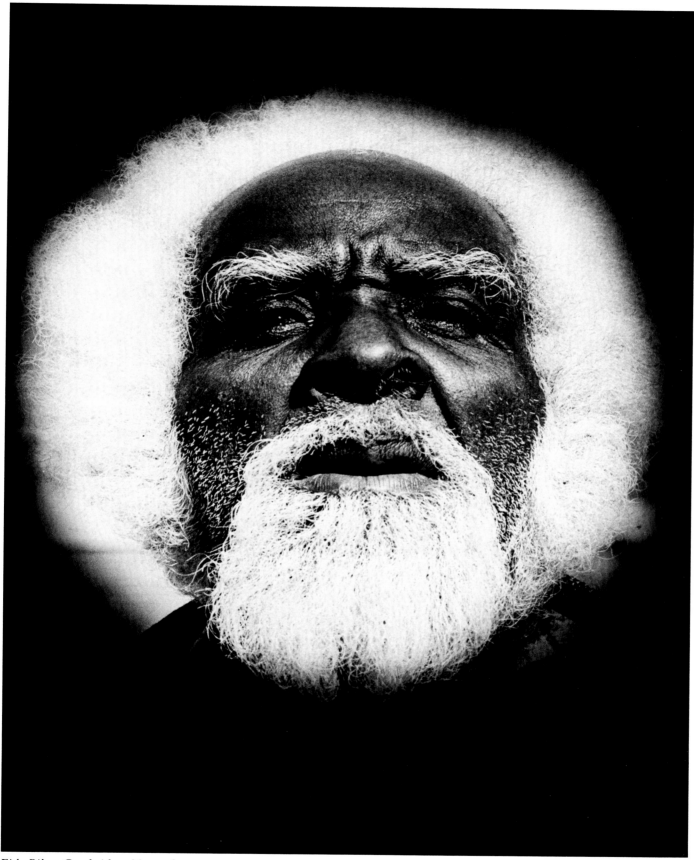

Fido Riley. Cambridge, Massachusetts.

PAUL CONNELL

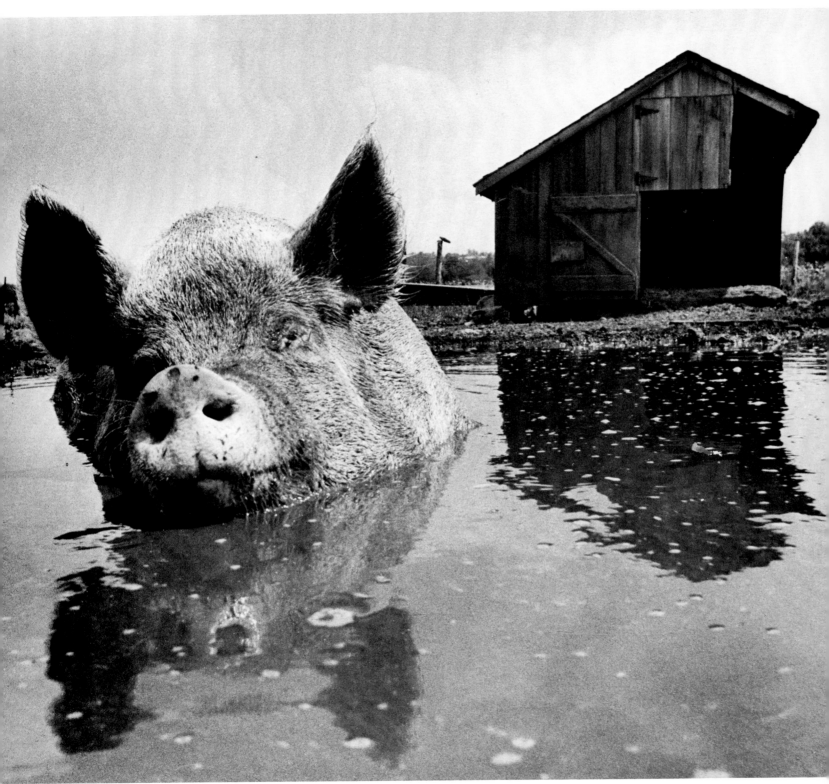

Dover, Massachusetts.

Opposite: Benny Keats. Chelsea, Massachusetts. STAN GROSSFELD

DAVID L. RYAN

Sports

QUESTIONS AND ANSWERS:

Q. Do you get in free?

A. Yes, but I have to schlep about 60 pounds' worth of camera equipment along. And if I miss a key picture, if a referee walks in front of my camera, or I sneeze at just the wrong time, if my focus is just a bit out, or my motor drive batteries are a little low, or I just simply get caught up in the game, and watch it without the interruption of pushing the little button, then I'm in big trouble. My editors are probably watching the game on TV, and their replays may show the play you missed from seventeen different angles in super-slow motion. One replay always catches you on the sideline adjusting your zipper, or stealing a glimpse at a pretty cheerleader.

Q. Any tips for covering prize fights?

A. Never wear white at ringside for a Marvin Hagler bout — it'll wind up in a polka-dot pattern from the blood.

Q. What makes a good sports photograph?

A. A peak action shot of a player from team A in conflict with a player from team B — plus the ball. Sports photography is winners and losers and offbeat moments. It's good training for all photojournalists because it's fast; focusing is difficult; it cannot be recreated; and the challenge is to always get something different.

Q. Are sports heroes arrogant?

A. Some are, some aren't, and some are only part of the time.

Take Willie Mays. He and a host of stars from different sports showed up at a benefit at Symphony Hall for former Red Sox player Tony Conigliaro. As photographers traded elbows in the battle for positions in front of the podium, one photographer spotted Mays in the very back of the room by the bar. The photographer slipped away from the pack and made his way to the back of the room; Mays smiled and nodded hello. The photographer looked to his left and saw Ted Williams. Without a word spoken, Mays sensed what the photographer wanted, and moved closer to Williams.

Just then Joe DiMaggio showed up. The photographer looked at Mays, and Williams, and then over toward DiMaggio. This was the dream outfield, the Hall of Fame outfield. Getting them together would be a far better picture than the usual press conference shot. The ever-helpful Mays called DiMaggio over, even told him to move in a little closer. The photographer focused and composed his shot, but did not press the shutter; DiMaggio's head was turned away.

The press conference was starting; the exclusive picture was about to disappear. The photographer called out, "Mr. DiMaggio!" No response. "Joe D!" Nothing. Finally, desperate, the photographer yelled, "Hey, DiMag! I grew up in the Bronx, give me a break." Willie Mays turned to the photographer and smiled.

"You got your break," he said. "You're out of the Bronx!"

Then there is Larry Bird. Bird was tired and cranky when he got off the plane in Los Angeles. A photographer shot a picture of him. "Take your pictures when I'm on the basketball court,"

Bird snapped. The photographer moved away, and, using a longer lens, took another frame. Bird then demonstrated that great baskeball players have terrific peripheral vision. "Take another picture and you'll eat that camera," Bird threatened.

Five minutes later Bird was in a better mood. So the photographer told him how, on an assignment in Lebanon, he had photographed a US Marine standing guard in Beirut wearing a Celtics jacket. The Marine said Bird had mailed him the jacket.

The picture was transmitted via telephone lines to Boston and appeared on page one of the *Globe*. The Marine told the photographer that Bird wrote a letter, saying how proud he was of him, and how what he was doing was so important for the country.

Little did Bird know that the very same Marine, a real Celtic fanatic, had driven to the Celtic star's Brookline home just before leaving for Lebanon. Bird was outside the house, mowing the front lawn. The Marine jumped out of the car with his Instamatic and tried to take a picture. But Bird issued some quick direct orders, and the Marine retreated.

The Marine told the photographer he'd gotten a big kick out of the fact that the same Larry Bird who cussed him out in the US would send him a jacket and a personal letter, without ever knowing he was the same guy. Bird listened to the tale, then laughed. It was not he who wrote the letter, he said, but his girlfriend, who happened to know members of the Marine's family.

Opposite: U.S. Olympic hockey team defeats Soviets. 1980. FRANK O'BRIEN

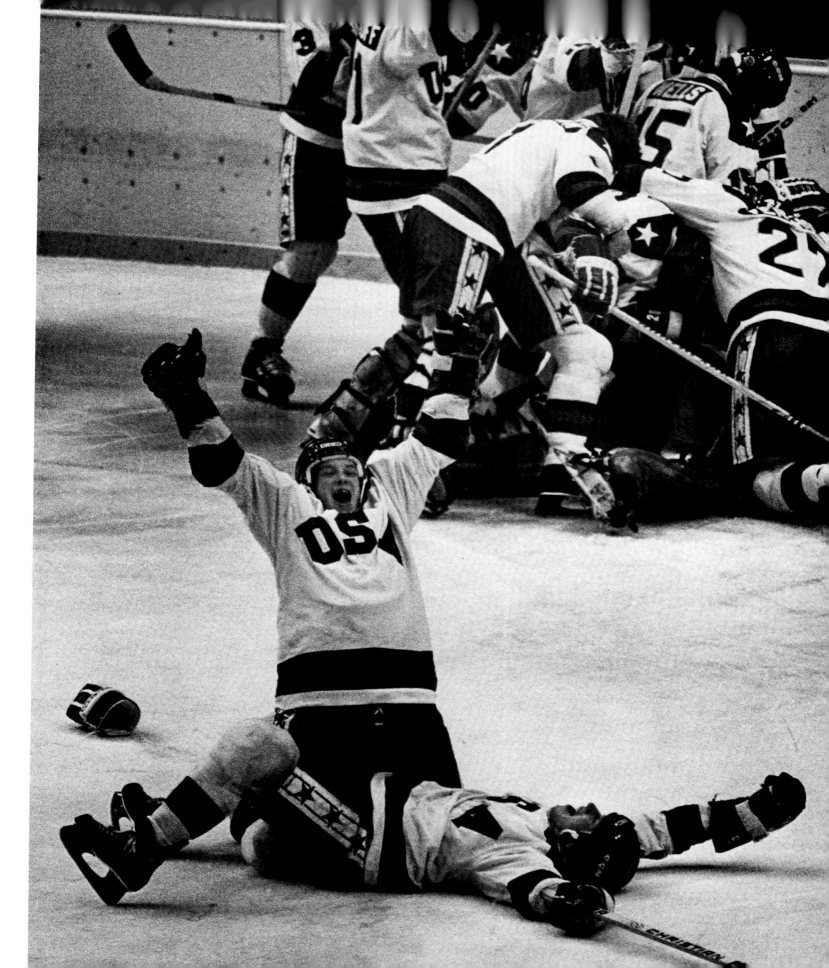

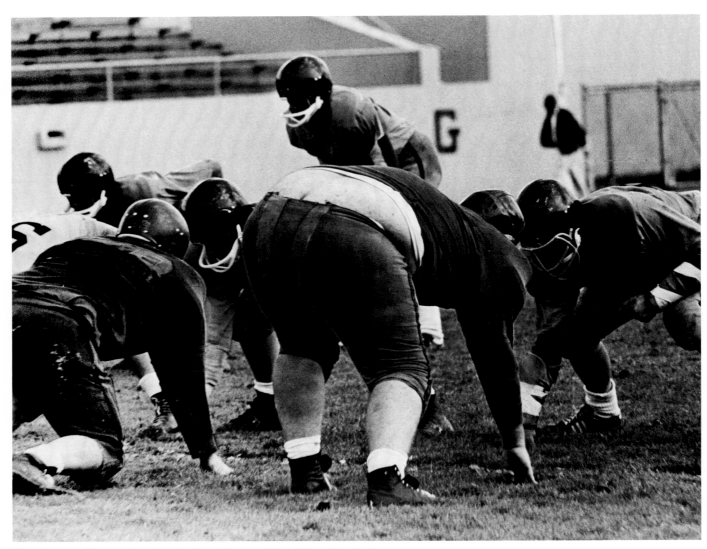

This lineman fills any hole for the South Boston High School football team.

PAUL CONNELL

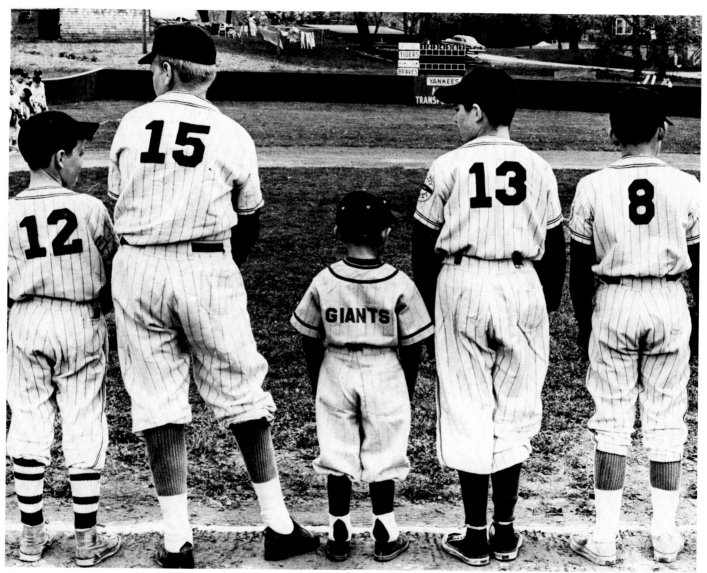

Giants are easy to spot in any lineup. Millis, Massachusetts.

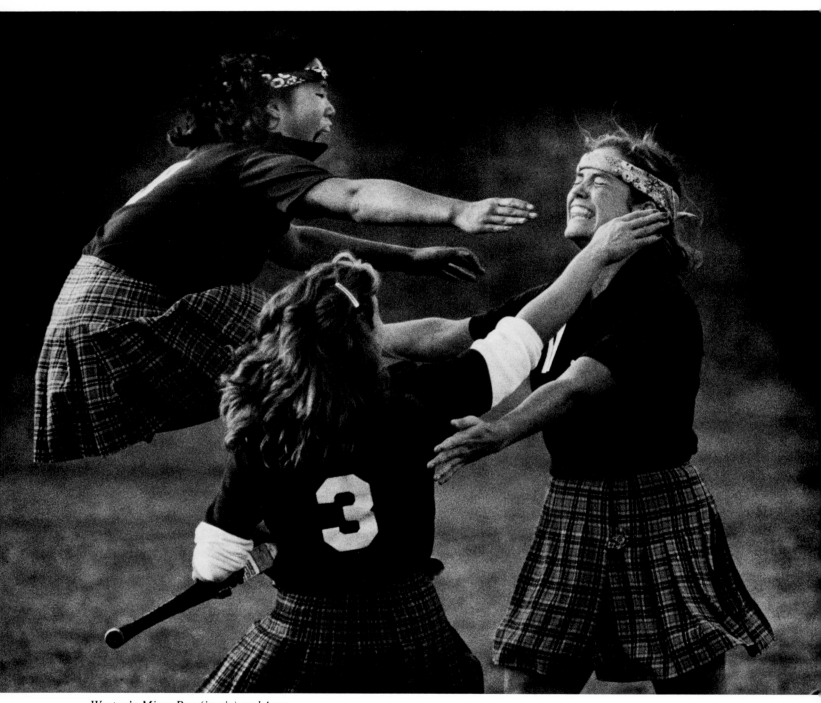

Weston's Missy Pan (in air) and Amy Coller (3) rush to greet teammate Lindsay Tomkins after her goal ties the score against Ipswich. November 1982.

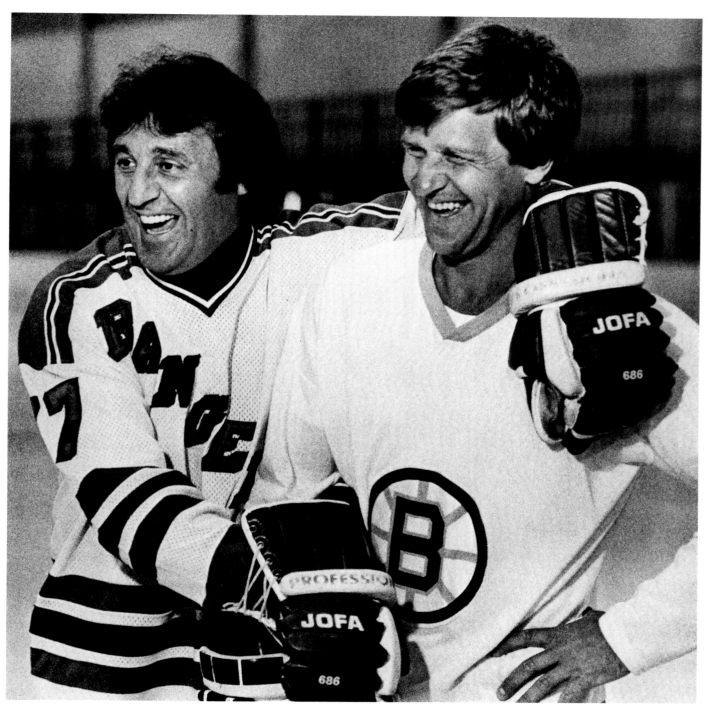

The boys are back. Retired Boston Bruins Phil Esposito and Bobby Orr ham it up at the Babson College rink. Wellesley, Massachusetts, June 1981.

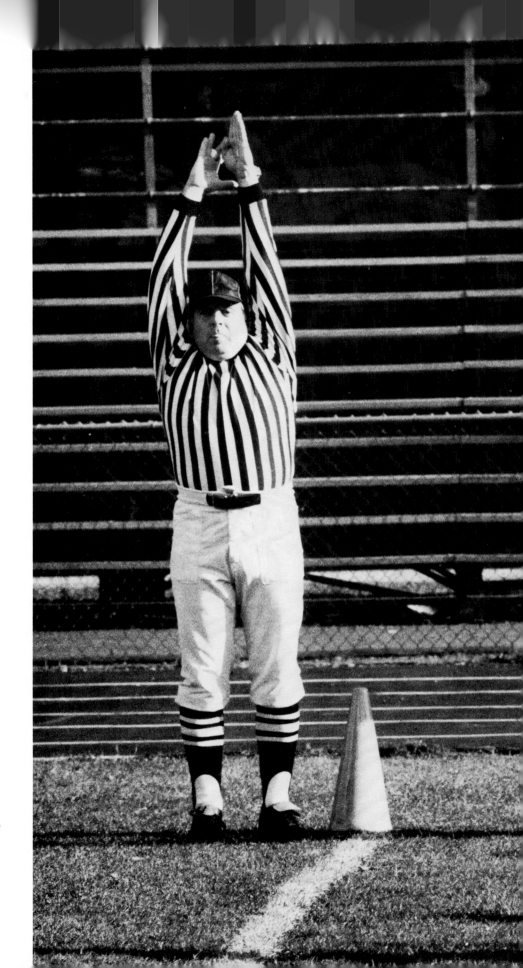

The official signals a touchdown as Medford, Massachusetts' Mike Todisco tumbles into the end zone after a 14-yard reception. Peabody, Massachusetts, October 1981. JOHN BLANDING

108

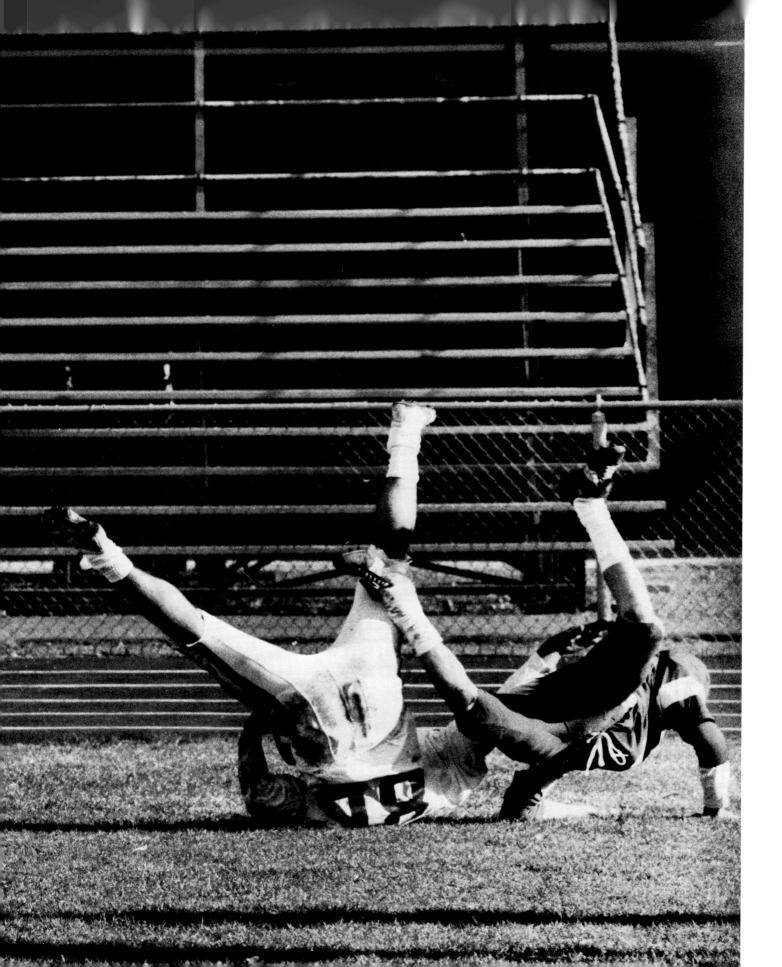

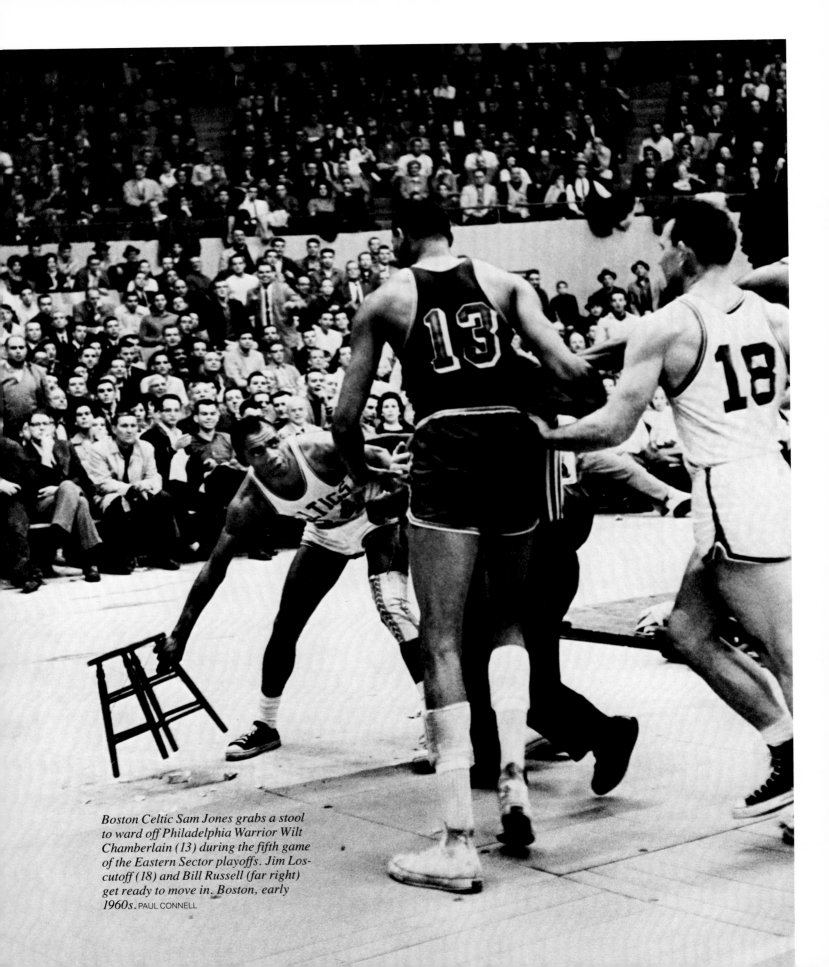

Boston Celtic Sam Jones grabs a stool to ward off Philadelphia Warrior Wilt Chamberlain (13) during the fifth game of the Eastern Sector playoffs. Jim Loscutoff (18) and Bill Russell (far right) get ready to move in. Boston, early 1960s. PAUL CONNELL

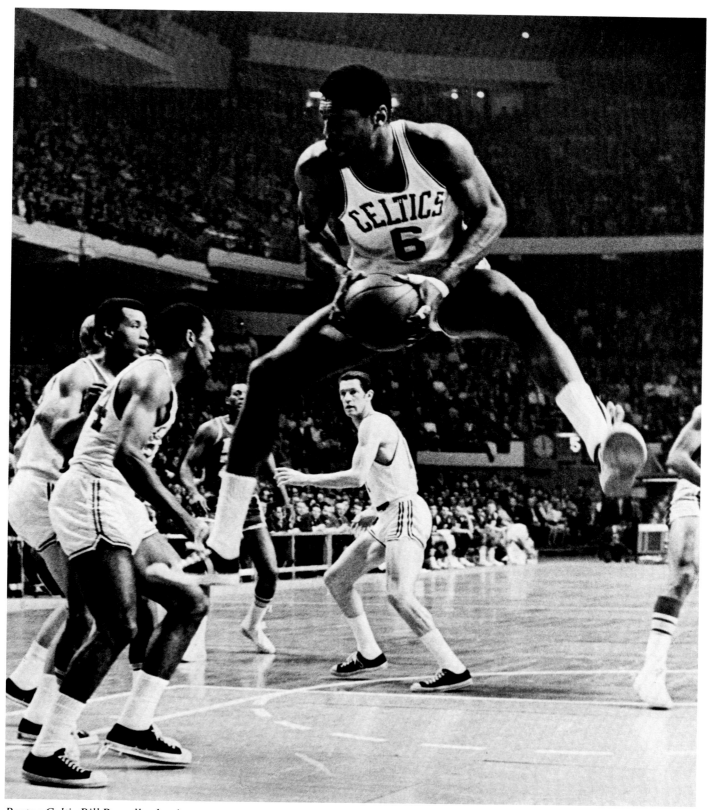

Boston Celtic Bill Russell rakes in a rebound during the fifth game of an Eastern Division playoff series against the Philadelphia 76ers. Boston, April 1965.

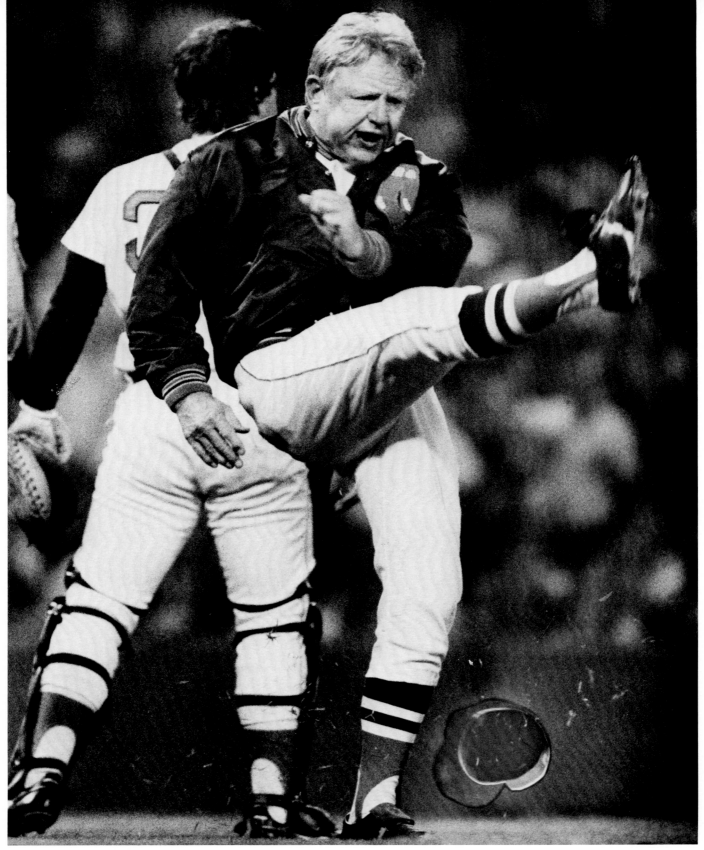

Boston Red Sox Manager Ralph Houk drop-kicks his cap in a dispute with umpires at a game against the Cleveland Indians. Boston, September 1982.

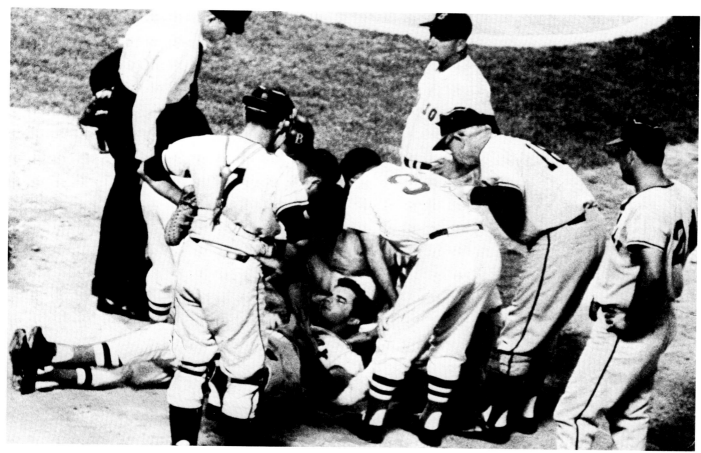

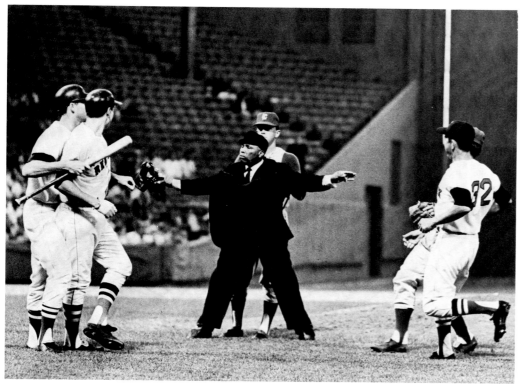

Boston Red Sox player Tony Conigliaro is surrounded by teammates after being hit on the head by a fourth-inning fast ball from Jack Hamilton of the California Angels. Boston, August 1967.
CHARLES B. CAREY

Umpire Emmett Ashford intervenes between irate Tony Conigliaro (left) and Kansas City pitcher Lew Krausse, who hit Conigliaro with a pitch. Don Demeter restrains Tony, while Pete Runnels and Dick Green enter from right. Boston, July 1966.
DAN GOSHTIGIAN

Terry O'Reilly (top left) drops to the ice in disbelief as the Boston Bruins are defeated 1-0 by the Philadelphia Flyers in the Stanley Cup playoffs. Philadelphia, May 1974. FRANK O'BRIEN

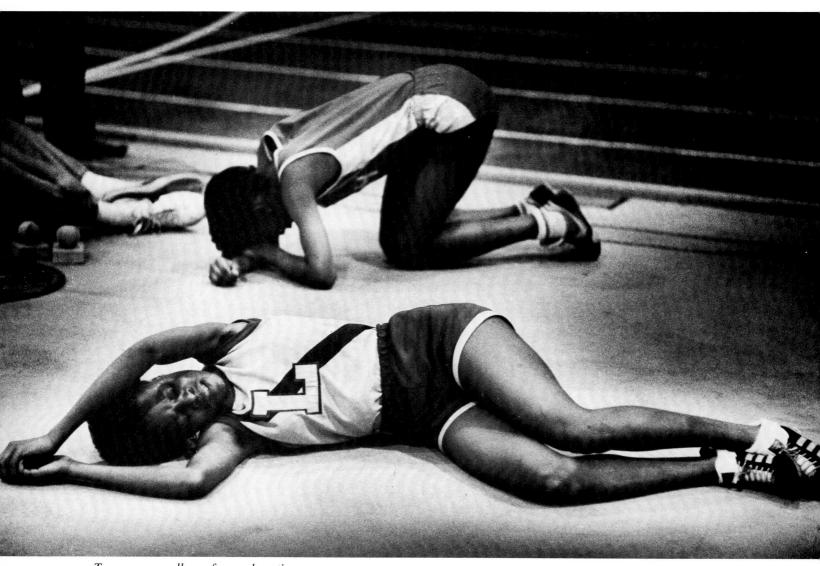

Two runners collapse from exhaustion after a race at a high school track meet at Harvard University. Cambridge, Massachusetts, October 1983.

116

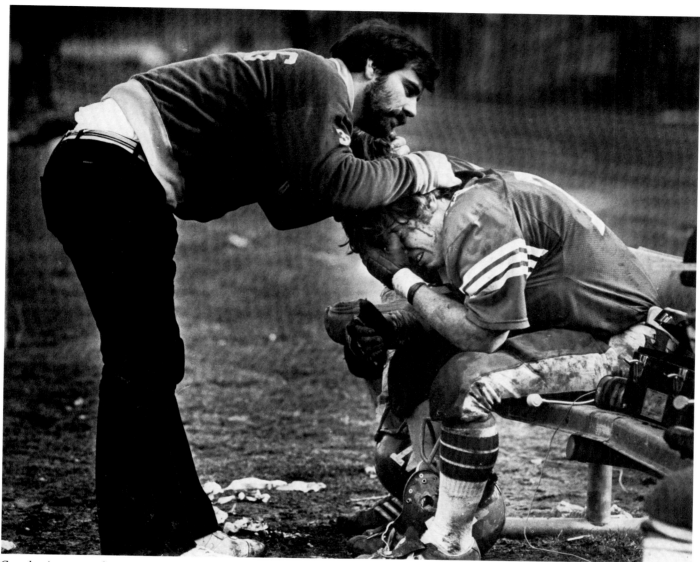

Coach tries to comfort a senior member of the Waltham High School football team as his side loses the Thanksgiving Day game. Waltham, Massachusetts, November 1980.

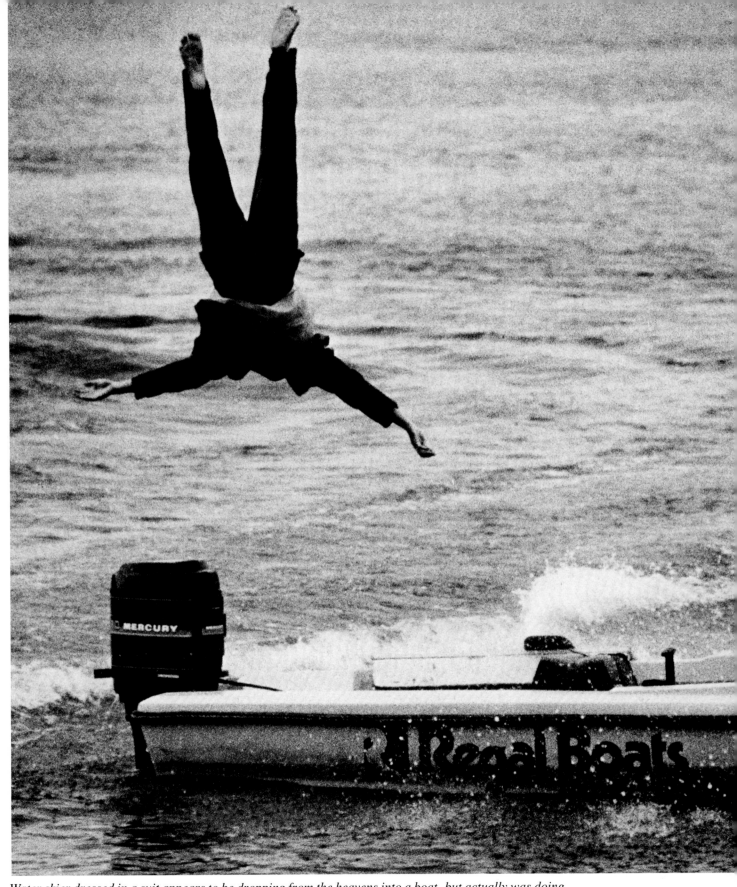

Water skier dressed in a suit appears to be dropping from the heavens into a boat, but actually was doing a somersault as part of a routine at Seaworld. Orlando, Florida, December 1980.

JOHN TLUMACKI

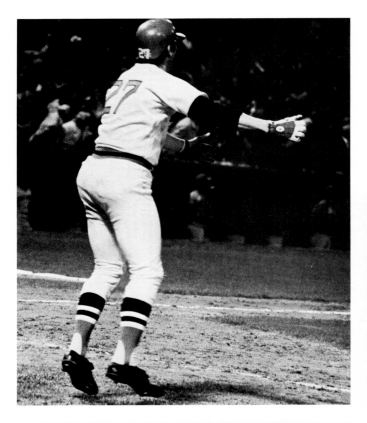

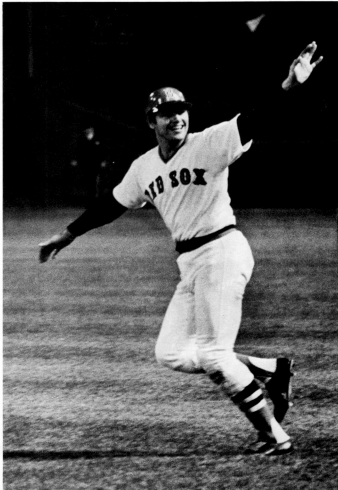

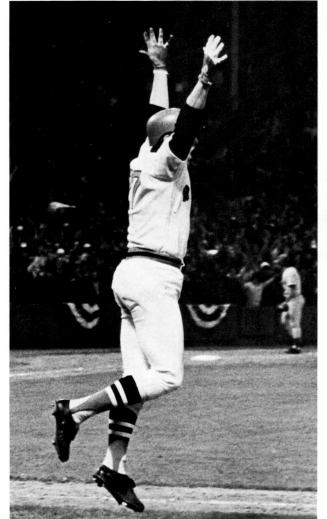

Red Sox catcher Carlton Fisk uses body language as his twelfth-inning home run heads for the netting just to the right of the left-field foul pole to give the Boston Red Sox a 7-6 win over the Cincinnati Reds in the sixth game of the World Series. Boston, October 1975.
FRANK O'BRIEN (3)

Opposite: Fisk receives a hero's welcome at home plate. Boston, October 1975.
TOM LANDERS

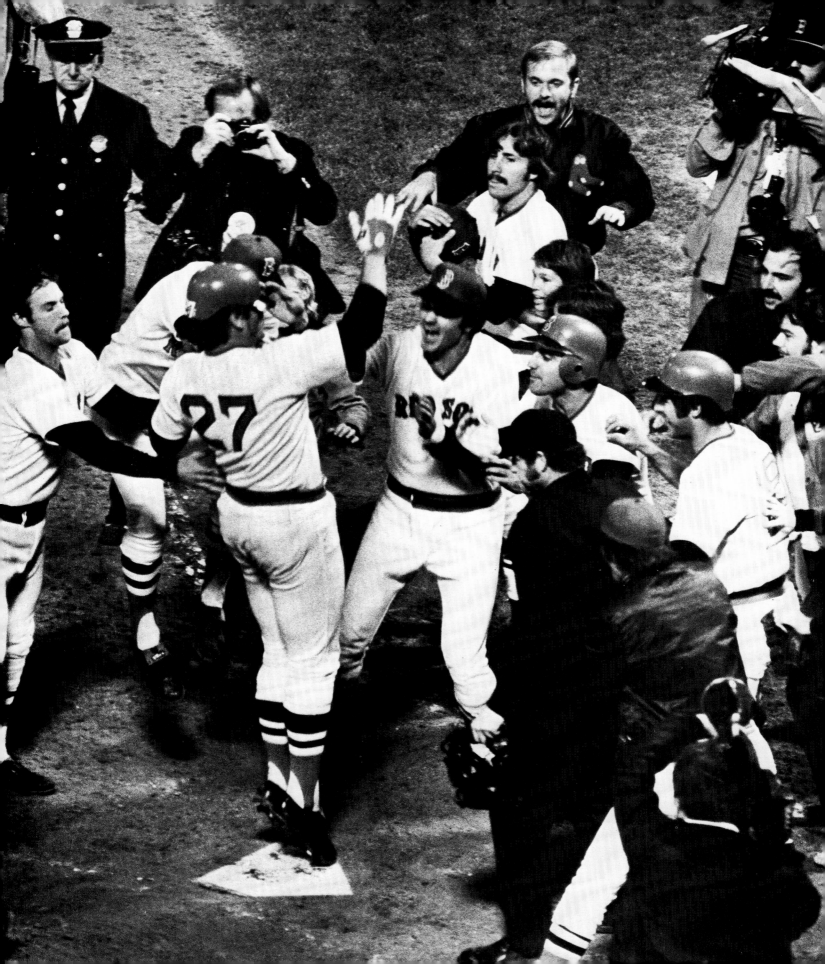

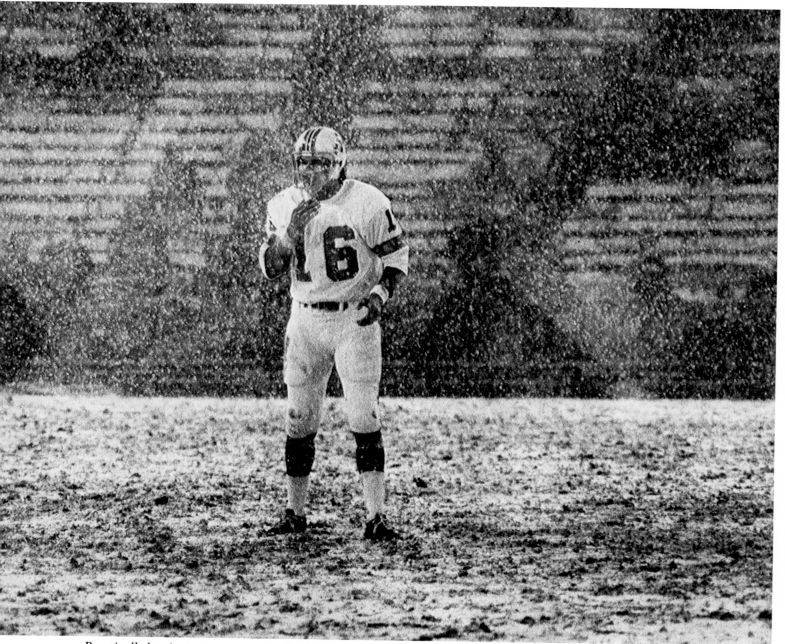

Practically lost in a snowstorm, New England Patriot quarterback Jim Plunkett looks to his bench for help during a game against the Baltimore Colts. Baltimore, Maryland, December 1973.

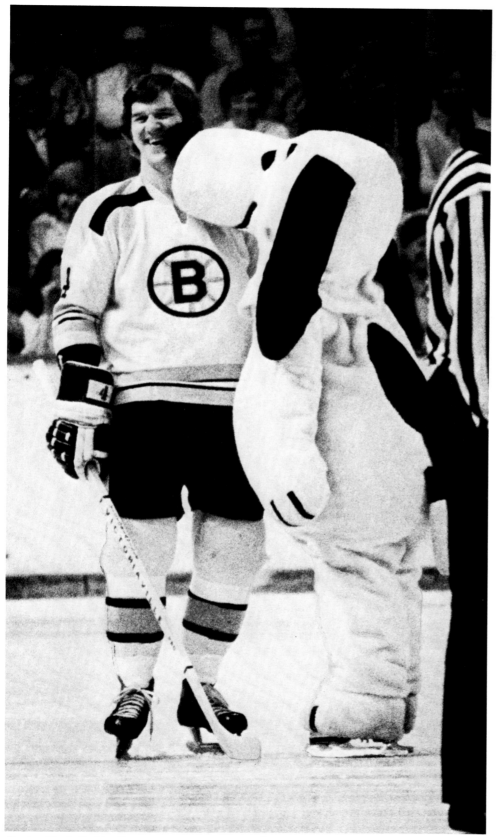

Boston Bruin Bobby Orr gets a pre-game smooch
from Snoopy during an Ice Follies promotion. Boston.

FRANK O'BRIEN

123

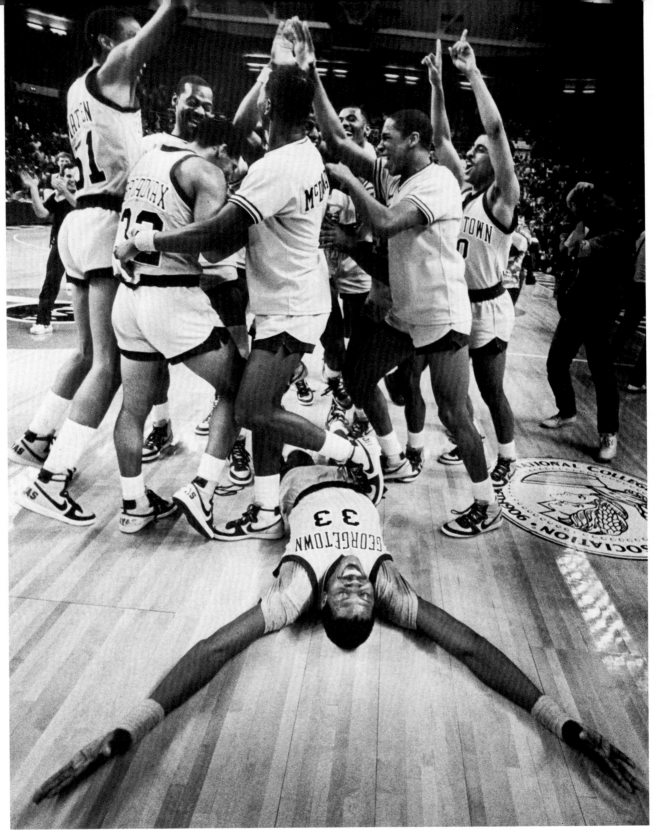

Georgetown's Patrick Ewing is overwhelmed by his teammates
after a win against Memphis State.

JOHN TLUMACKI

Opposite: Larry Bird celebrates with general manager Red Auerbach's victory cigar
after the Boston Celtics outlasted the Houston Rockets, 102-91,
to win their 14th NBA title. Houston, Texas, May 1981. FRANK O'BRIEN

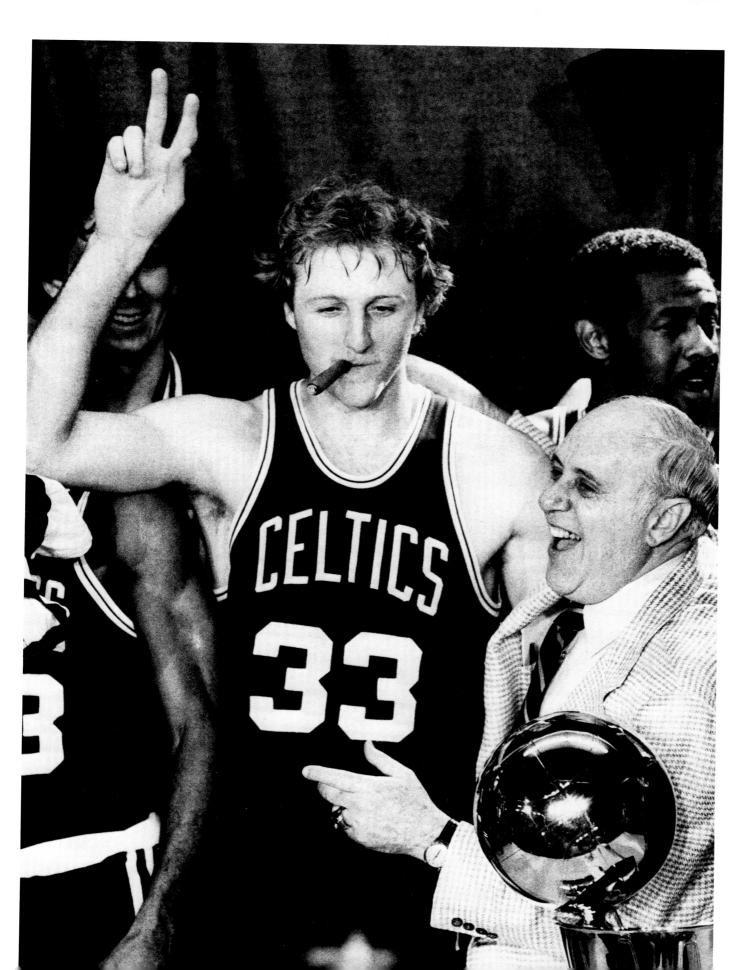

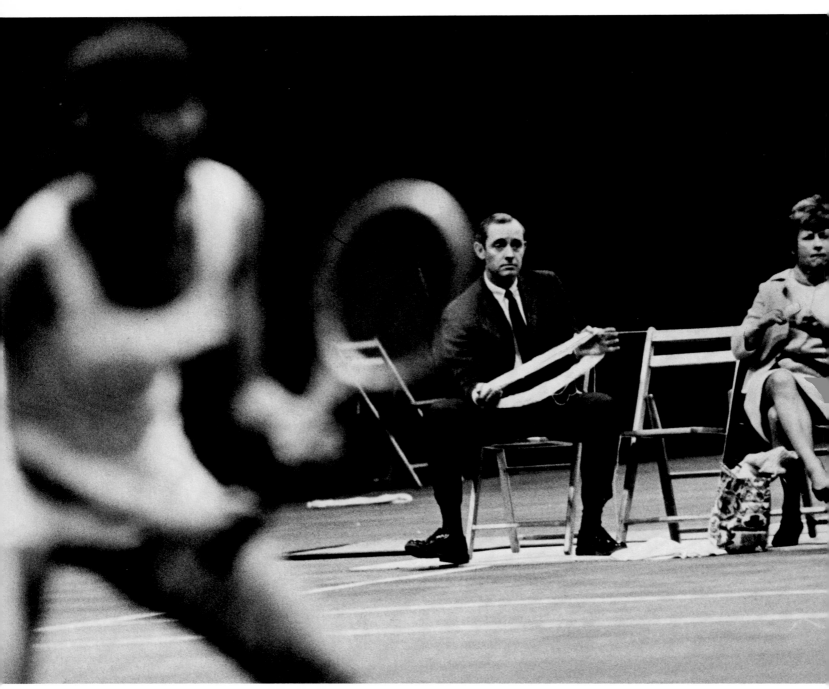

Tennis referee Arthur Hills helps his
wife ball yarn at the National Indoor
Women's Doubles Championship.
February 1967.

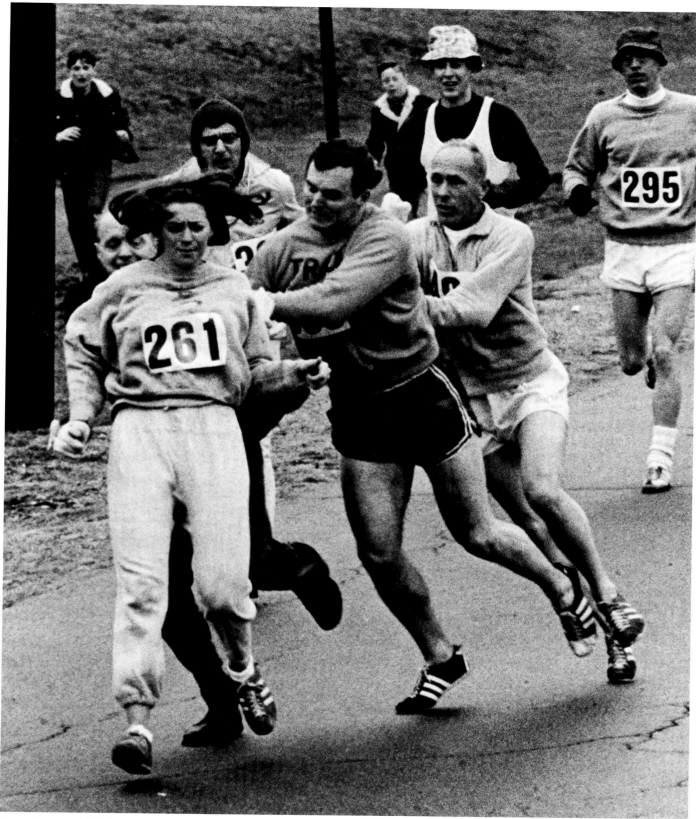

"I am hurt to think that an American girl would go where she is not wanted." — Will Cloney, Boston Marathon official, 1967. *Kathy Switzer of Syracuse is spotted early in the Boston Marathon by Jock Semple, who tries to rip the number off her shirt and remove her from the race. Switzer's friends intervene and she makes her getaway to become the first woman to "officially" run the Boston Marathon. Boston, April 1967.* PAUL CONNELL

Three-time Boston Marathon winner Bill Rodgers stands alone on the winner's platform. Rodgers finished the drizzle-drenched course in 2:9:27, 45 seconds ahead of Japan's Toshihiko Seko. Governor Edward J. King applauds in background. Boston, April 1979. BILL BRETT

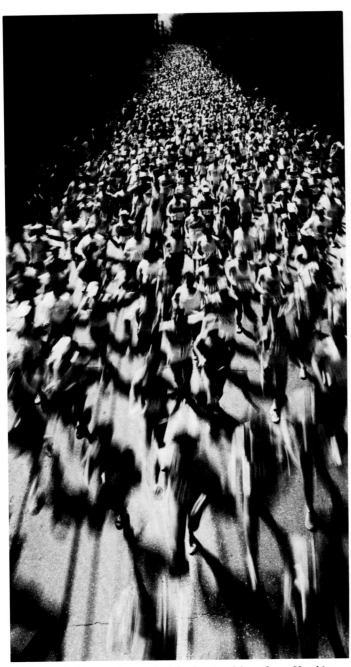

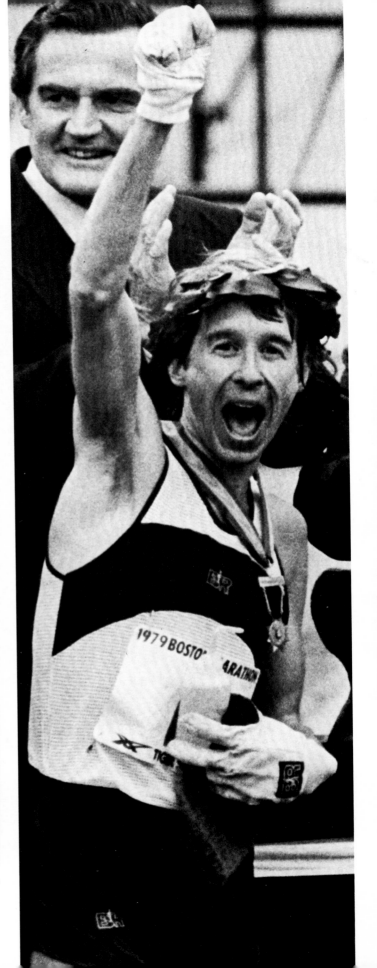

A blur of bodies at the start of the Boston Marathon. Hopkinton, Massachusetts, April 1978. STAN GROSSFELD

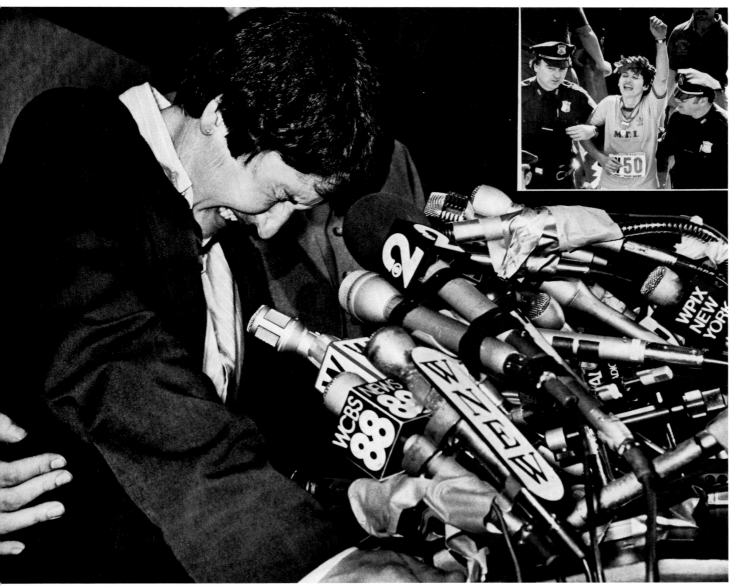

Controversial first-place finisher Rosie Ruiz breaks down at a New York press conference on April 24, 1980, in response to questions about whether she actually ran the entire Boston Marathon. Ruiz later was stripped of her women's marathon title after a unanimous vote of the BAA Board of Governors. Inset: Ruiz dons a laurel wreath and medal after her 2:31:56 finish, the third-fastest marathon ever run by a woman. Boston, April 1980. STAN GROSSFELD & BILL BRETT (INSET)

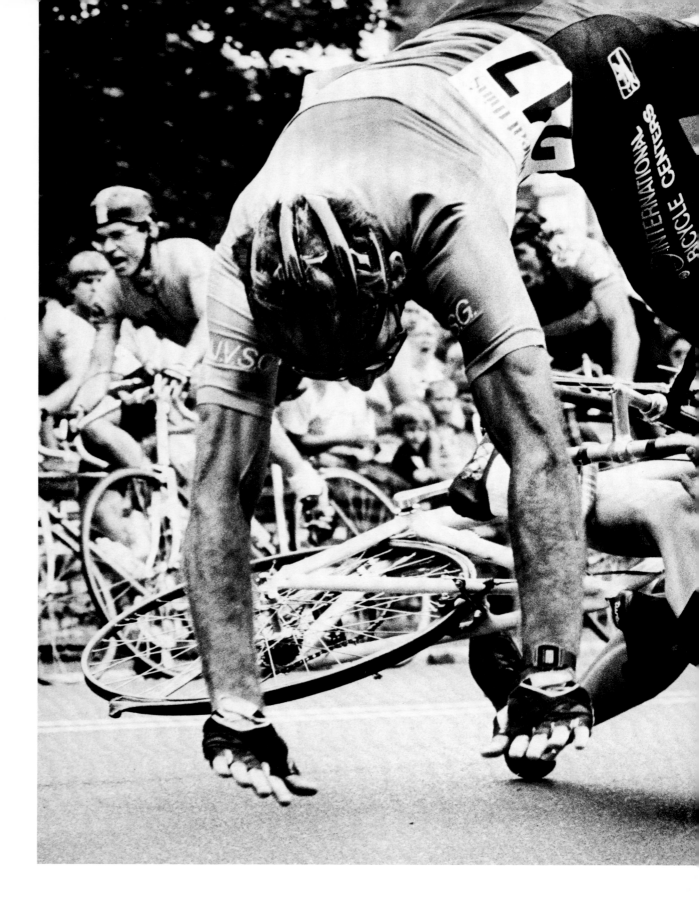

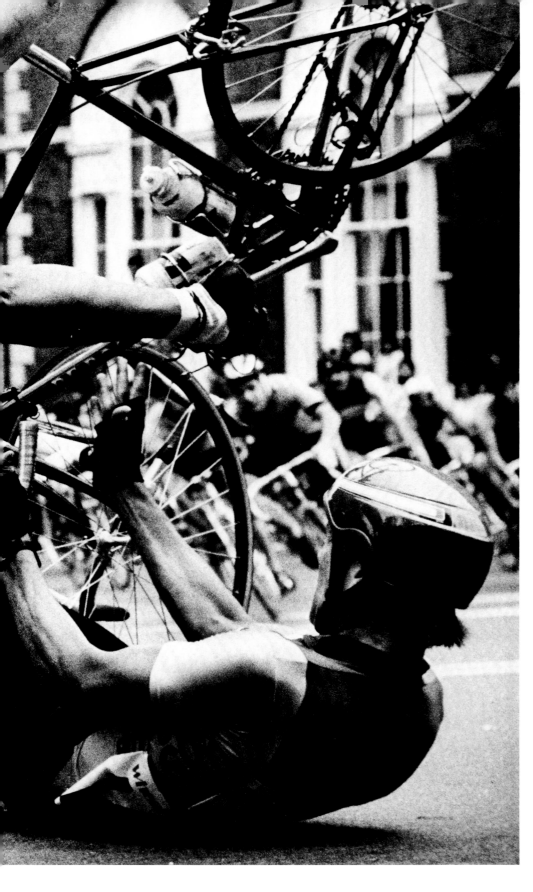

Brian Griffith and his bicycle tumble over a fallen Ed Bernasky in Mayor's Cup Races at Salem. July 1985.

131

Catchers clash as Carlton Fisk of the Red Sox tags Thurmon Munson of the New York Yankees (left) and sends him head over heels (right). Fisk and Munson square off as teammates from both benches head for the action. Boston, August 1973 (below). DAN GOSHTIGIAN (3)

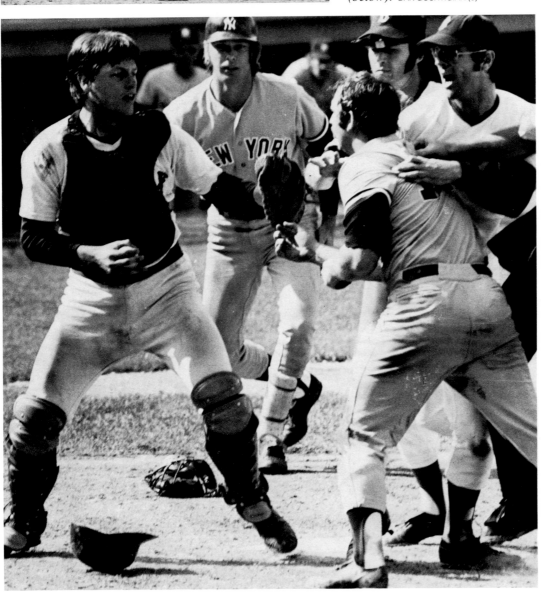

132

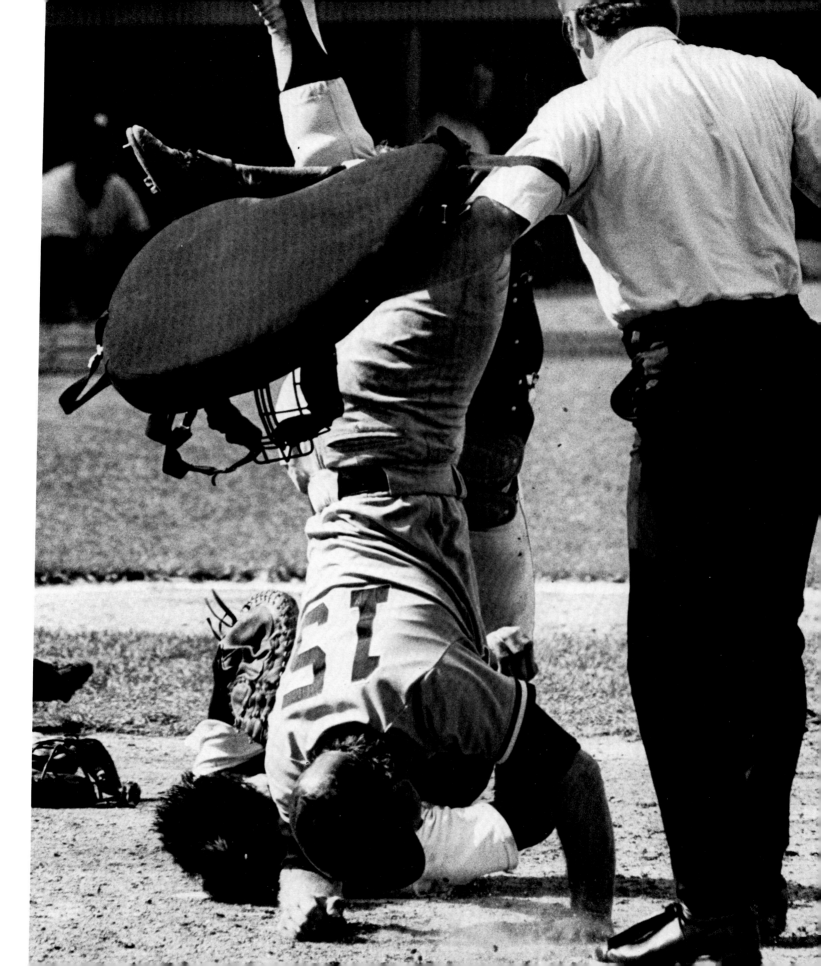

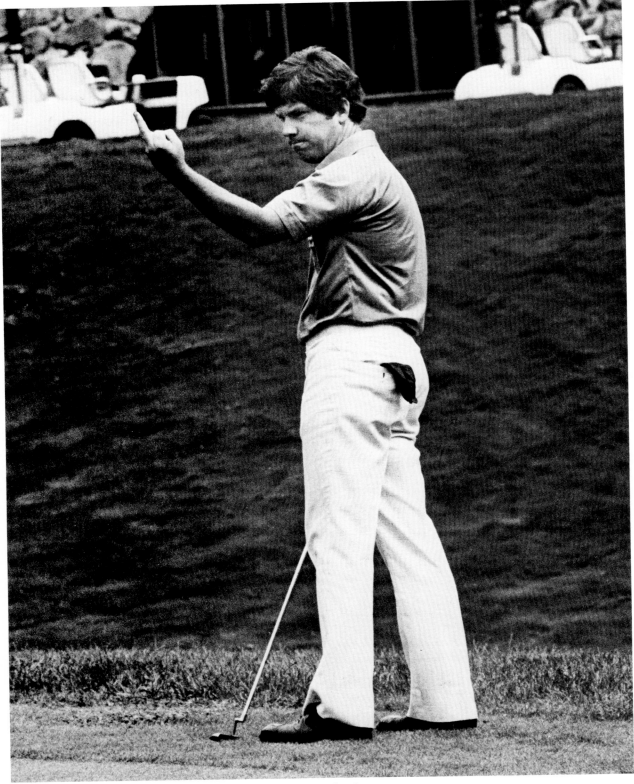

Golfer at Wollaston Golf Club is not pleased at missing a twelve-foot putt.
Quincy, Massachusetts, August 1979. PAUL CONNELL

Opposite: Golfer Jack Nicklaus knows before anyone else in the gallery that he is going to miss a birdie attempt on
the 18th hole at Pleasant Valley Country Club. The putt would have given him a chance at the Pleasant Valley
Classic title. Sutton, Massachusetts, July 1977. STAN GROSSFELD

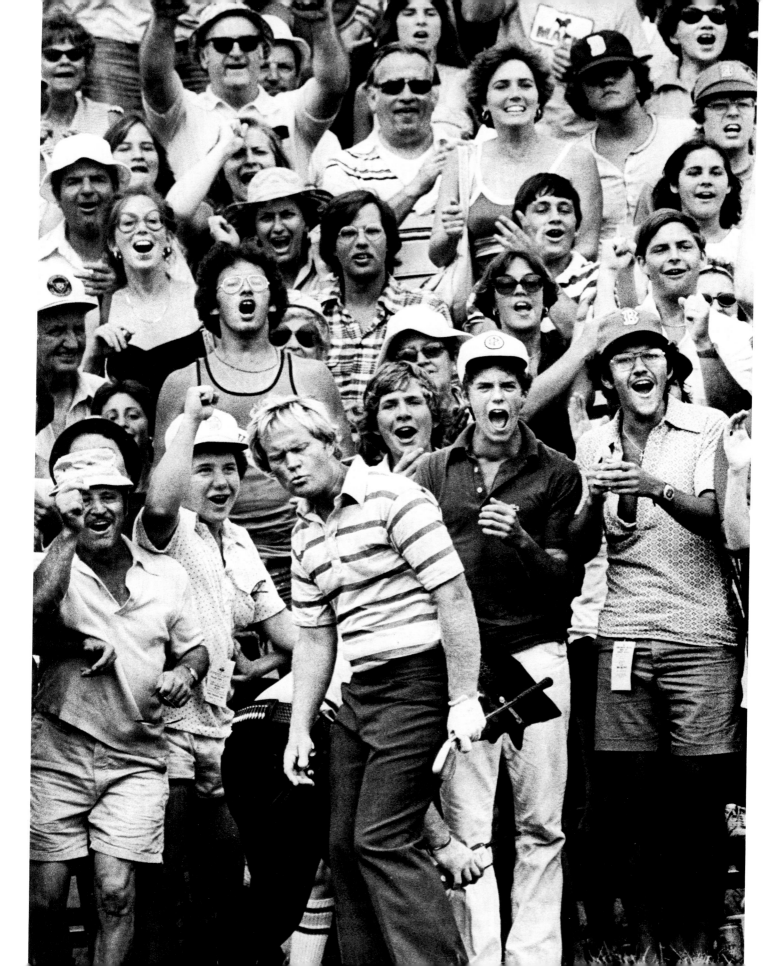

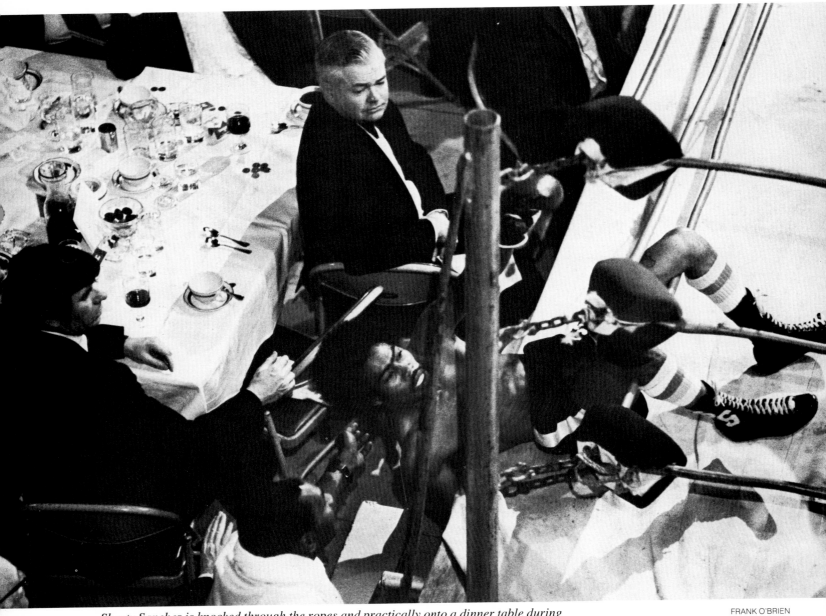

Shorty Sanchez is knocked through the ropes and practically onto a dinner table during the third round of a fight at the Harvard Club. Boston, March 1977.

Opposite: Two tiny contenders learn the ropes at the South Boston Boys Club. FRANK O'BRIEN

136

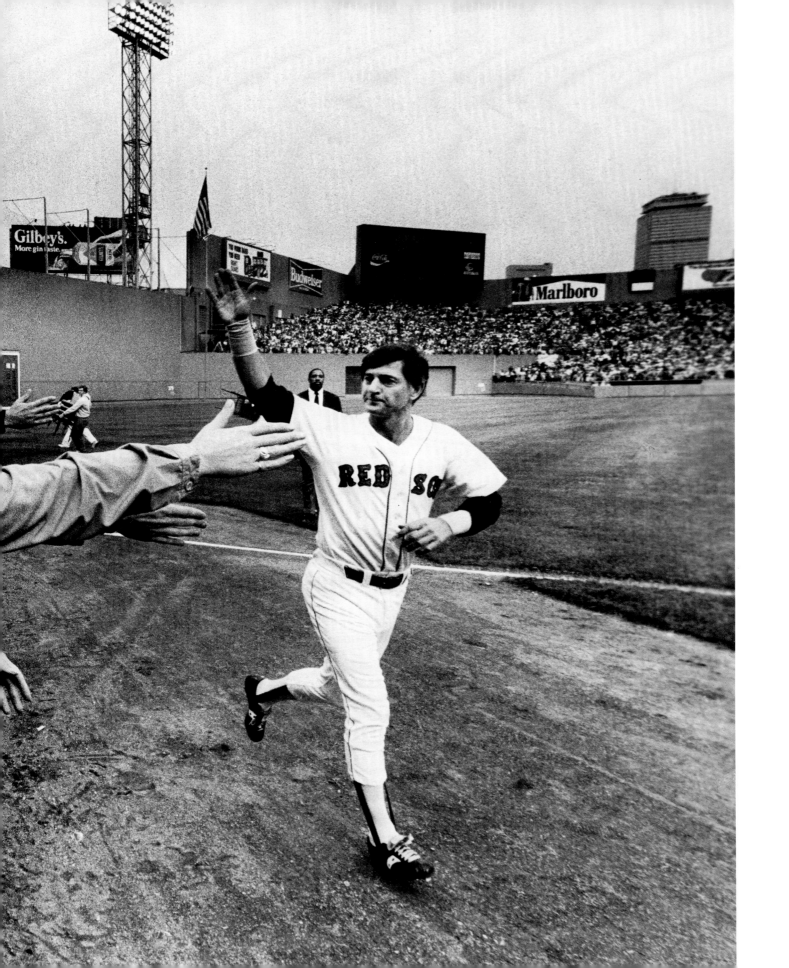

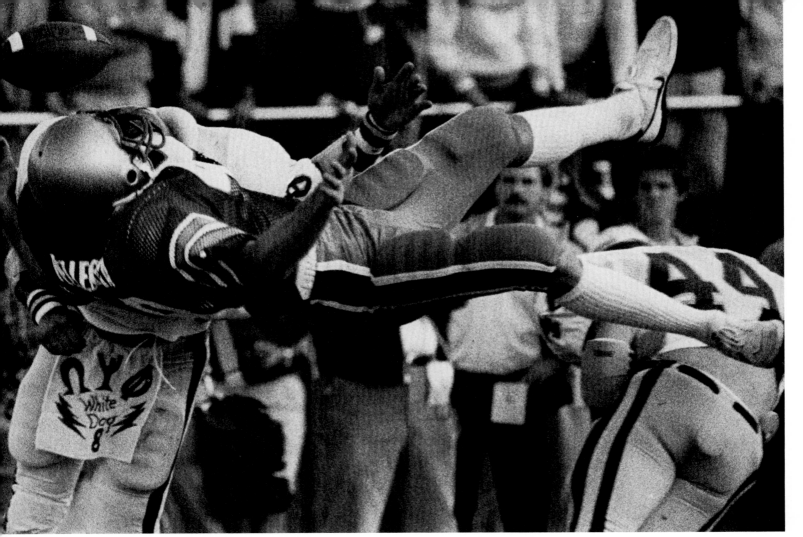

Boston College receiver Carl Pellegata
flies after a pass. Newton, Massachusetts, 1983.

JIM WILSON

*Preceding: An emotional Carl Yastrzemski touches the
hands of fans as he says goodbye during a Fenway Park
pre-game ceremony marking his retirement as an active Red
Sox player. A sellout crowd of more than 30,000 gave a six-
minute ovation to Yaz for his 23 years in baseball, his .285
lifetime batting average, and his 3419 career hits. Boston,
October 1983.* BILL BRETT

The Carrabassett Valley Rats from Kingsfield, Maine, and the Mudsharks of P.J.'s Pub of Beverly, Massachusetts, tumble into the muck during the annual World Mudfootball Championship game at Hog Coliseum in North Conway, New Hampshire. September 1983. JOHN TLUMACKI

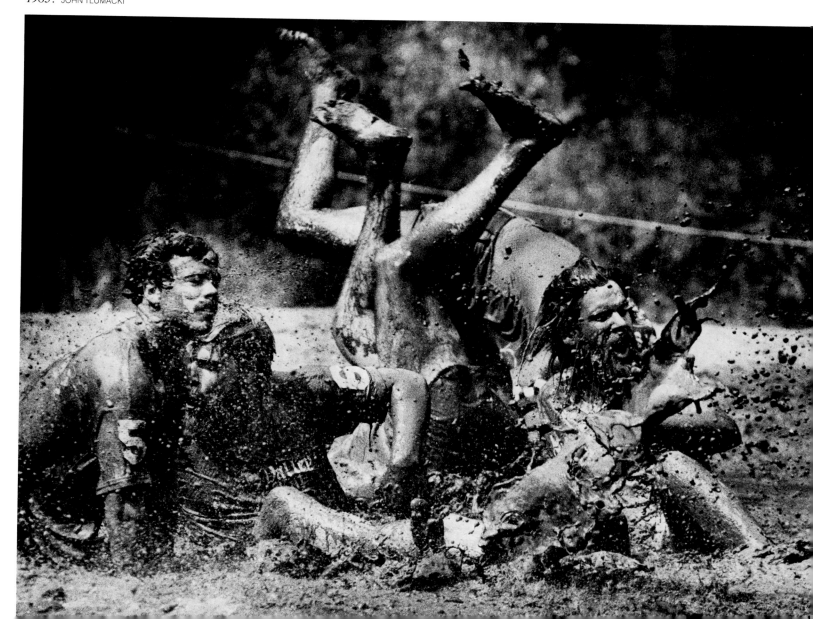

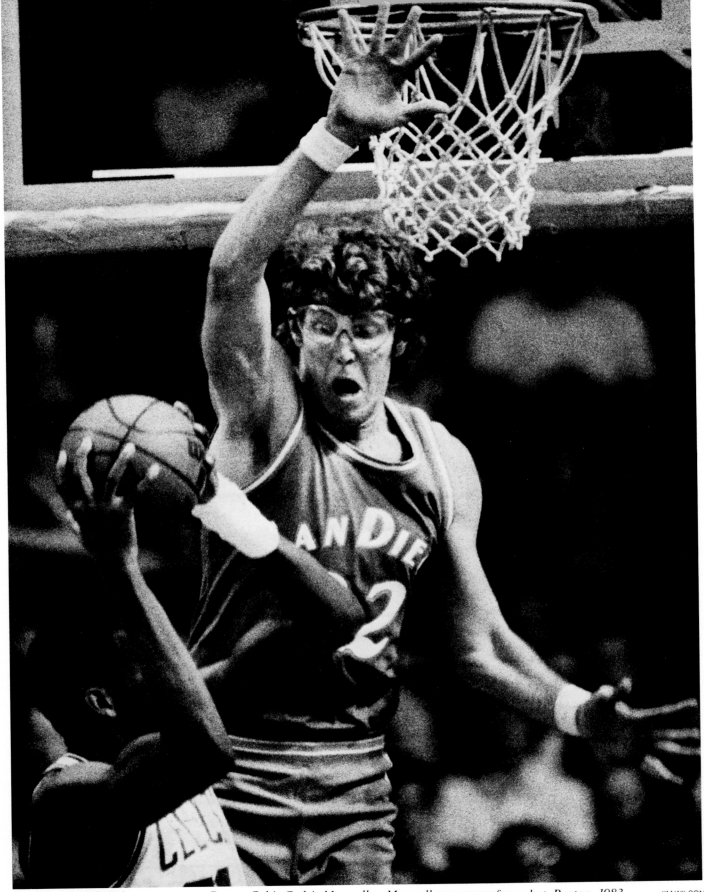

San Diego's Bill Walton towers over Boston Celtic Cedric Maxwell as Maxwell maneuvers for a shot. Boston, 1983. JIM WILSON

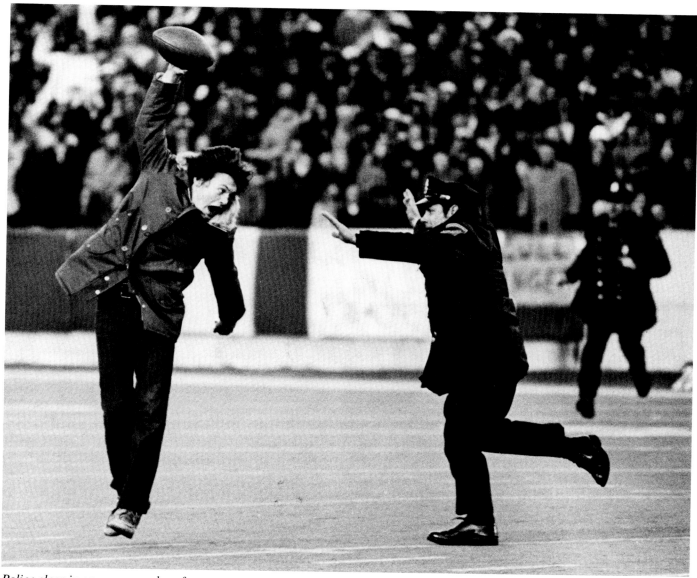

Police close in on an overzealous fan who tries to steal the ball at a New England Patriots game. Foxboro, Massachusetts, November 1973.

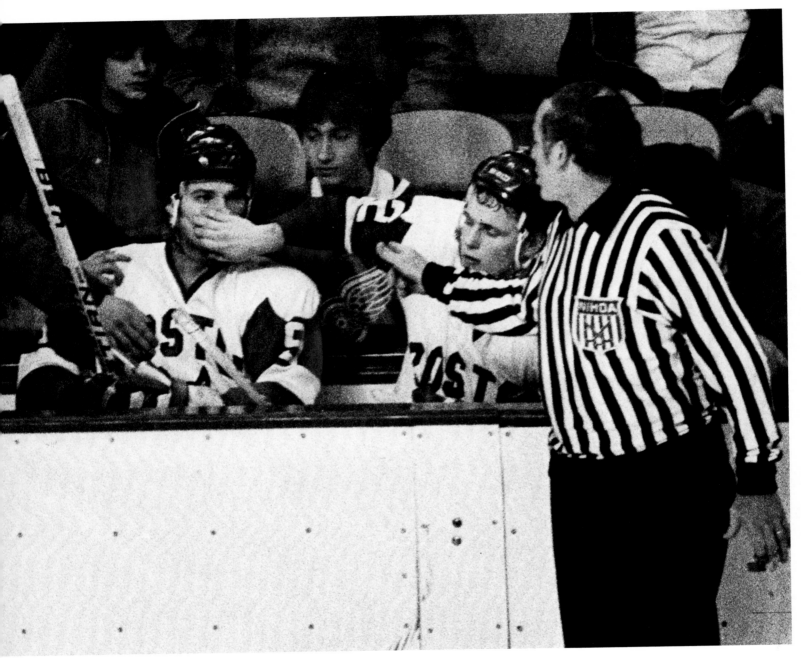

*Boston University's Mark Fidler uses
all his powers of persuasion to keep
teammate John Bethel from getting into
more trouble with the referee during the
first round of the Beanpot Tourney.
Boston, February 1978.*

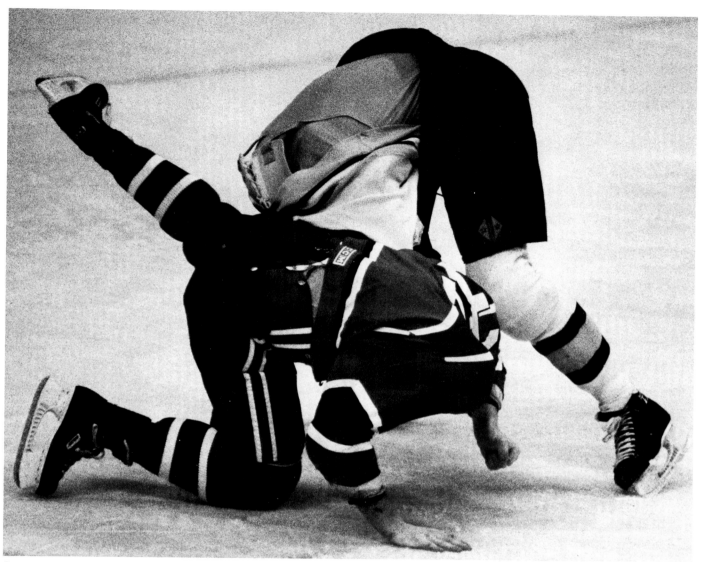

Boston Bruin Brian Curran and Montreal Canadien Normand Baron lose their heads during a playoff game at the Boston Garden. Boston, April 1984.

JOHN TLUMACKI

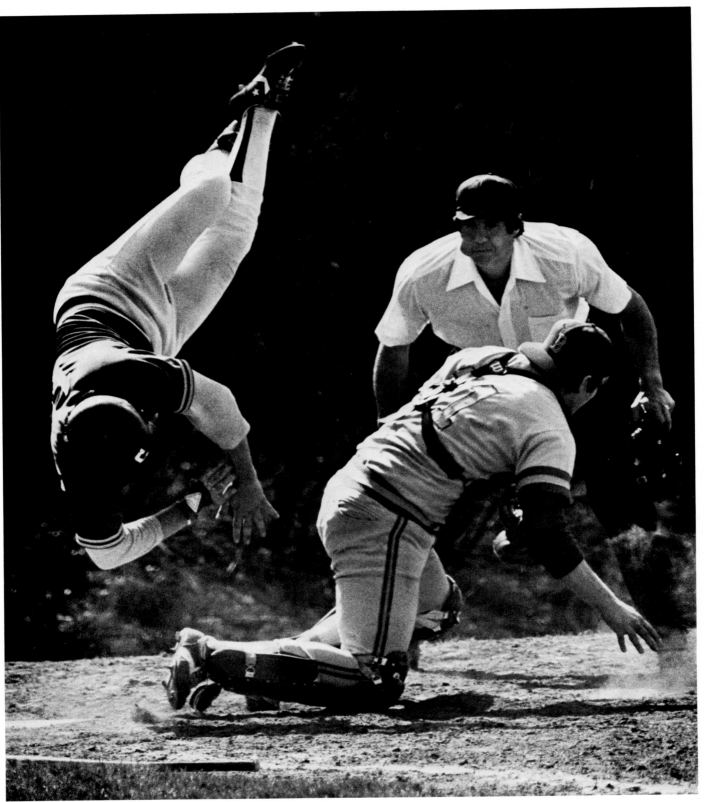

Mark DeJoise of Stonehill College is tagged out at home plate by Bentley's Jim Clifford during an Easter Sunday game. Massachusetts, 1981.

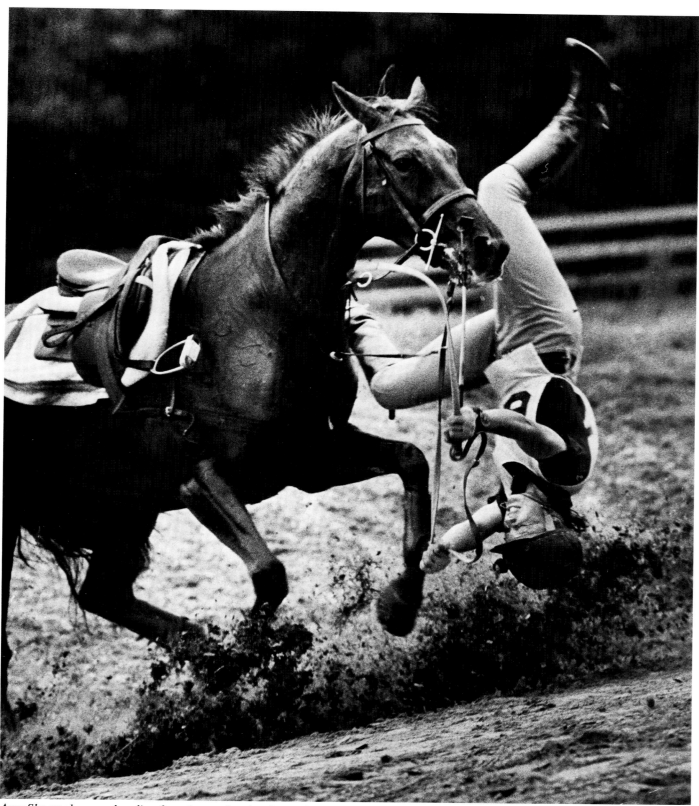

Amy Shoemaker was heading for a jump when her horse, Brer Fox, balked. Uninjured and undaunted, she was up and riding in seconds. The mishap occurred during the North American Junior team championship. South Hamilton, Massachusetts, August 1979.

News

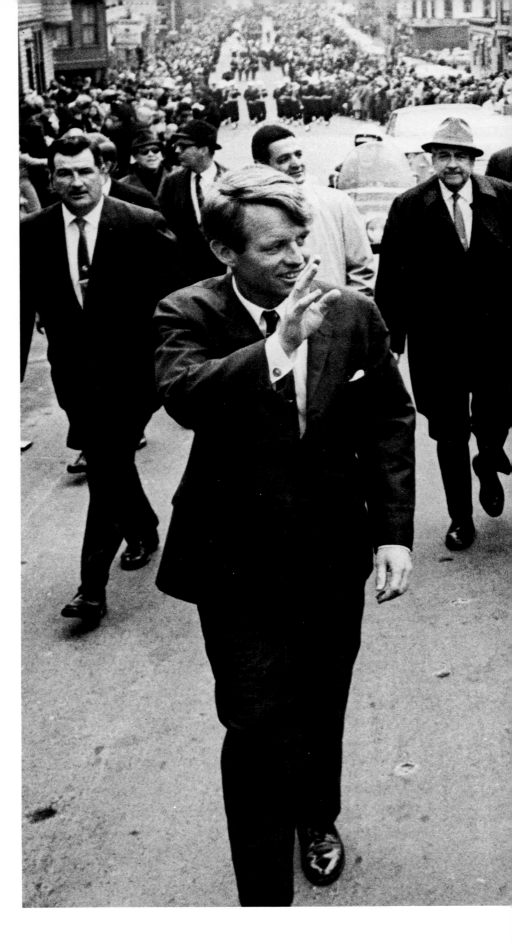

*Brothers Robert and Edward Kennedy
march along a Dorchester street during
the annual St. Patrick's Day parade in
South Boston. March 1968.*

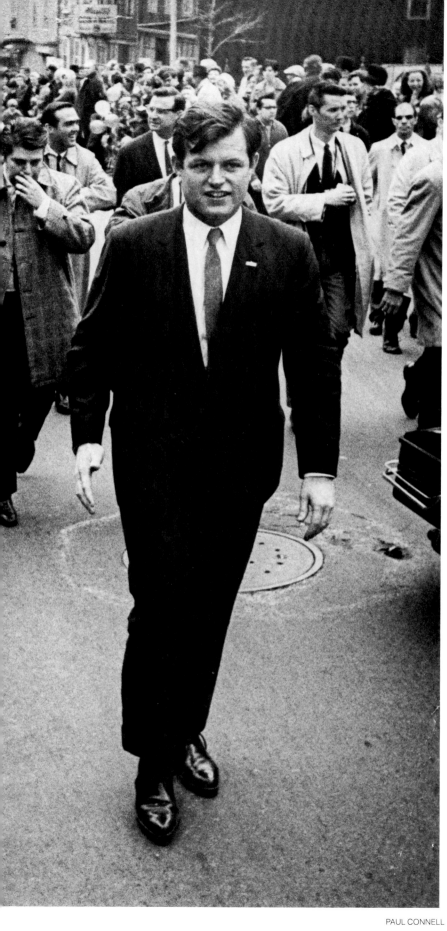

PAUL CONNELL

149

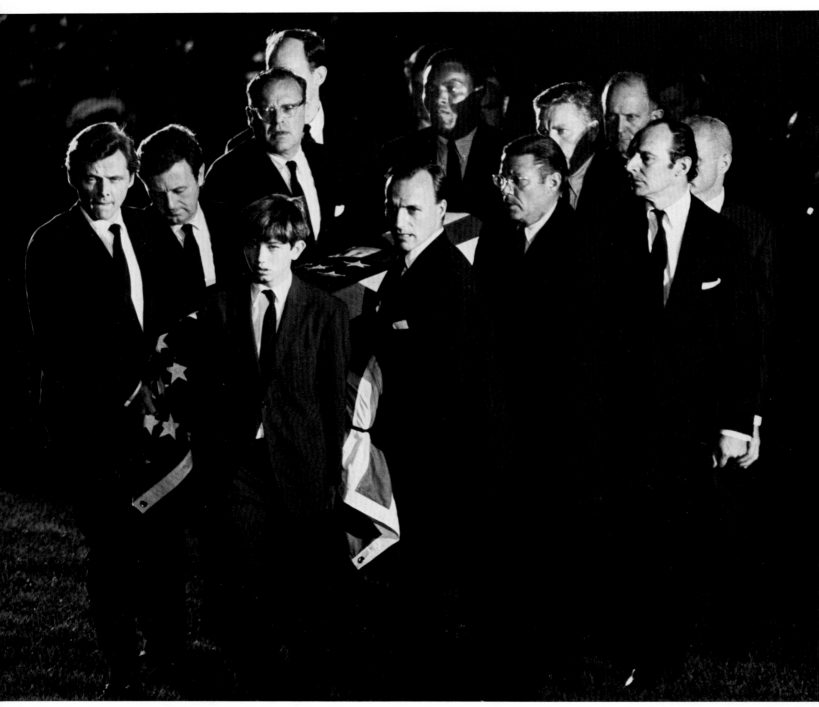

The casket of Robert F. Kennedy is carried to the gravesite at Arlington National Cemetery. The pallbearers are led by Robert Kennedy, Jr. Washington, D.C., June 1968.

150

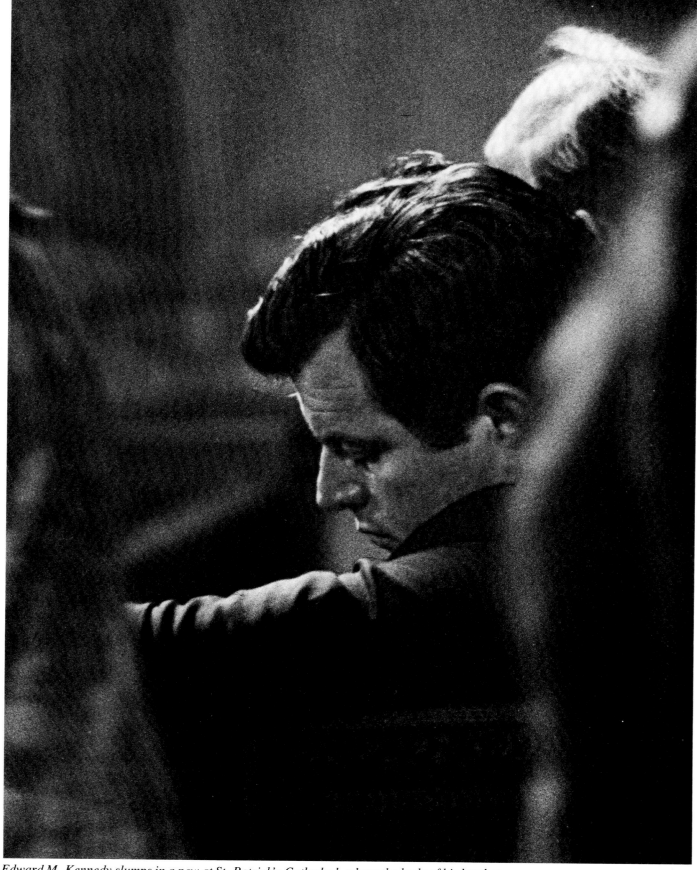

Edward M. Kennedy slumps in a pew at St. Patrick's Cathedral, where the body of his brother Senator Robert F. Kennedy lies in state. New York City, June 1968.

JOE DENNEHY

151

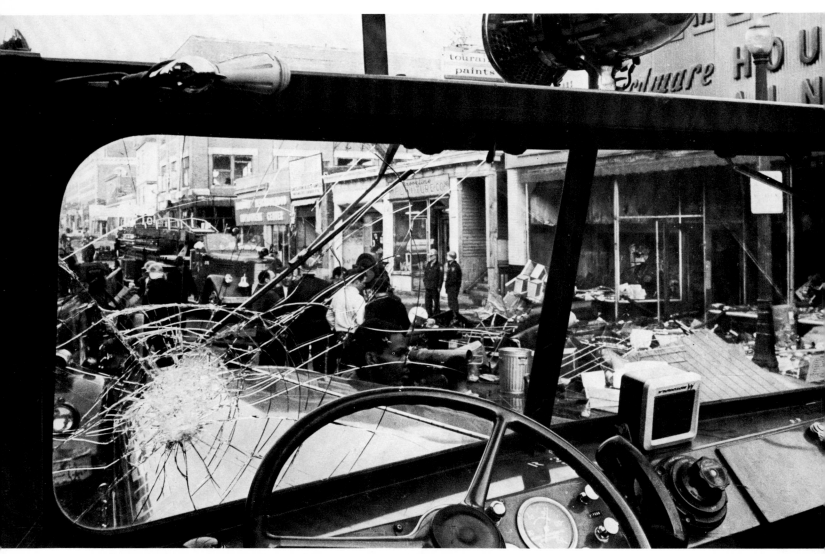

Aftermath of riot in Grove Hall area of Roxbury, Massachusetts. June 1967.

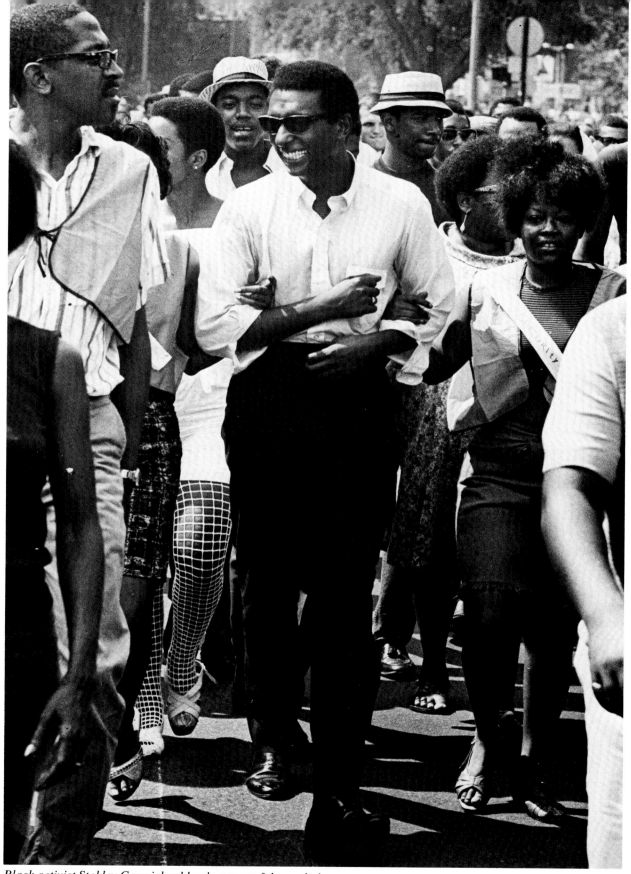

Black activist Stokley Carmichael leads a peaceful march down
Massachusetts Avenue. Boston, June 1967.

OLLIE NOONAN, JR.

153

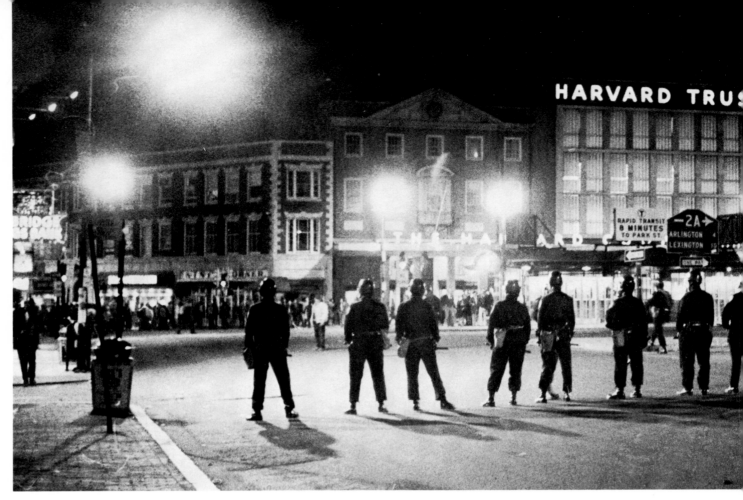

Students demonstrating for the abolition of the Reserve Officers Training Corps (ROTC) and other concessions are evicted from Harvard's University Hall by force following a predawn raid by riot-equipped police. Cambridge, Massachusetts, April 1969.

DAN SHEEHAN

154

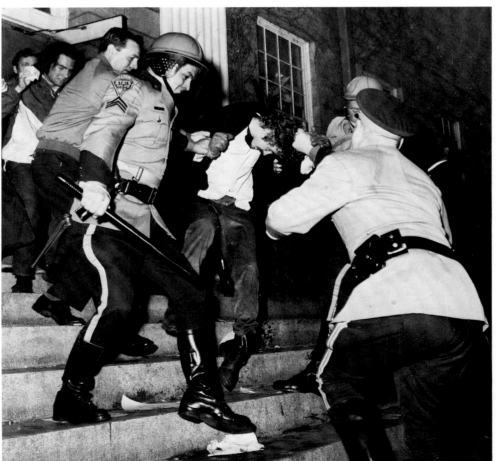

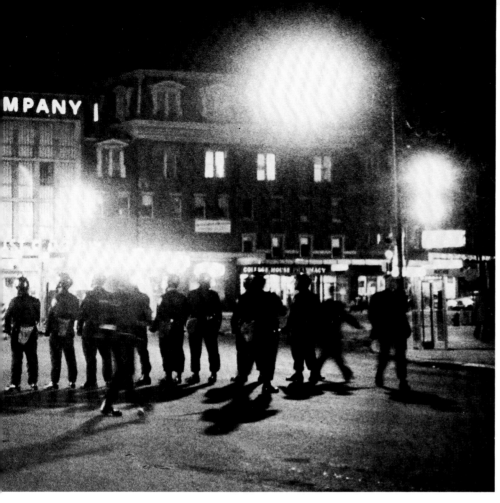

Police in riot gear block Massachusetts Avenue during an antiwar demonstration in Harvard Square. Cambridge, Massachusetts, April 1972. BILL BRETT

Riot-garbed policemen clash with Vietnam protesters in the Charles Street area. Boston, 1968. DAN SHEEHAN

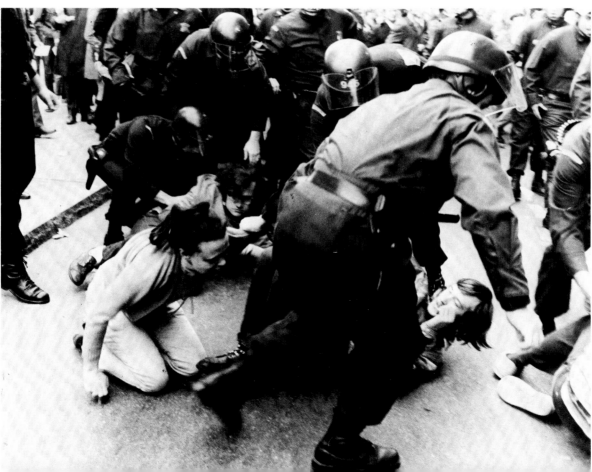

Dry Cleaners, Swampscott, Massachusetts, 1974. SAM MASOTTA

*Streaker hurdles a bike rack at Mont-
clair State College, New Jersey, 1974.*
STAN GROSSFELD

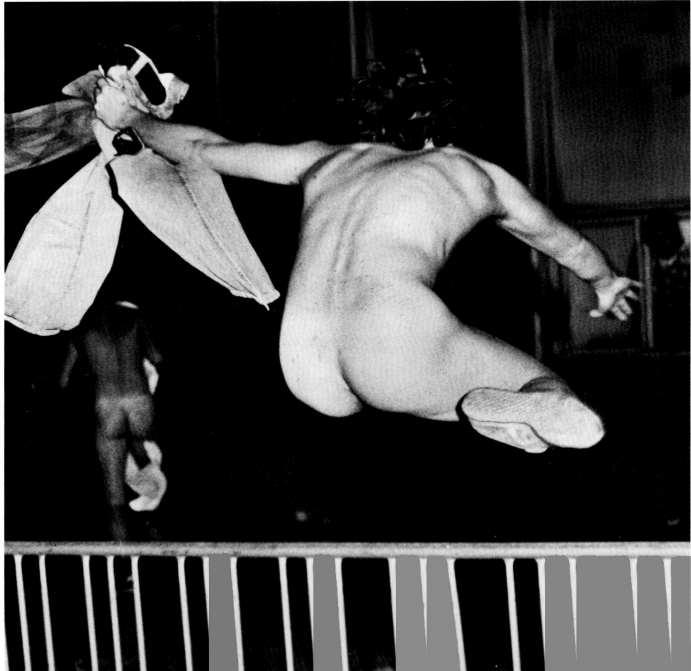

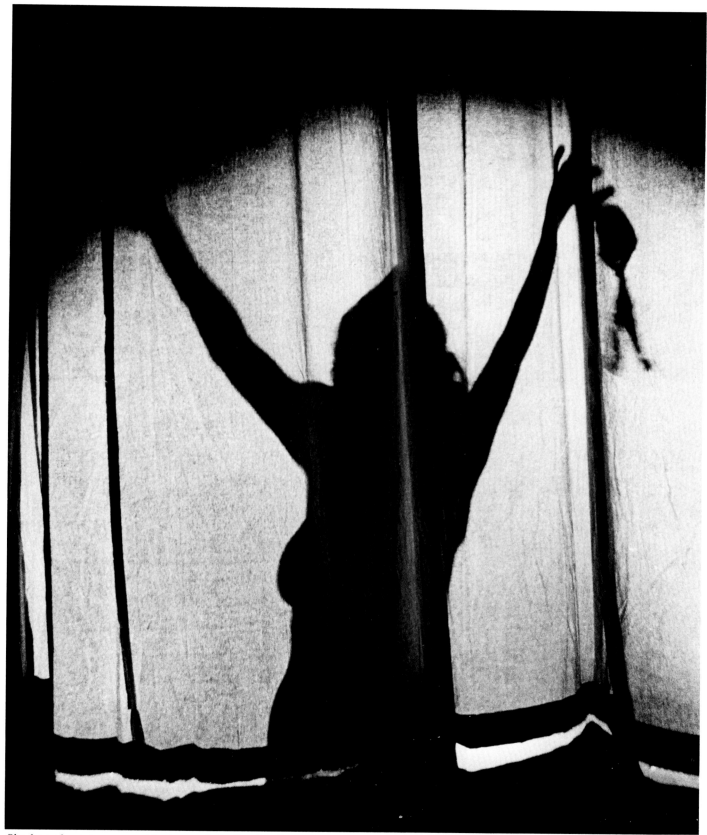

Shadow of a stripper on a black curtain in Combat Zone. Boston.

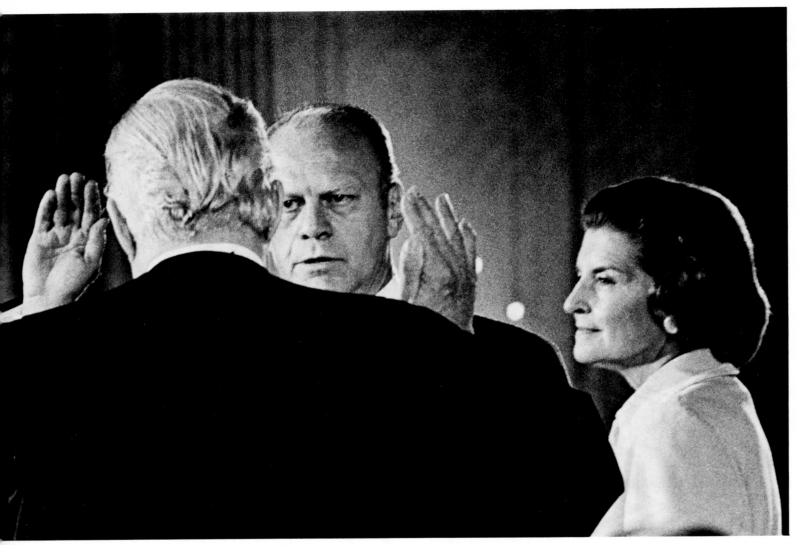

Gerald Ford takes the oath as the 38th President of the United States with his wife, Betty, standing at his side. Chief Justice Warren Burger administers the oath. Washington, D.C., August 1974.

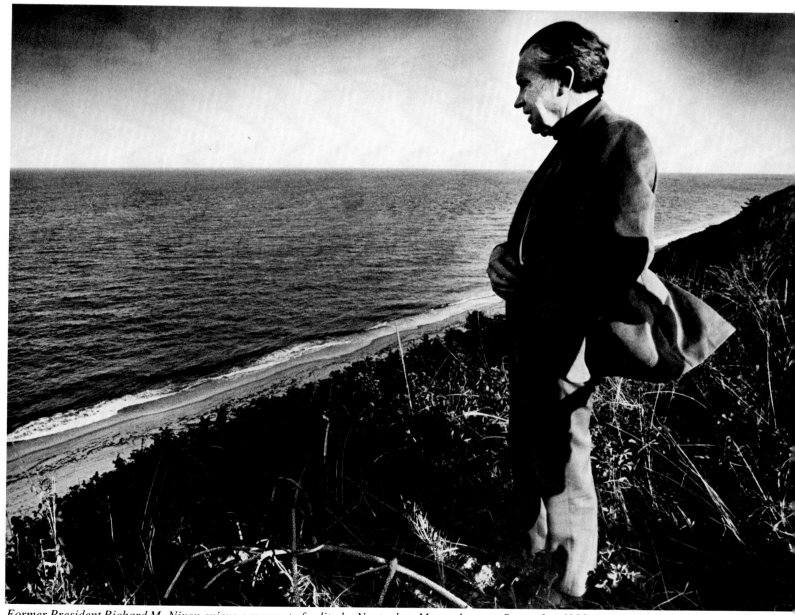

Former President Richard M. Nixon enjoys a moment of solitude. Nantucket, Massachusetts, September 1980. STAN GROSSFELD

159

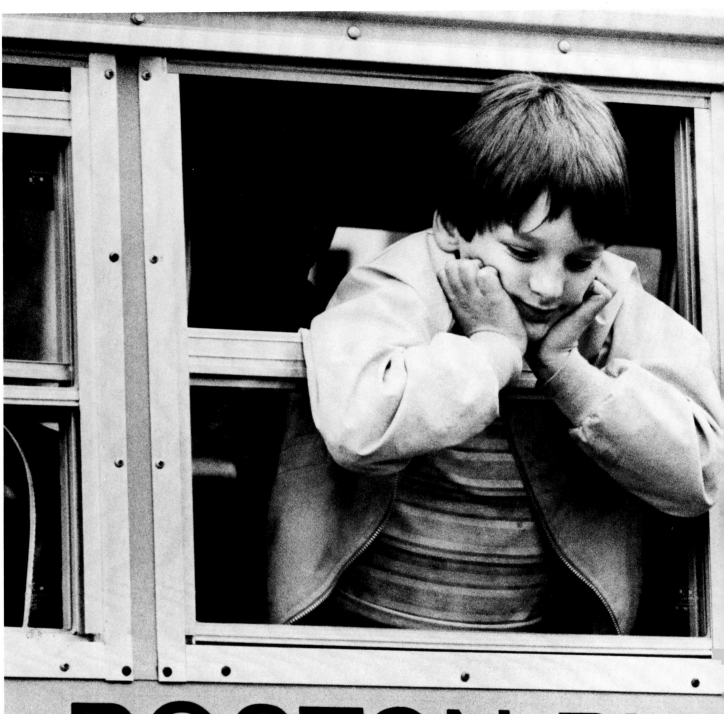

Kevin Dahl and Michael Tyler, third graders at the Murphy School in Dorchester, Massachusetts, wait for a ride home.

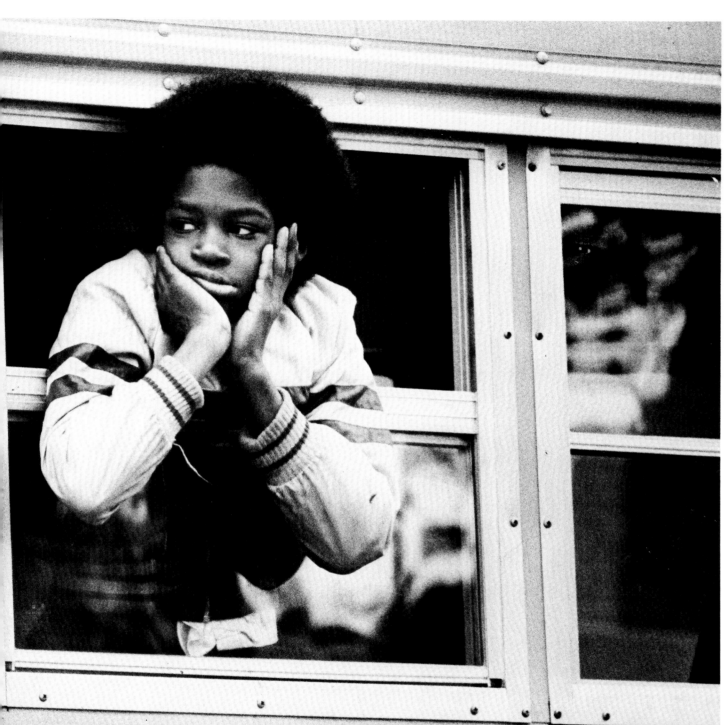

IC SCHOOLS

TED DULLY

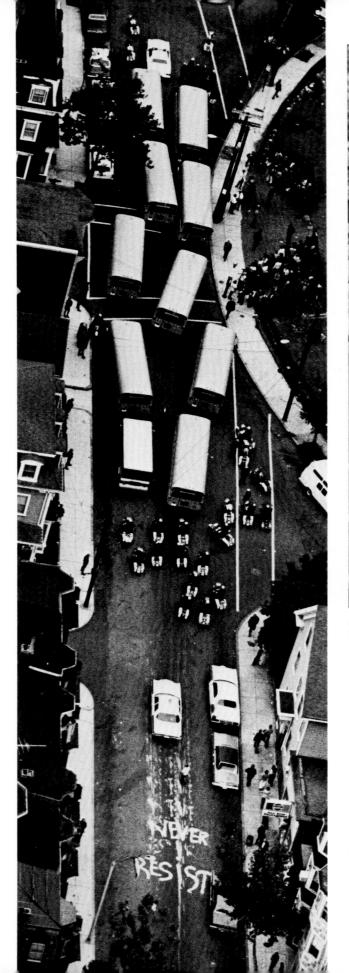

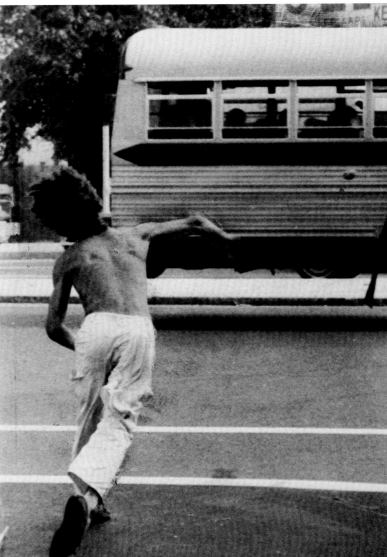

A youth hurls a rock at buses carrying black students. BOB DEAN
South Boston, September 1974.

Aerial view of buses as they arrive at South Boston High School.
September 1975. TOM LANDERS

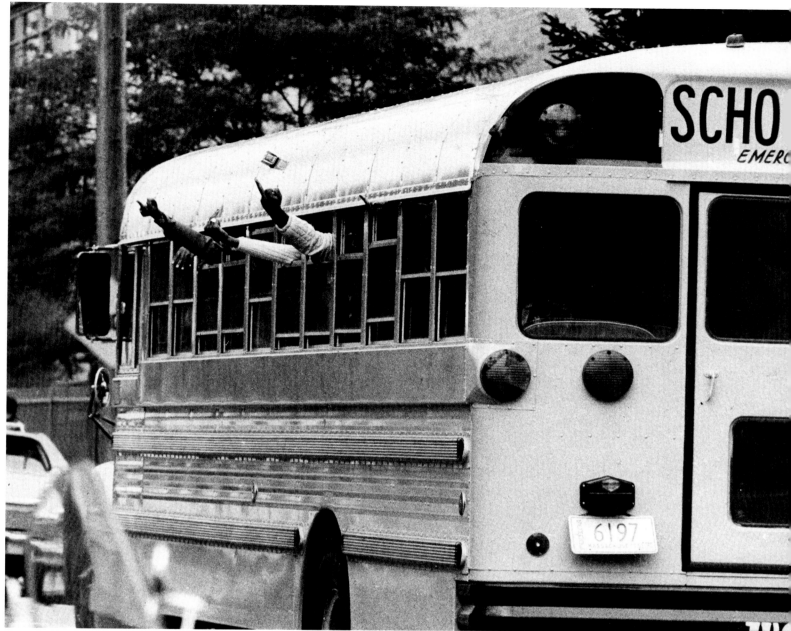

Busing students return home following a fight at Hyde Park High School. Boston, October 1975.

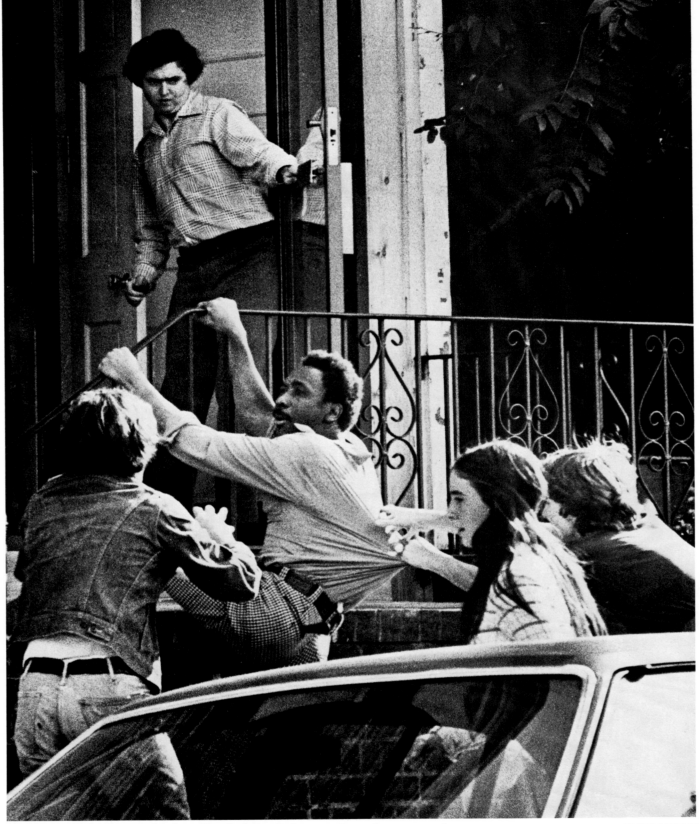

Jean-Louis Andre Yvon grabs the railing in front of a house as he seeks to escape the mob that pulled him from his car when he drove into the aftermath of an antibusing demonstration. South Boston, October 1974.

JOHN BLANDING (3)

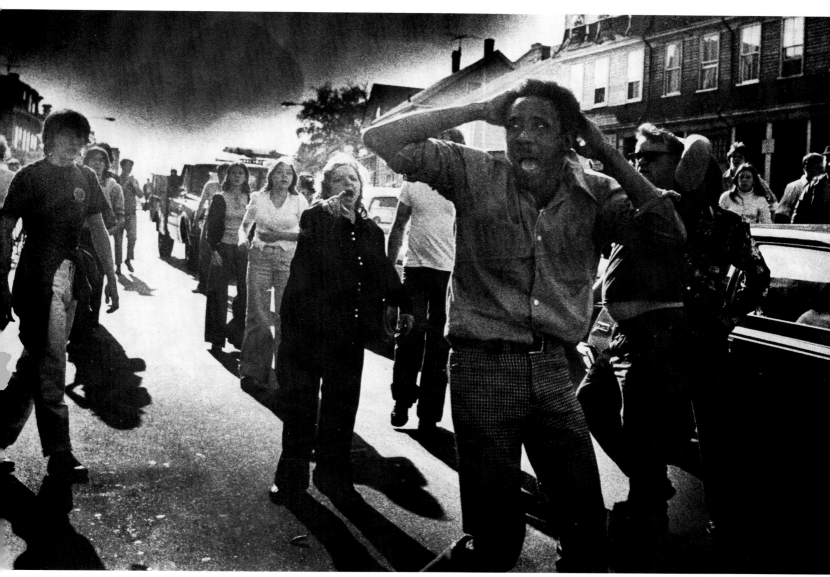

Woman points a taunting finger at Jean-Louis Andre Yvon as he tries to flee the mob.

Yvon stares back at his attackers after being beaten on the head, chest, legs, and arms.

It was 2:00 a.m. Captain Midnight, otherwise known as Dan Sheehan, had just settled into the cushions of his favorite booth at the Victoria Diner. He plugged his scanner into an outlet under the table and ordered his hamburger, medium-rare.

With forty years in the business, twenty-two in the midnight cruiser assigned to spot news, Dan Sheehan knows the implications of trying to enjoy a little sustenance. "As soon as you order food, boom, something happens."

"This call came in as your basic accident," Sheehan said. An ambulance was dispatched to an accident, people trapped in a vehicle on Adams Street in Dorchester. Boston Rescue 1, the Fire Department's crack team for extricating wounded from wrecks, was also routinely dispatched.

Car accidents are a dime a dozen and don't make the paper unless they are unusual, Sheehan told the rookie reporter assigned to him that night, Northeastern University intern Peter Mancusi. "All right kid, don't worry. Start eating, if it's big enough it'll still be there when we get there."

Over the years Sheehan has won the respect and admiration of more than forty interns and newly hired reporters assigned to the cruiser to learn the city. When it came to street-smarts, Sheehan was and is the master. He taught young photographers how to fire a quick shot from the hip in a tense situation. He taught reporters shortcuts around the city, how to get information from a fire chief, and where to find a good corned beef sandwich at 3:00 a.m. More important for someone new to the lobster shift, he taught when to respond to a call, and when to relax.

This night, the scanner went quiet.

Sheehan started on his burger, Mancusi on his eggs. But this accident was not routine.

Mancusi: "The firefighters approached the vehicle from the rear of the car and saw this guy slumped toward the steering wheel with a six-foot piece of fencepost speared through the windshield, through him, and through the seat. His girlfriend was screaming.

"They assumed the guy was dead, until he opens his eyes, lifts his head, and says, 'Would you mind shutting off the

GEORGE RIZER

ignition? The vibrations are hurting my chest.' " Mancusi learned all this later from the firemen.

Back at the diner, the police channel crackled. "I heard the cop say something about 'a pole embedded,' " Sheehan recalled. "Right away I said, 'Stop eating, let's go.' " Sheehan grabbed his burger and rushed out of the diner. Seconds later, in the cruiser, he heard the policeman's voice again: "I'm following the ambulance into City Hospital, my partner's on board helping with the patient."

From years of listening to radios,

Sheehan picked up the clue. "See, basically, no cop gets out of his cruiser; this was something different."

Sheehan swung his car around toward City Hospital, put his foot to the floor, and arrived seconds ahead of the ambulance.

"The ambulance came rolling in, backed up, and the doors opened. I made one shot and no, I didn't have anything, there were too many people around him. And then it opened up and I could see the guy, I could see the post. Boom, boom, I got two frames away and it was over. I knew I had it."

Sheehan, who has seen it all in forty years, stopped for coffee and finished his hamburger. The crew of Rescue One scrubbed up and carried a circular saw into surgery. Even emergency rooms do not stock the kind of saw you need to cut fenceposts.

Sheehan's picture ran on page one of the evening edition of the *Globe*. Some editors got a little queasy and moved the photo to a more discreet page inside the next edition. "They should never have done that, because it was a miracle of science," Sheehan maintains to this day.

Editors' judgment sometimes conflicts with photographers' enterprise, but usually prevails. Some editors feel that some pictures are just too shocking to be used at all, or to be displayed on page one.

As it turned out, the accident victim, Tom Brennan, miraculously recovered. He was in intensive care for six weeks; the day he was removed from intensive care, Sheehan was there, wearing a surgeon's robe. He'd been tipped off by a friendly nurse.

Looking very professional and nodding in scholarly fashion, Sheehan learned that Brennan was to be married

166

the next day in his hospital room to his girlfriend, Arlene Sickoll, who had suffered a broken arm in the accident. Sheehan pulled a camera out of his robes and made a photograph of the couple. It ran on their wedding day.

The sad part of the story is that you would figure that a guy who survived a fencepost through his body would survive anything. But seven years later, Brennan was watching the waves pound the shore in Hull, Massachusetts. He climbed the sea wall for a better view, when a thirty-foot wave swept him out to sea. He drowned.

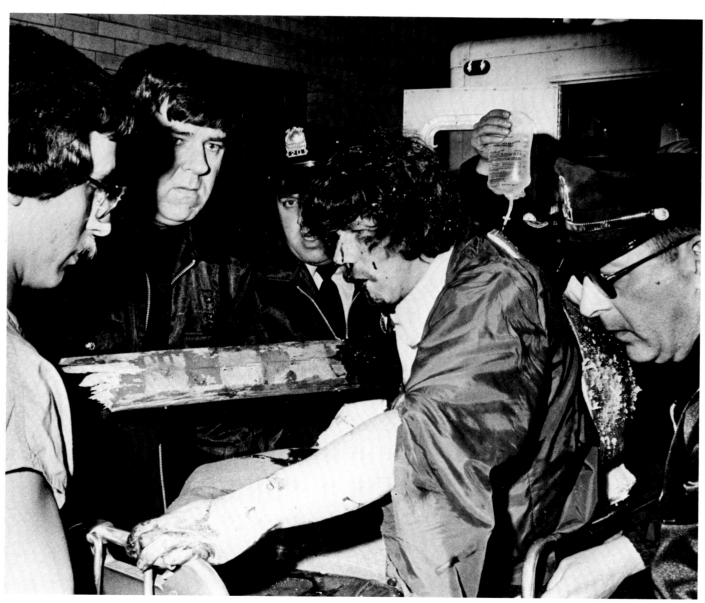

DAN SHEEHAN

167

Listening to three police scanners monitoring fire, ambulance, airport, state and local police offends the ear, like playing scratchy Yoko Ono record albums at 78 rpm.

The secret is to not listen for words, but to tones. A cop calling in to check a driver's license sounds bored; not to worry. But the voice of a policeman who's looking at people hanging out of a burning window sounds different. You learn to pick that up quickly from a scanner.

Bill Brett remembers how it sounded. "The cop spotted the fire and was screaming for some fire apparatus to be sent to 1118 Harrison Avenue in Roxbury," recalls Brett. "I was on Harrison Avenue by the Boston City Hospital, less than a mile away."

As Brett pulled up, a woman, Latanya Bailey, clad only in a bedsheet, climbed out of a third-floor window, flames at her heels. Boston policeman James Donovan pleaded with her not to jump, to stay put until the ladder trucks arrived.

"You could hear the fire engines roaring down the street. But she couldn't wait, she screamed and leapt," Brett said. He shot a single frame with a Mamaiflex 2¼ square camera and a Honeywell strobe as Officer Donovan moved in to break the terrified woman's thirty-five-foot fall. She hit him, and they both went down heavily. Neither was seriously hurt.

Brett says that when he returned to the *Globe* he was so shaken that he asked fellow photographer Charlie Carey to process the roll for him. He knew what he had, and didn't want to risk messing it up loading the reels. That's part of processing where a shaky hand can ruin a photograph by allowing one portion of undeveloped film to overlap another, thereby erasing the image.

The image was sharp, and the negative well exposed—literally. When Bailey jumped, the bedsheet unwound. The picture was too good not to use, but the editors had to make a concession to the dignity and constraints of a family newspaper. The editors decided to have *Globe* artist Frank Yancey airbrush what would look like white panties on the appropriate place on the print. *The Boston Record American,* which had a photograph shot from a different angle, opted for black panties. Brett: "Then the wire services played around with it and one paper ran the photograph with polka-dot panties."

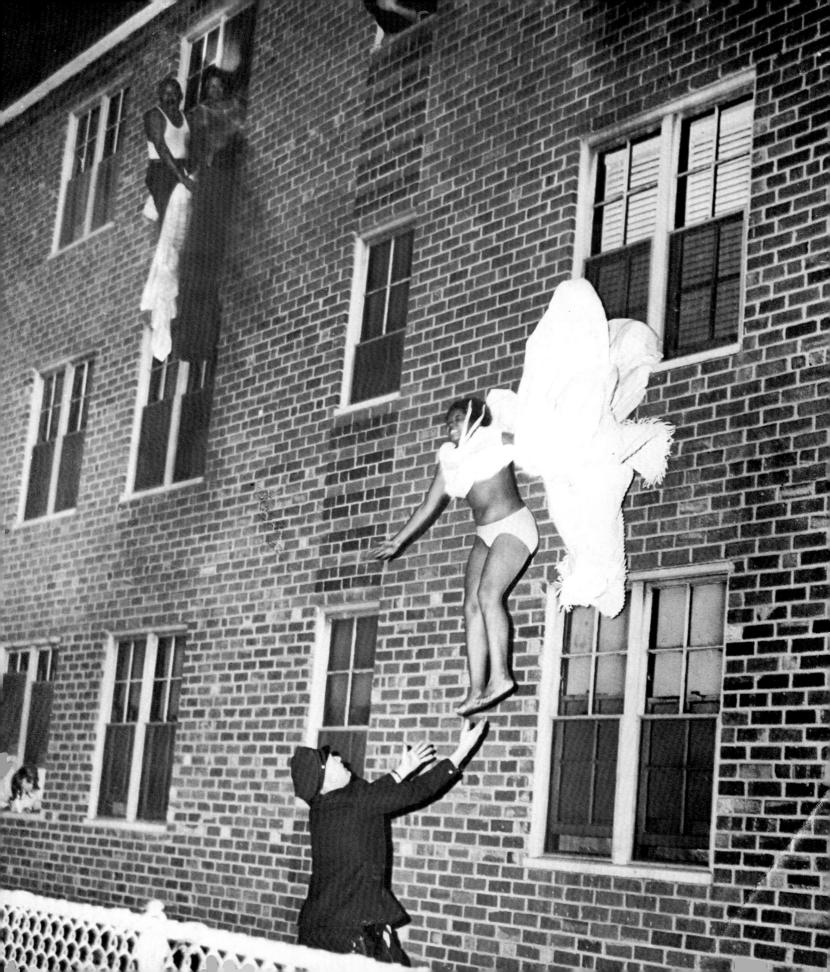

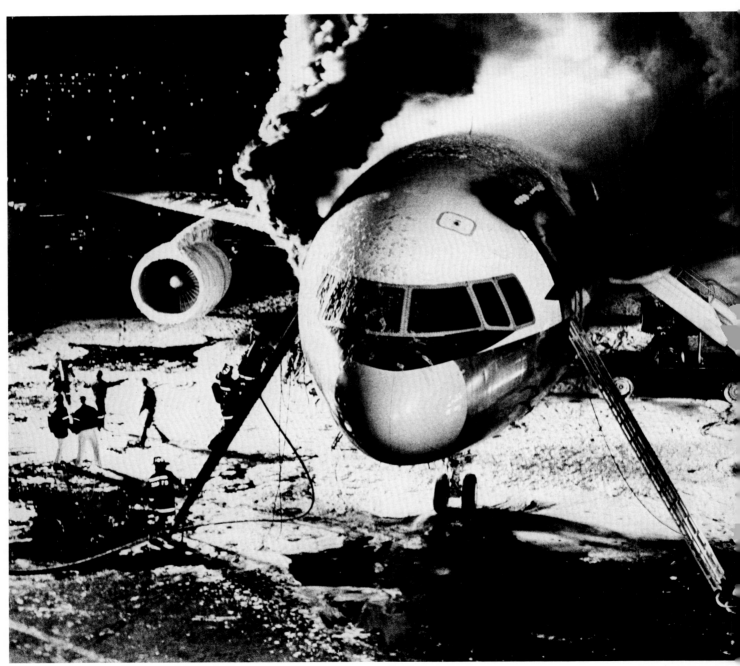

A TWA L-1011, with electrical problems, bursts into flames at Logan International Airport. Boston, 1974.

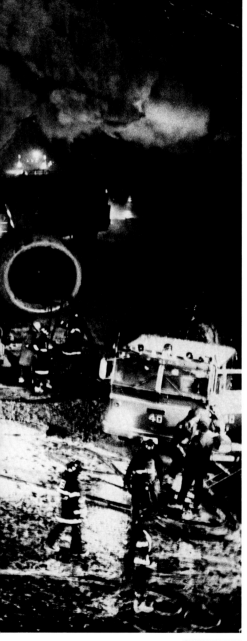

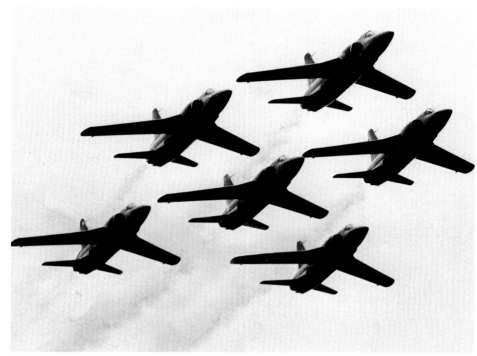

U.S. Navy Blue Angels cruise at 600 m.p.h. over the Weymouth Naval air base. Weymouth, Massachusetts.

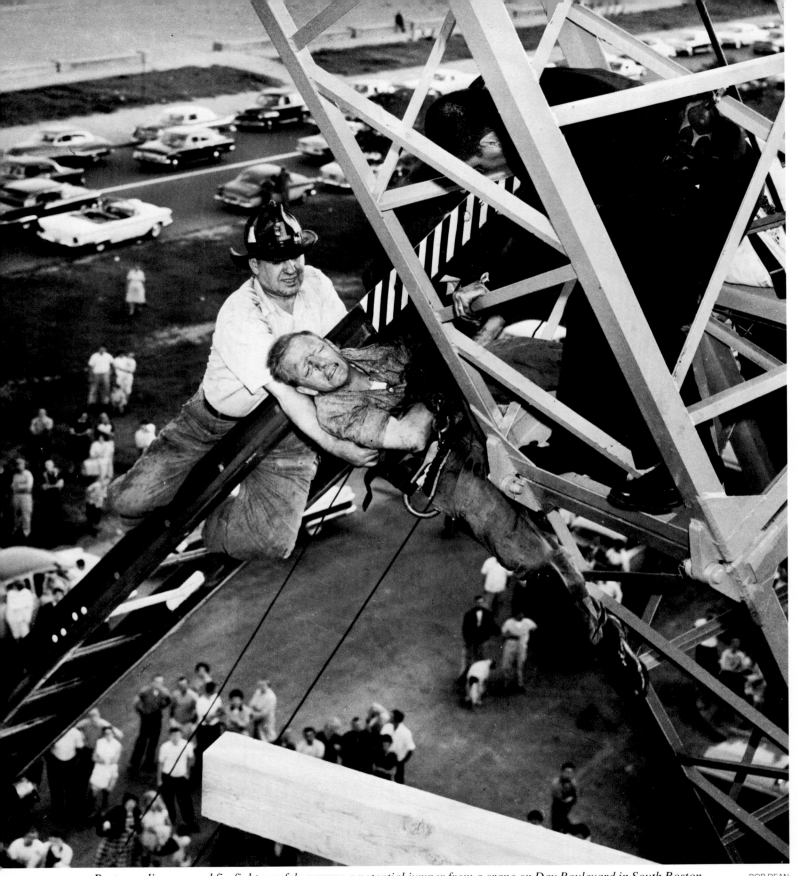

Boston policeman and firefighter safely remove a potential jumper from a crane on Day Boulevard in South Boston.

BOB DEAN

172

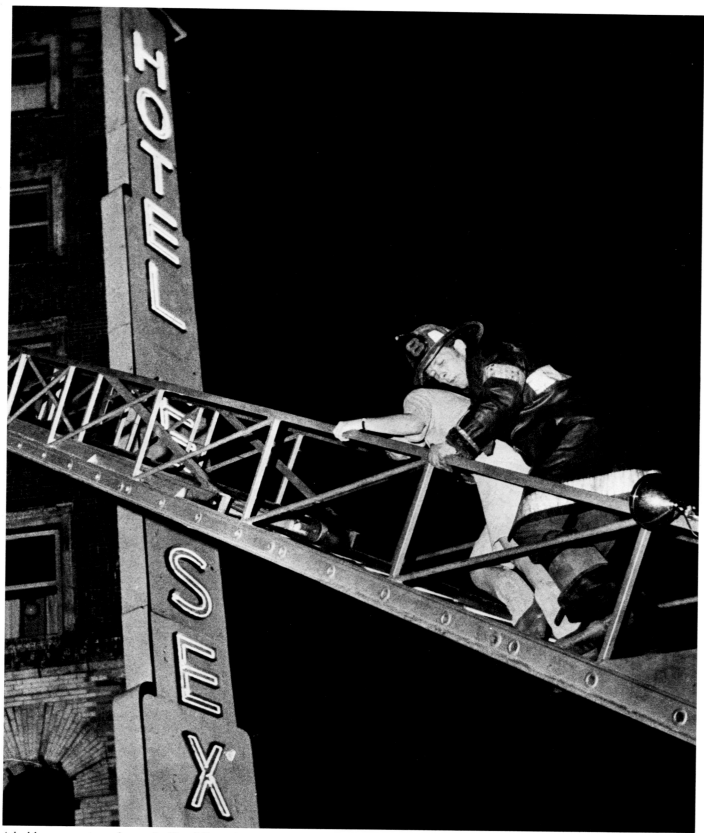

A ladder rescue transforms the Hotel Essex into a different type of hotel. Boston, 1978.

DAN SHEEHAN

173

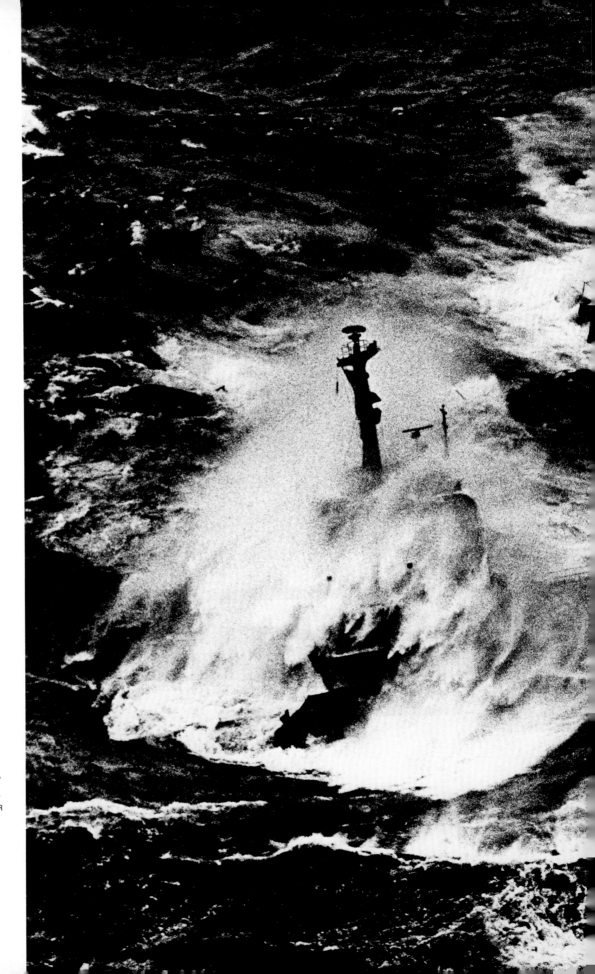

*Pounded to pieces by the
storm-tossed Atlantic, the*
Argo Merchant *sinks into
Nantucket Sound, creating
the nation's worst oil spill,
December 1976.* ED JENNER

174

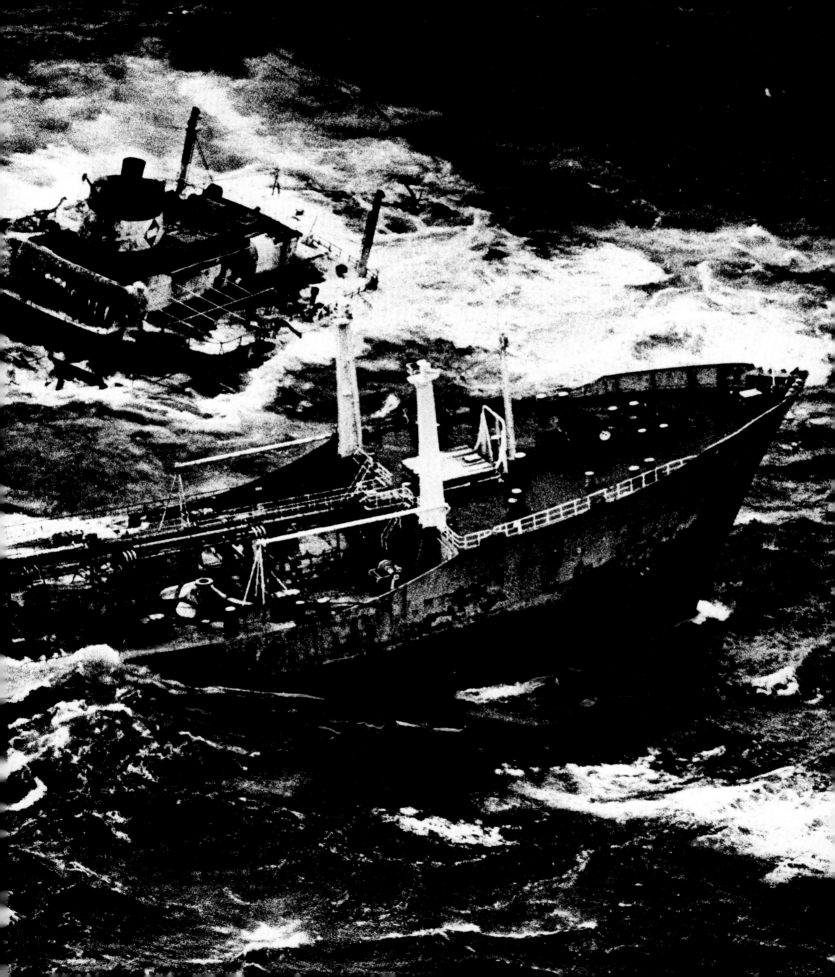

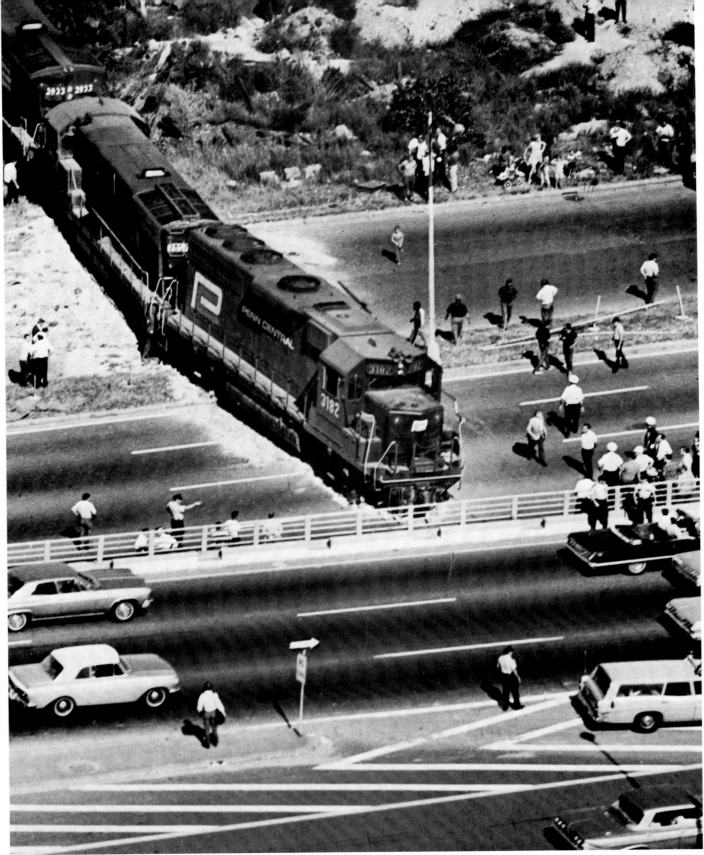

''We just don't know what happened. They just ran away out of the engine house and onto the loop track. There was nobody aboard.''—Railroad spokesperson
Runaway Penn Central locomotive blocks most of the northbound lane of the Southeast Expressway. No injuries were reported. Boston, August 1969.

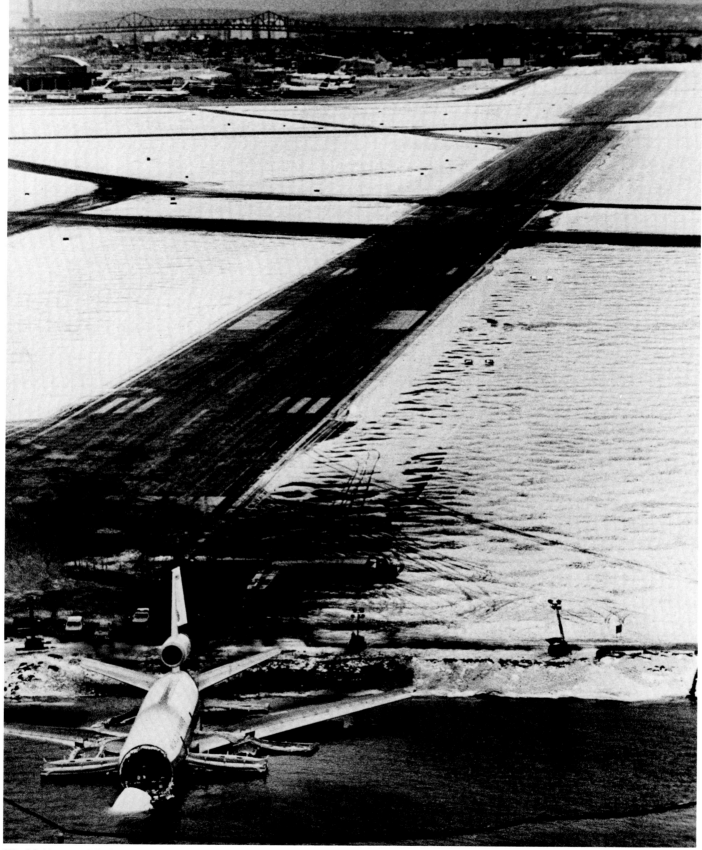

World Airways Flight 30 comes to rest in Boston Harbor after skidding off an ice-and-snow covered runway BOB DEAN
at Logan International Airport. Two passengers on the DC10 aircraft were never found and are presumed drowned.
Boston, January 1982.

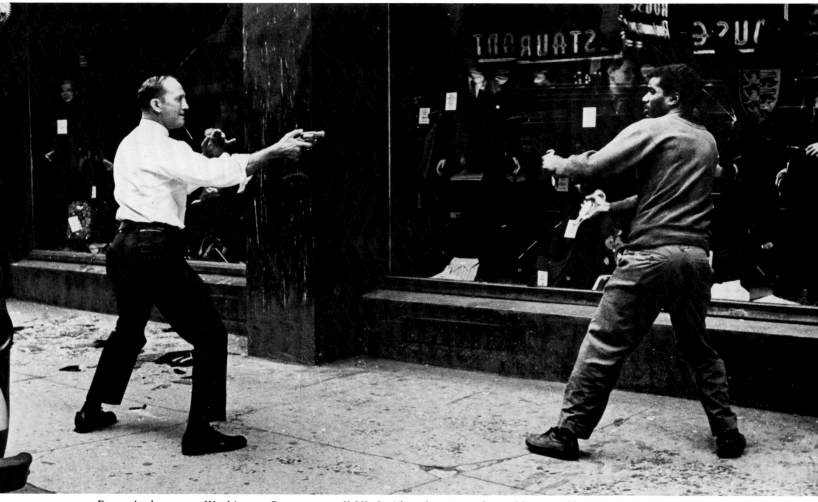

Boston's downtown Washington Street was well filled with pedestrians when a 28-year-old man, clutching a bottle in each hand, suddenly smashed a large plate glass window, then a second window. As pedestrians scattered, Sergeant James Tatosky, off-duty policeman, appeared.

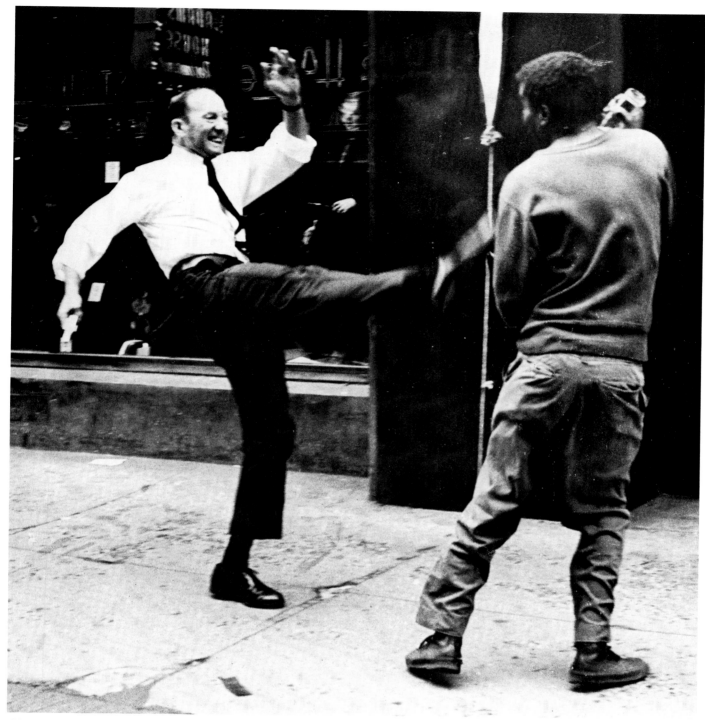

Globe *photographer Bill Brett records the action as Tatosky draws his gun (above)*
and then kicks one of the bottles out of the man's hand (right).
A Boston patrolman finally grabbed the man from behind.
August, 1967.

Bill Brett was flying in a helicopter making aerials of the damage done by the blizzard of '78.

The giant storm left 54 New Englanders dead, 10,000 homeless, dumped 27.1 inches of snow, and stranded over 3,000 cars on Route 128 alone.

The helicopter suddenly lost power. They were coming down. "I thought it was all over," said Brett. The pilot guided the chopper to an emergency landing in a snow drift just behind the Scituate, Massachusetts, police station.

"There wasn't a person around. I jumped out of the chopper and I was up to my armpits in snow. I didn't have any boots because the helicopter picked me up on the *Globe* roof." Brett made his way to the police station, where he startled an officer who wondered how he had gotten there with all the roads closed.

After a cup of coffee and some quick repairs by the pilot, Brett reluctantly returned to the air. The next day another newspaper, *The Patriot Ledger* of Quincy, Massachusetts, rented the same helicopter. "It wound up in the trees in the Blue Hills," Brett said.

To cover the blizzard the *Globe* rented two snowmobiles, and photographer Bob Dean put chains on his '67 Chevy. David Ryan tucked his cameras inside his foul-weather suit and walked four miles to the waterfront to reach a restored steamer, the *Peter Stuyvesant,* which had been lifted off its concrete cradle and left half-submerged and listing. The *Globe* also rented rooms at nearby motels, where the exhausted staff grabbed a couple of hours sleep.

Brett now recalls it as heaven. "It was the ideal situation for a photographer. The paper couldn't take any ads and there was a lot of room for pictures."

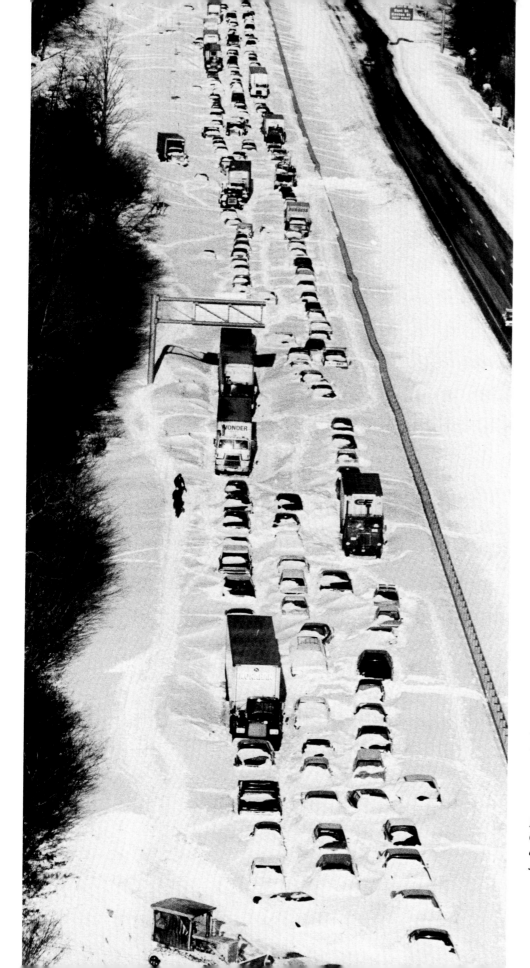

Cars buried on Rte. 128 near the Dedham — Westwood line. February, 1978. ED JENNER

Following:
Commuters fight storm winds at Columbia Circle. Boston, January 1978. TOM LANDERS

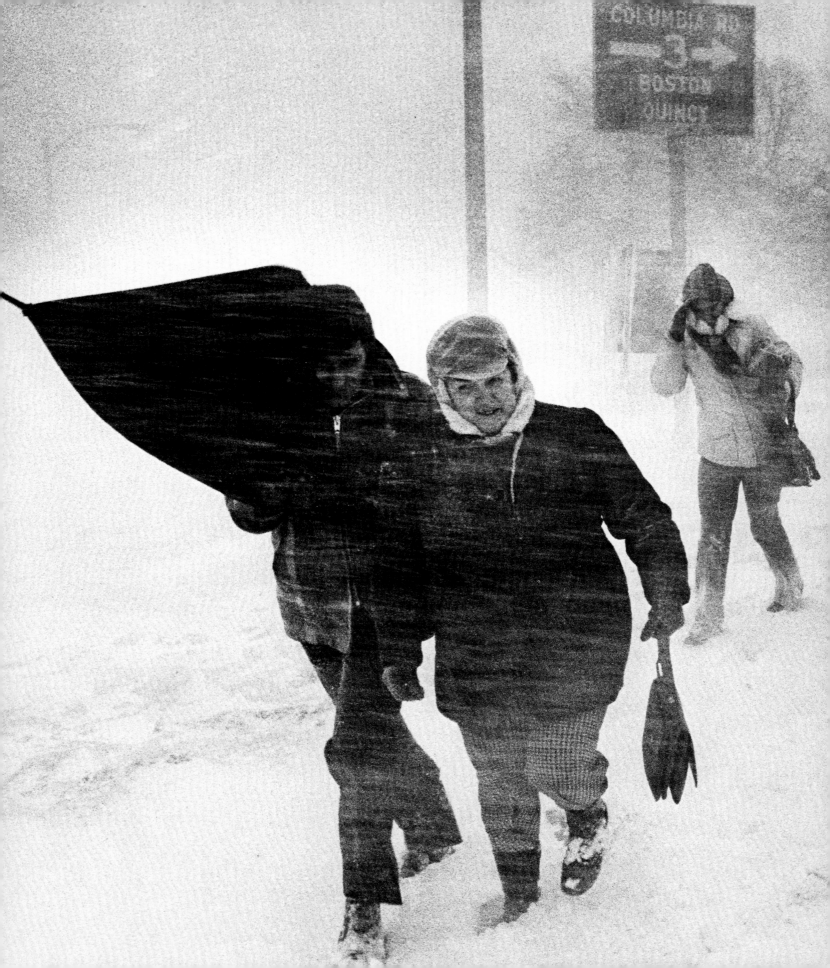

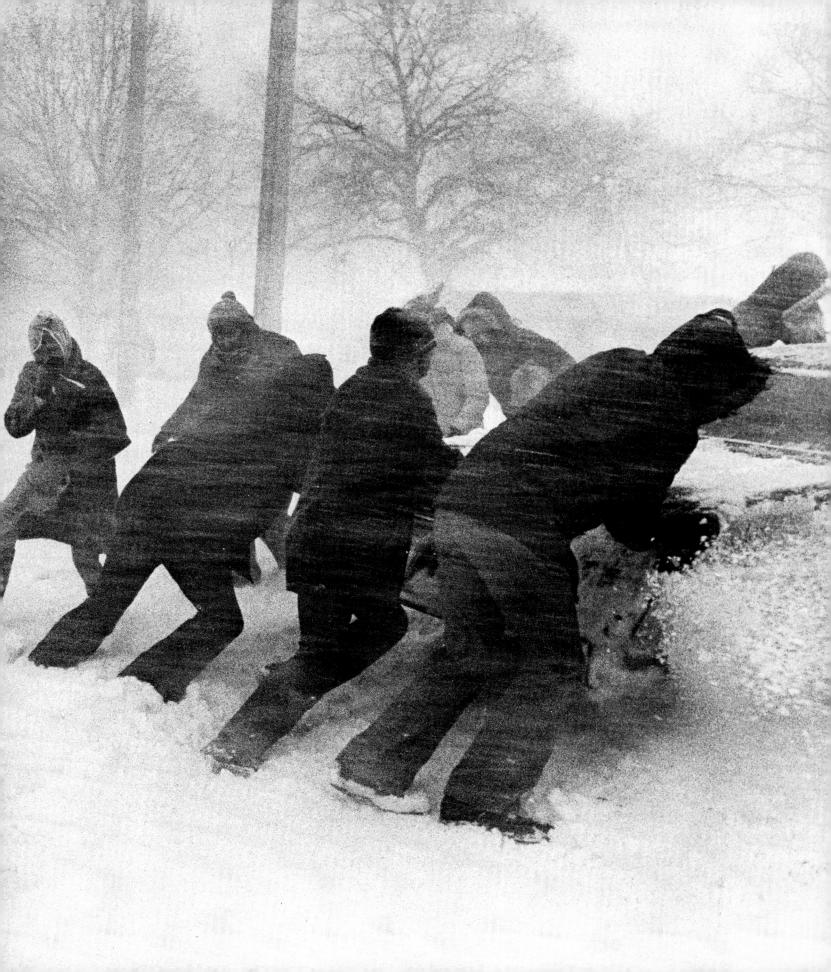

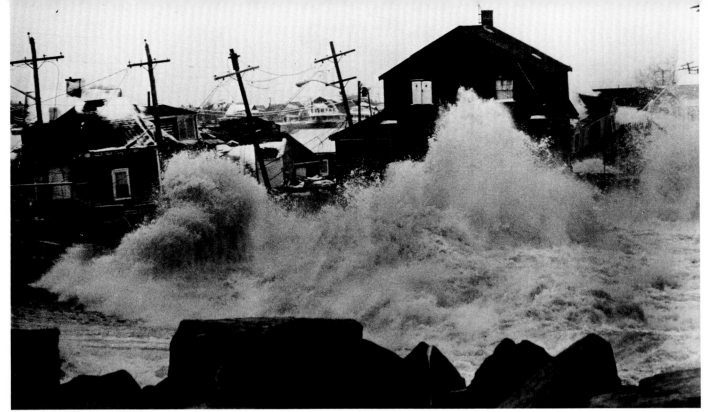

Houses are pounded by swollen waves in Scituate, Massachusetts. February 1978.

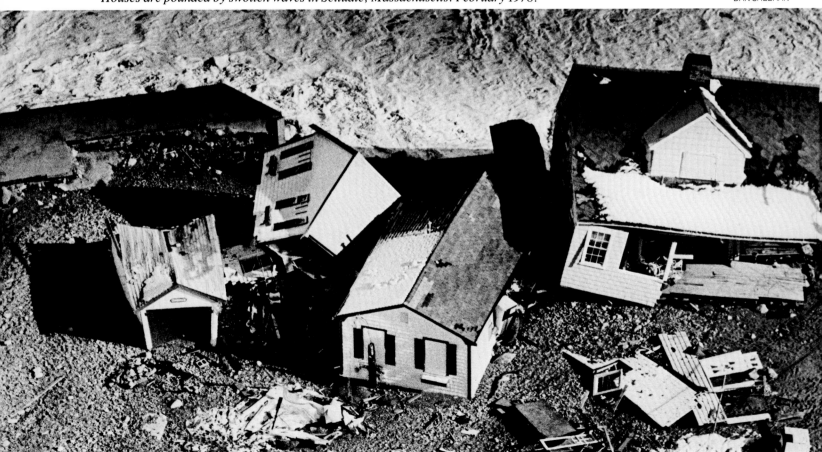

Aerial shot of houses torn from their foundations in Scituate, Massachusetts. February 1978.

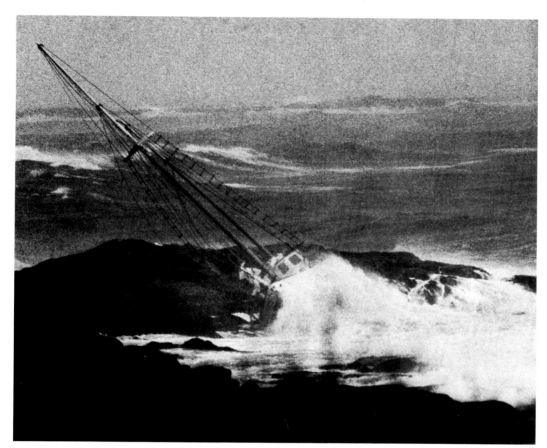

Boat is buffeted off Cohasset shore, in Massachusetts. February 1978.

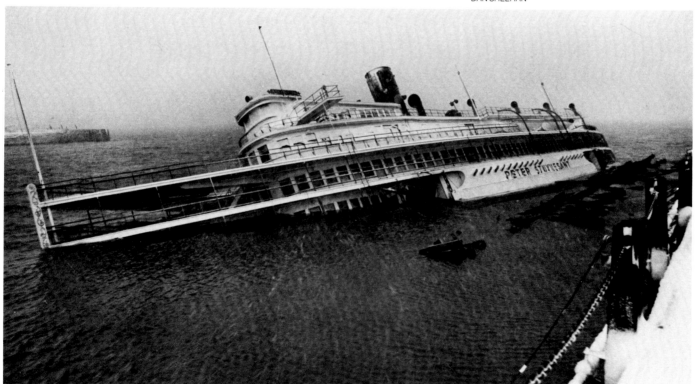

A famous landmark, the Peter Stuyvesant, *starts sinking during the blizzard. Boston, February 1978.*

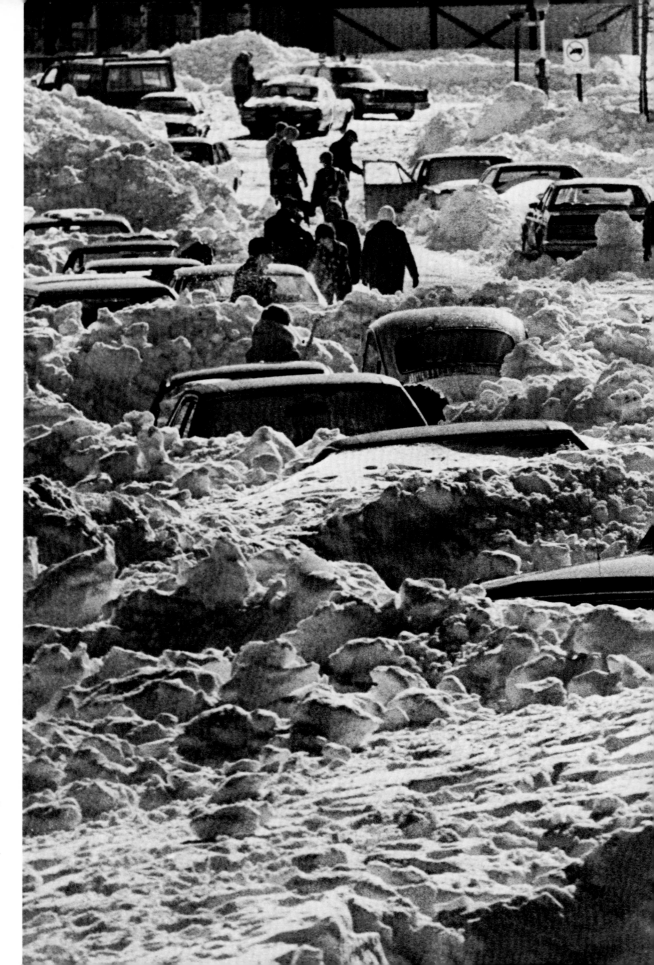

*Residents of
Farragut Road
dig out.
South Boston,
February 1978.*
BILL RYERSON

186

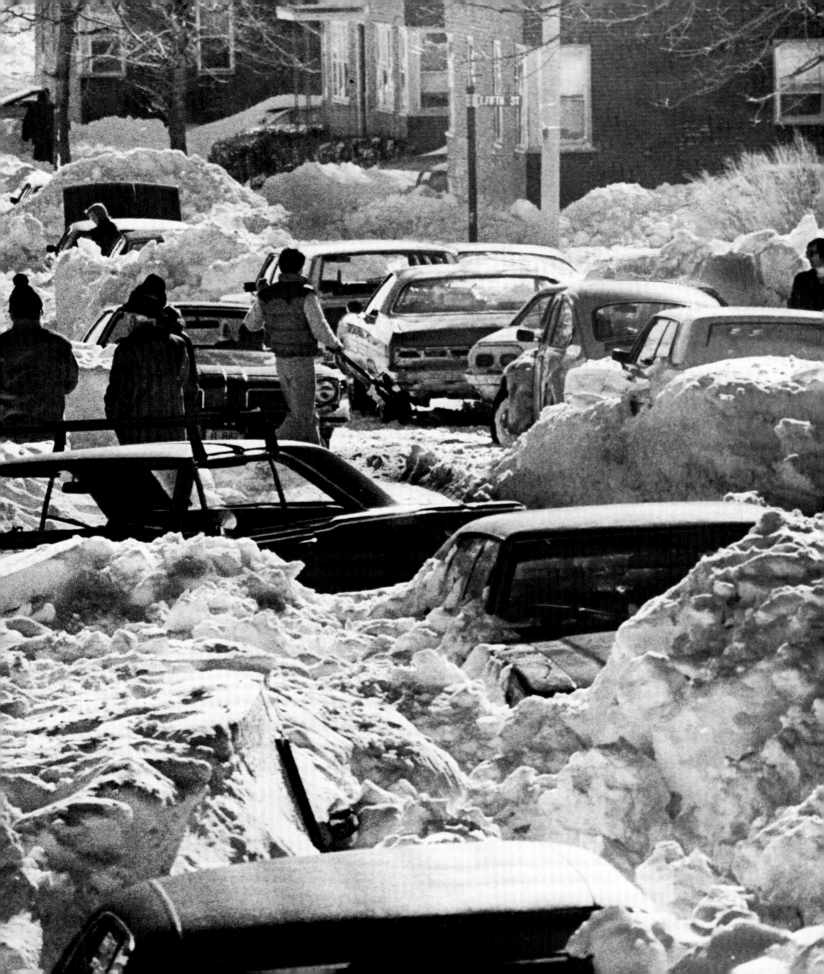

*Pope John Paul II
kneels for a brief
prayer in the
Cathedral of the
Holy Cross before
addressing a
packed assembly.
Boston,
October 1979.*
ULRIKE WELSCH

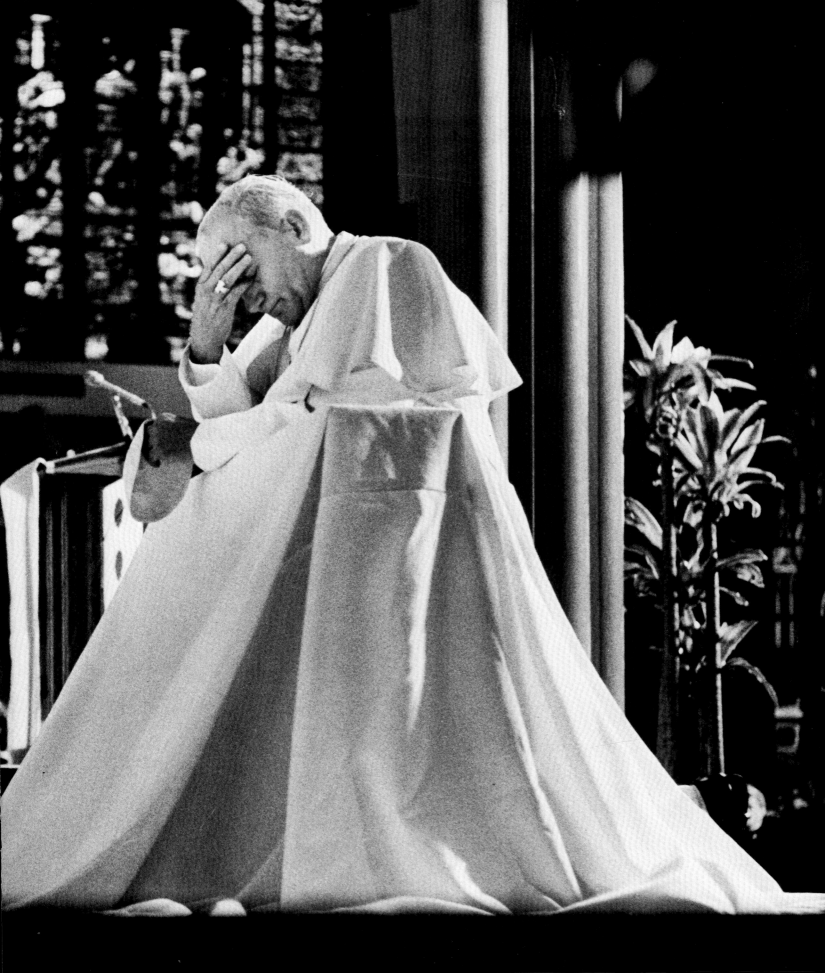

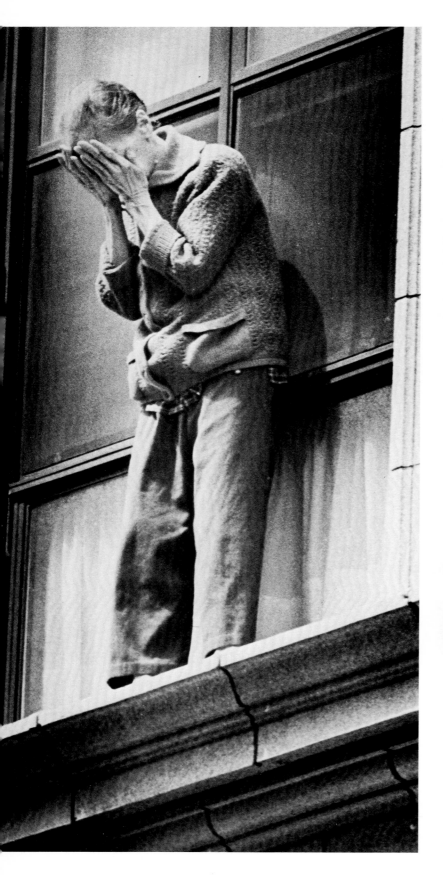

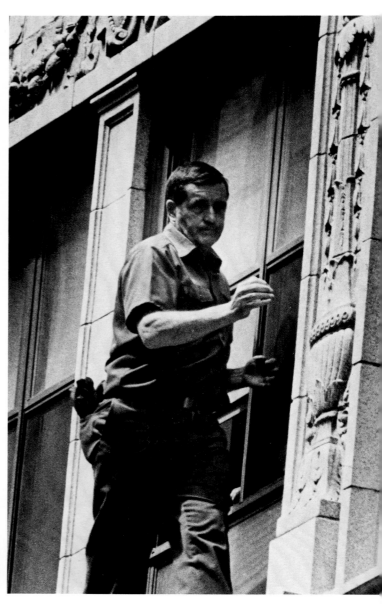

Fireman Robert Mackey and policeman Thomas Galvin rescue suicidal woman. Boston, June 1977. TOM LANDERS (4)

190

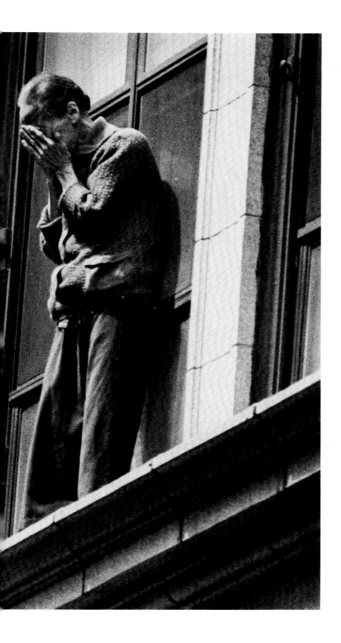

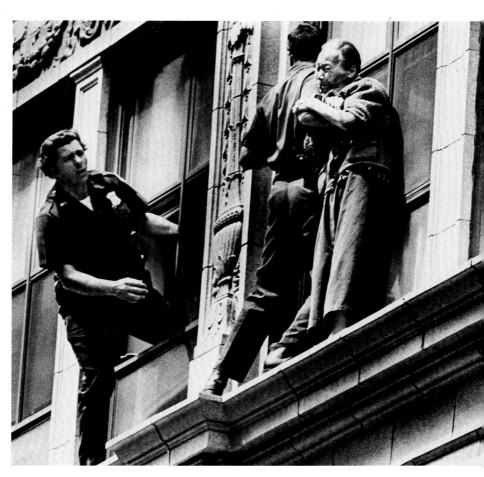

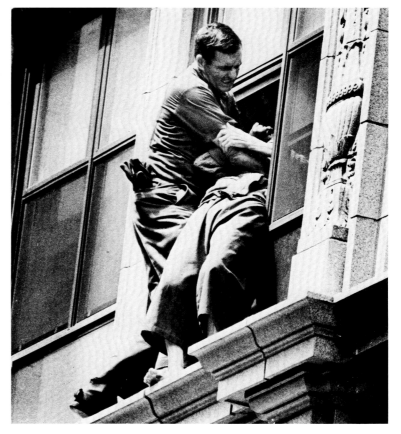

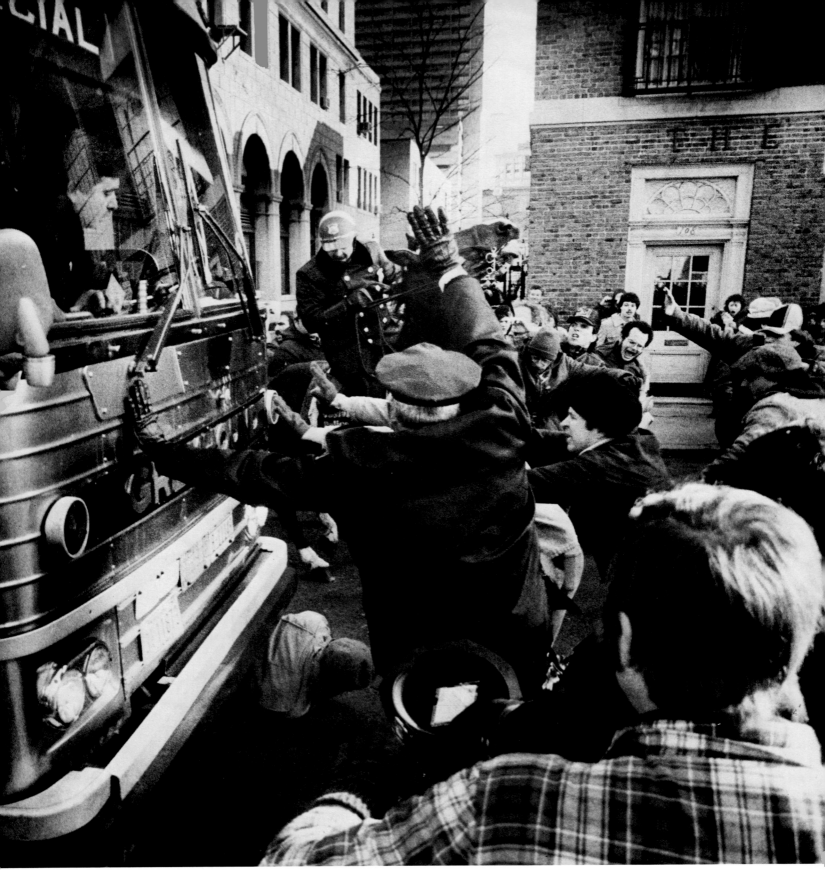

Boston police signal driver of Greyhound bus to stop after a picketer fell in the path of the bus. The man was unhurt. Boston, November 1983.

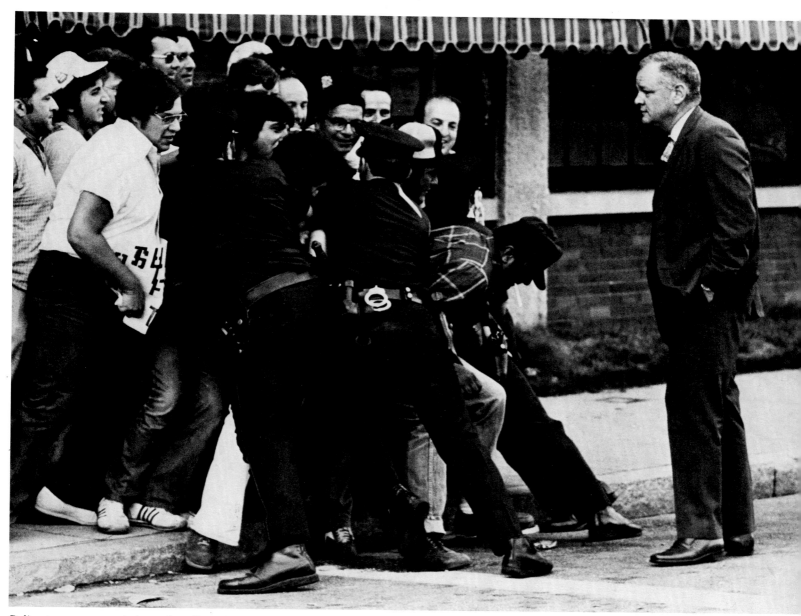

Police try to cut a path through striking General Dynamics workers so an executive can enter plant. Quincy, Massachusetts, October 1977.

PAUL CONNELL

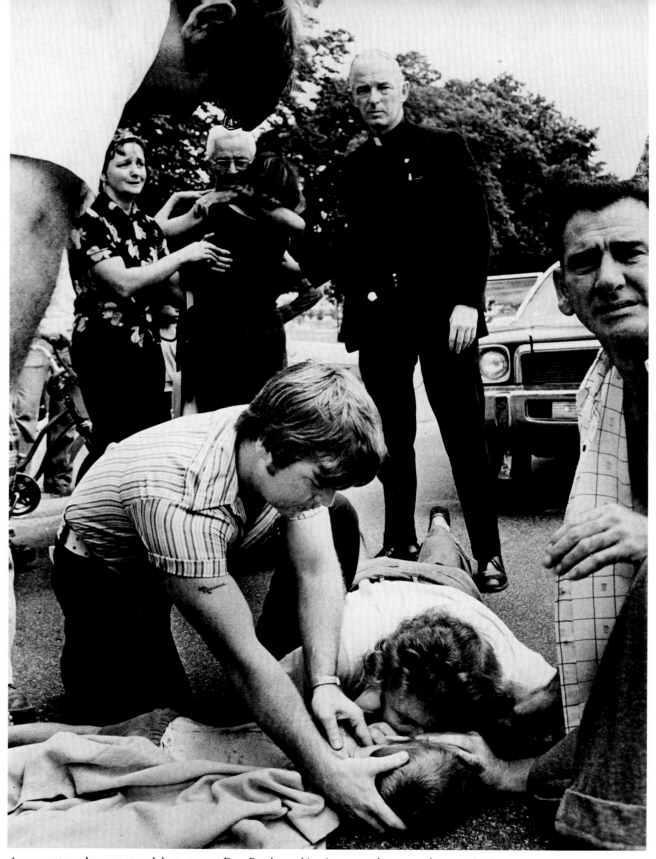

BILL BRETT

A youngster who was struck by a car on Day Boulevard is given mouth-to-mouth resuscitation as his mother is consoled in background. Moments later, Father James Lane gave the fatally injured boy the last rites. South Boston, 1975.

Opposite: Woman is rescued from a Columbia Road blaze. Dorchester, Massachusetts, 1982. WENDY MAEDA

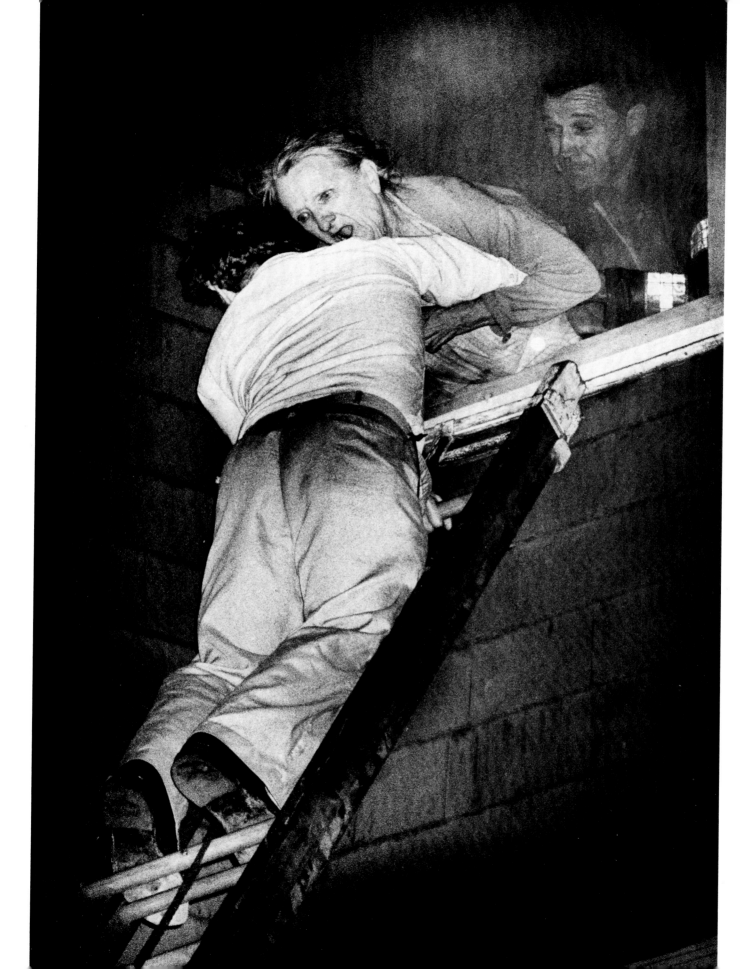

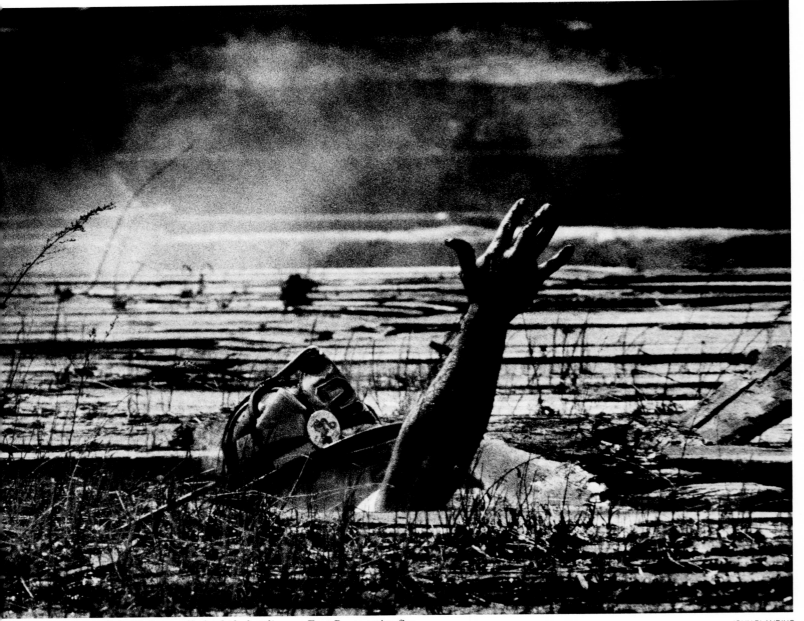

A firefighter calls for help battling an East Boston pier fire.

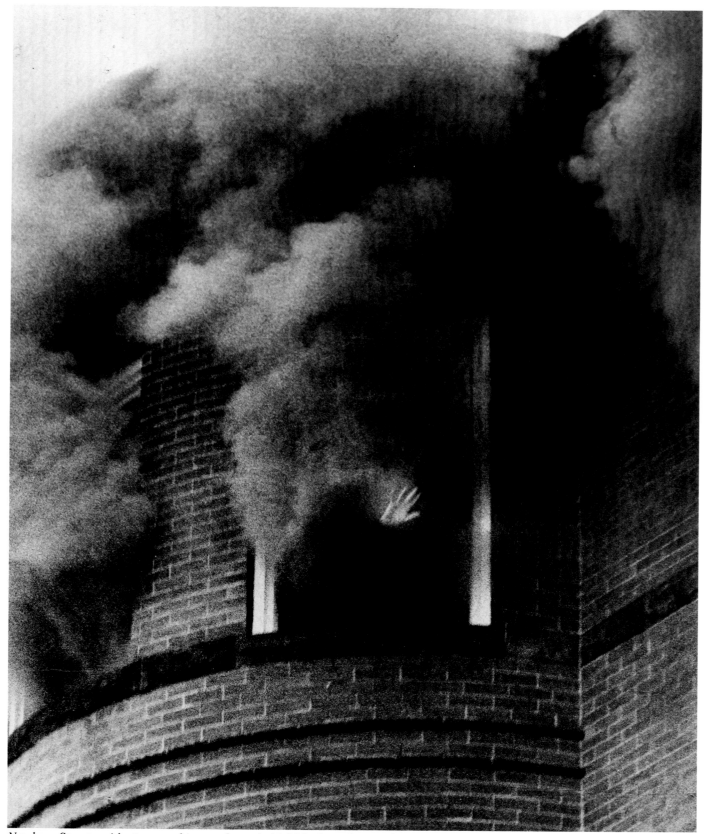

Newbury Street resident gropes his way through thick black smoke to safety. Boston, 1973. DAN SHEEHAN

Following: Metro Police rescue Judith Nicoll of Ipswich, Massachusetts, who fell through the ice on the Charles River. Boston, January 1979. BILL CURTIS

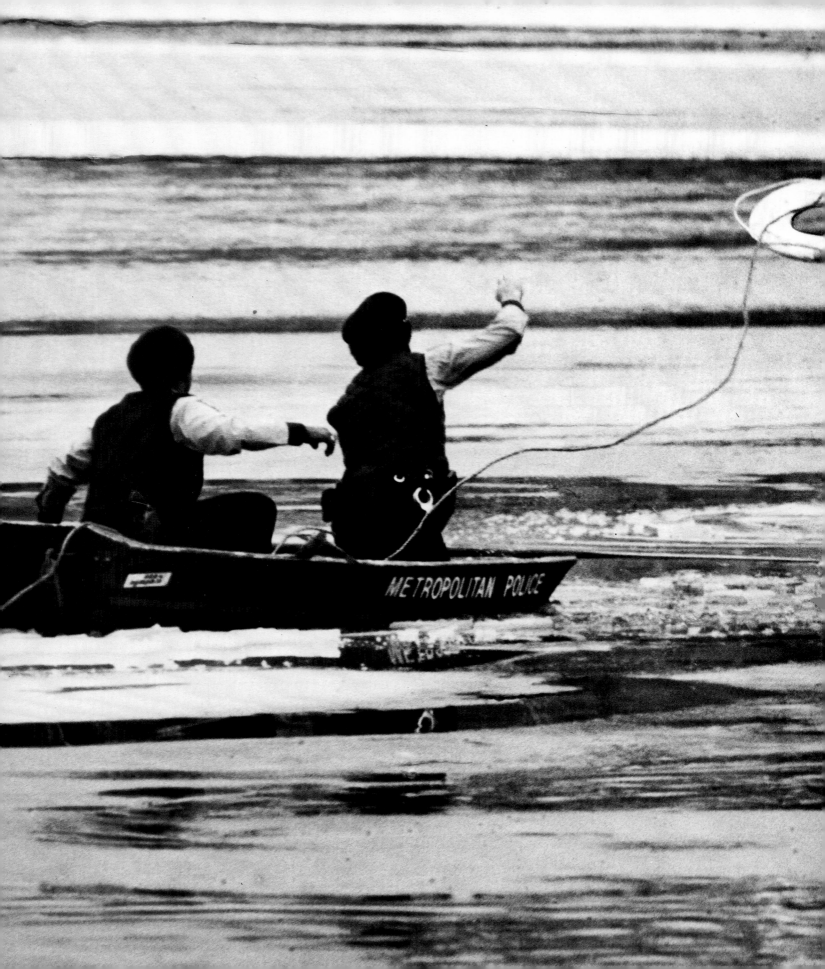

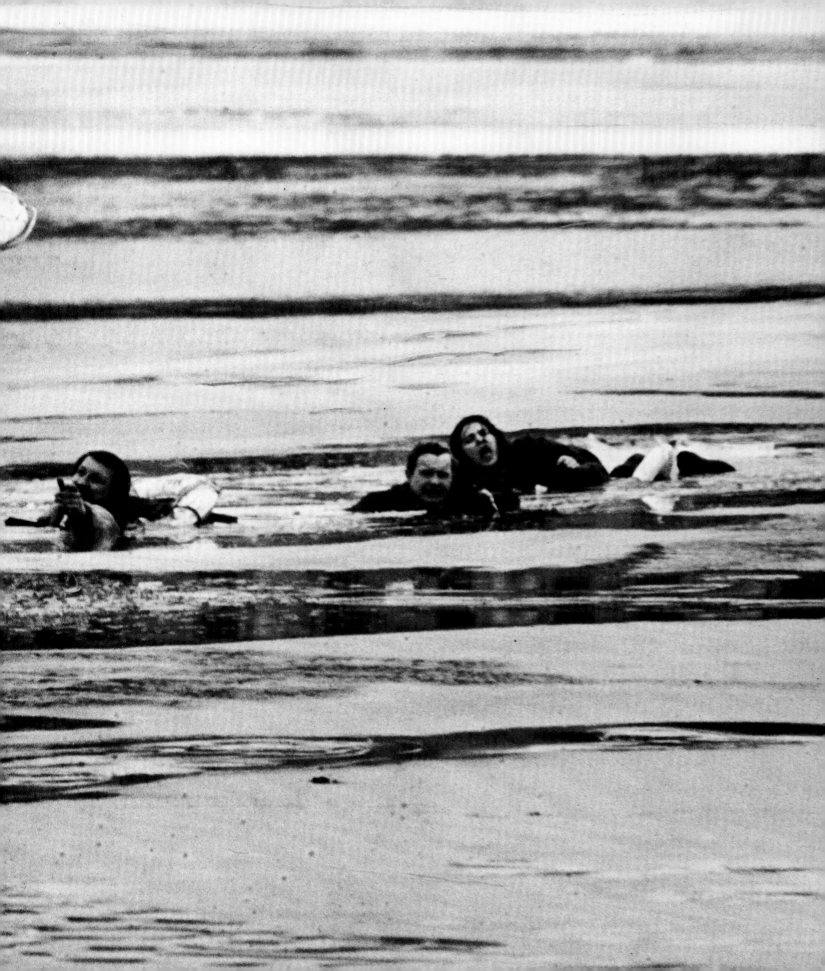

It was one of those hot August days when the car seat feels like Ethiopia and somebody in Boston goes crazy with a loaded pistol.

Bob Dean had the windows of his white Lincoln Continental rolled up tight and the air conditioner humming. The police dispatcher sent a cruiser to Roxbury for a reported domestic disturbance. Ho hum. Two minutes later the cruiser

BOB DEAN

was screaming, "Shots fired." The dispatcher responded immediately: "OT [officer in trouble], 14 Brinton Street, Roxbury." An OT call is guaranteed to draw every available cruiser in the district, very quickly. Dean started for Roxbury, adrenaline pumping.

One of the most frustrating things for a news photographer responding to a spot news situation is traffic. A few seconds can make the difference between making a dramatic photograph, maybe a prize-winner, or settling for a whiff of exhaust fumes from emergency vehicles leaving the scene.

Reporters can make a phone call from the office, or find an eyewitness hours later. Photographers have to be there. Dean took certain liberties beyond those deemed acceptable by the motor vehicle code of the Commonwealth of Massachusetts. When it comes to spot news, Dean drives like a raving maniac.

Unfortunately, Dean came across a Puerto Rican festival parading leisurely along Seaver Street near Franklin Park.

"They say everybody loves a parade. And so do I. But not when I'm responding to a spot news situation," Dean said.

Several years earlier, he was responding to a "fire showing, people trapped" call that came in while he was on the Southeast Expressway. He put his foot to the floor. When he got to the exit ramp he put his foot to the floor again, this time on the brakes. No brakes.

To his right was a group of kids coming out of a Howard Johnson's, ice cream cones in hand. Straight ahead was traffic. To the left was a median strip. Dean swung the Rambler left and went up the embankment and down into a five-foot ditch. He spent the night at Boston City Hospital.

This time, with everybody standing in the road watching the parade, Dean drove onto the sidewalk, "very slowly, very carefully, looking out for small kids."

When he got around the parade, he drove like mad. As he picked up speed, the cops were exchanging shots with a 28-year-old man who was holding hostages behind bullet-punctured venetian blinds. Dean hooked up with the SWAT team.

"Fortunately, I have a good working rapport with the TPF [Tactical Patrol Force] and had worked out with the SWAT team during its training exercises. So they trusted me, and permitted me to accompany them as they planned their assault," Dean explained.

While the SWAT members donned their bulletproof vests and gas masks, Dean shed the jacket and vest of his three-piece suit and donned a blue nylon jacket. The officers armed themselves with tear gas launchers, high-powered rifles, and shotguns. Dean chose a 24-mm lens for his Nikomat, and stuffed his pockets with extra Tri-X film and an 85-mm lens. He tucked a Honeywell strobe into his belt, and followed the assault team.

After firing the tear gas, two SWAT teams simultaneously charged the front and rear of the house. Dean came up the front steps right behind one squad and perched atop a three-foot high railing on the porch. The 24-mm wide-angle lens gave Dean good coverage of the front door; the railing gave him height and kept him out of the SWAT team's way.

The tear gas took its toll on Dean. "My eyes were burning and running so bad I couldn't focus the camera. By setting the focus scale on eight feet I knew that the 24-mm lens would give me plenty of depth of field at f/8 to get sharp pictures."

When the SWAT team dragged the screaming and wounded gunman from the house, Dean was in a perfect position to record it on film. He used a shutter

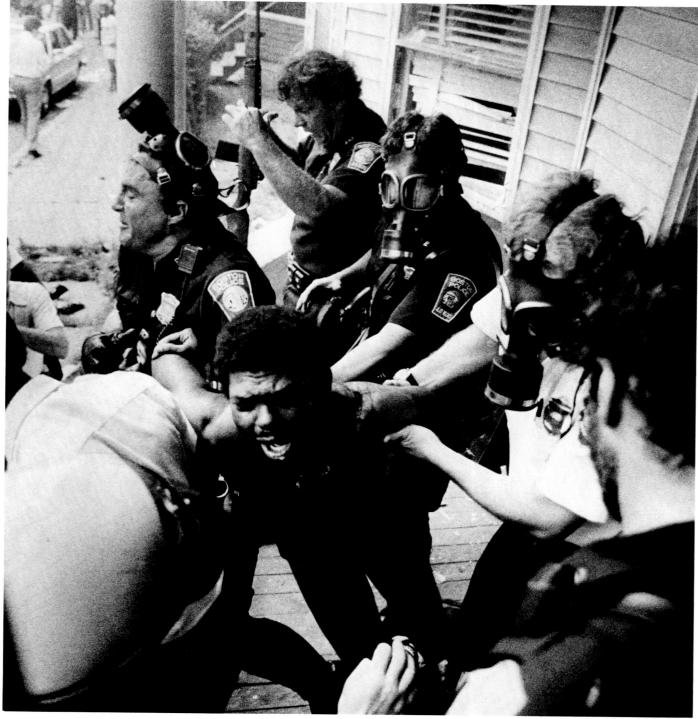

speed of 1/500-second in anticipation of the quickly-moving bodies. To do this, Dean rated his Tri-X film at ASA 800 instead of the normal 400.

Globe darkroom technician Jim Bulman increased the processing time of the film by twenty percent in D-76 developer to compensate for the underexposure. The negative was printed on number 4 Kodabromide paper.

The photo, which appeared on the front page of *The Boston Sunday Globe* on August 24, 1980, was awarded first place for "Best Spot News" in the United Press International New England photo contest.

So despite Bob Dean's tear-gas tears, it didn't rain on his parade.

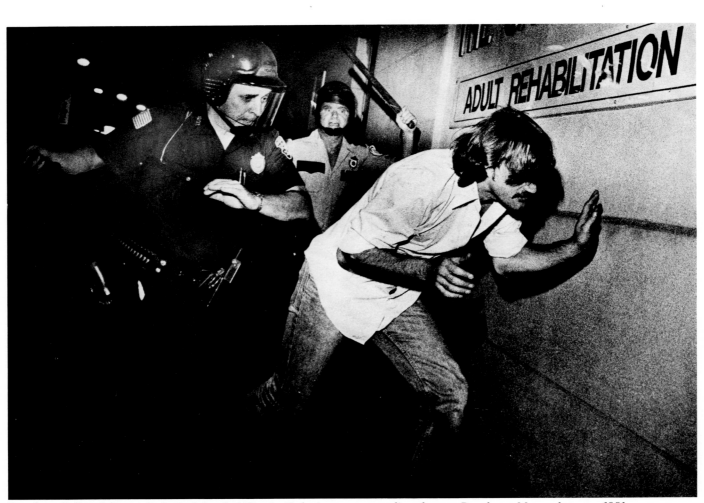

Brockton Police deliver a little "adult rehabilitation" during a summer disturbance. Brockton, Massachusetts, 1981. JOHN BLANDING

202

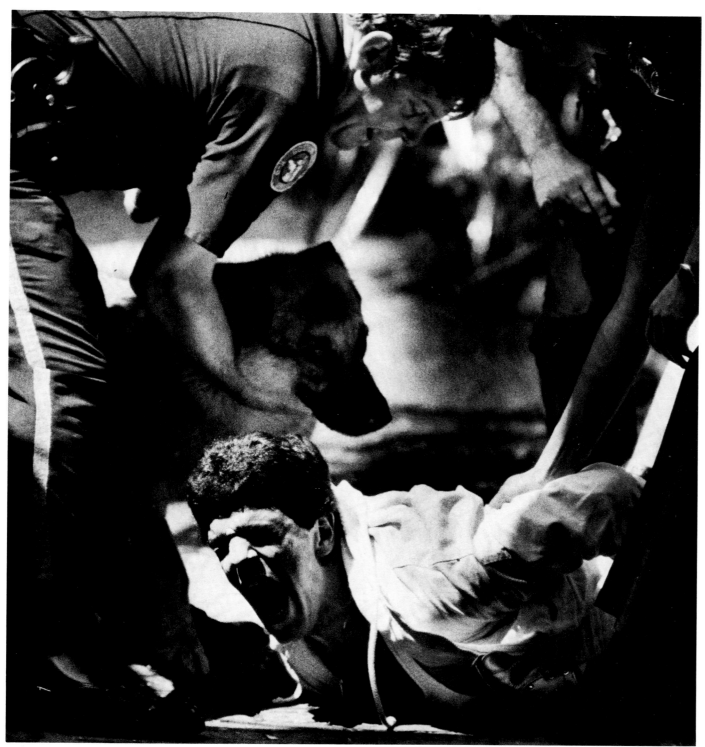

Police officers, with the help of canine, capture a drug suspect on Beacon Hill. Boston, June 1982.

For a news photographer there are no days off when a big story breaks. Joe Dennehy was headed back to Boston after a summer day at his New Hampshire place. Coming through Franconia Notch he saw the flashing red lights of emergency vehicles. Two mountain climbers had died on Cannon Mountain after one had fallen and his ropes had ensnared his mate.

The accident happened more than two miles in from the highway, so rescue workers had great difficulty reaching the site. Dennehy made the usual shots of the scene and the faces in the crowd which gathered at the staging area. He knew the important picture would be the one with the climbers. But how could he get halfway up Cannon Mountain when well-equipped rescuers were stymied? Even with his longest lens—a 500-mm—the image size would be too small. That's when he spied a telescope.

"Using a 24-mm lens, I looked through and photographed the image through the telescope. The guy from the New Hampshire Fish and Game couldn't believe it. But if you can look through a viewfinder and get an image, and you can meter it, you know you've got it. I was afraid that if the telescope moved, or my 24-mm lens moved one little millimeter, this image might get all screwed up. I couldn't press my lens right against the telescope because of vibrations. And I lost five f-stops [because he was aiming through the telescope, there was only one-fifth the available light] so my exposure was f/2.8 at 1/250 second. I called the City Desk and told them I had good stuff. They held page one for me, and used it well."

The picture was widely distributed by the wire services. Dennehy was told later that it was a runner-up for a Pulitzer Prize. "We got a lot of negative reaction, too," he added. "People were upset about it because it was a death, and they didn't think it should be played that way. I feel it's our job to report these things. The father of one of the two boys who died was a newspaperman from Minneapolis. He wrote a moving story about it, mentioning the picture, and how newspapers have an obligation to use pictures like that because mountain climbing is dangerous."

View through a telescope of two mountain climbers killed in an accident. Franconia Notch, New Hampshire, 1972. JOE DENNEHY

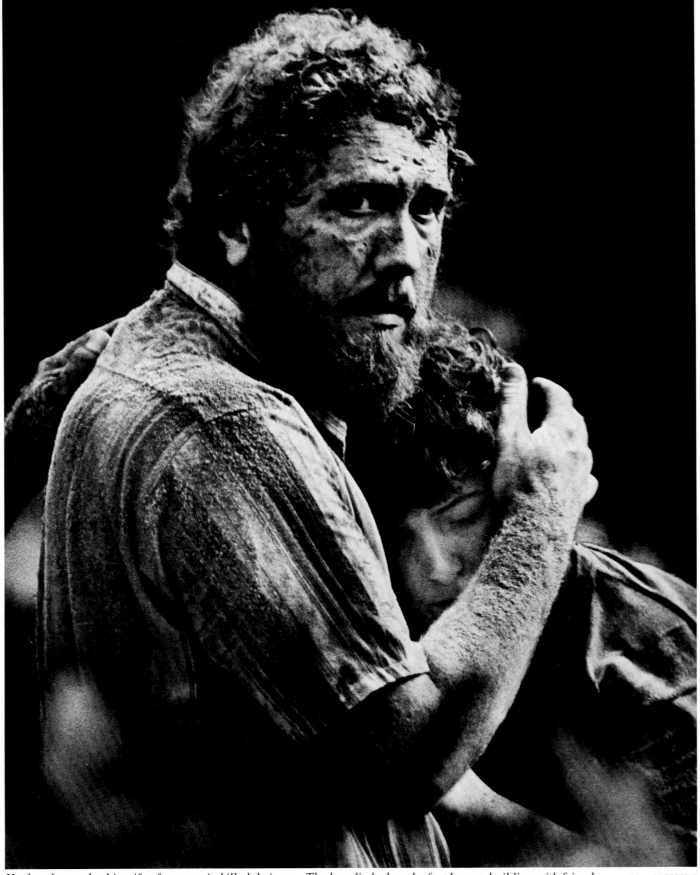

Husband consoles his wife after cave-in killed their son. The boy died when the fort he was building with friends collapsed and covered him with dirt. Needham, Massachusetts, August 1980.

STAN GROSSFELD

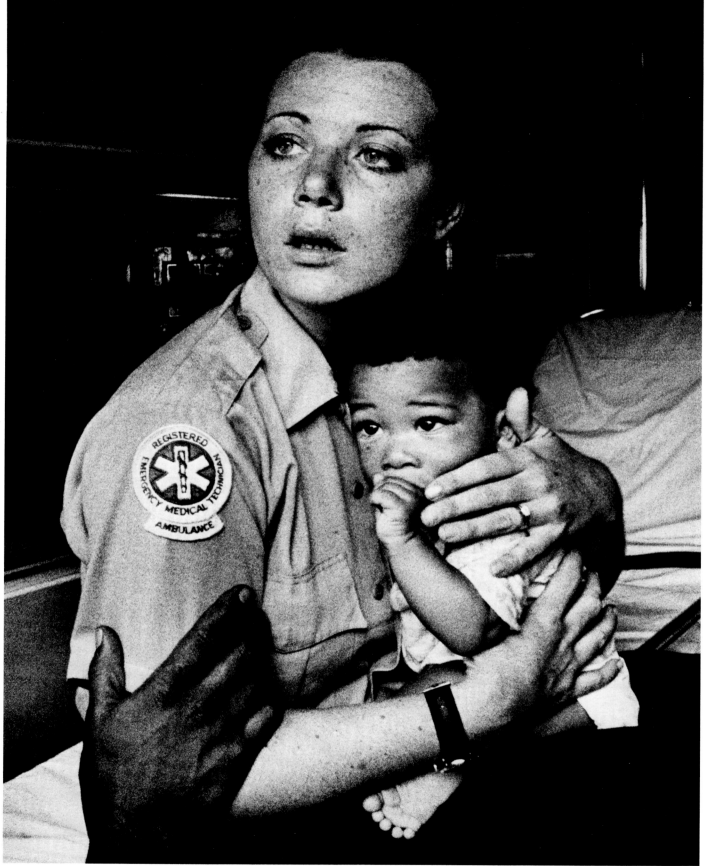

Emergency Medical Technician Maureen Hudella cradles an eight-month-old baby in ambulance after police found the baby's mother and three-year-old sister dead in the bathtub of their South End apartment. Boston, August 1977.

STAN GROSSFELD

207

A firefighter hangs over a roof trying to reach a stubborn blaze in front of a smiling cigarette advertisement. South Boston, July 1981.

JOHN TLUMACKI

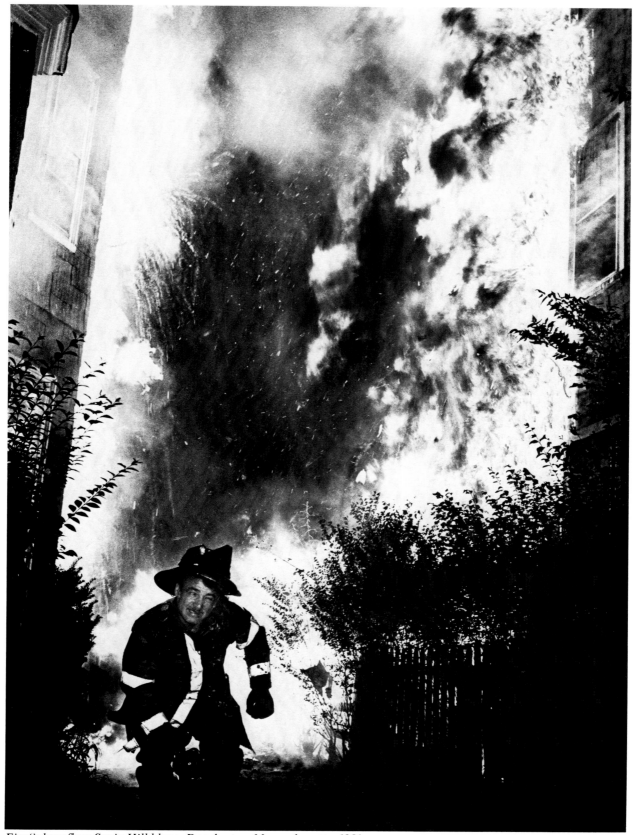

Firefighter flees Savin Hill blaze. Dorchester, Massachusetts, 1981.

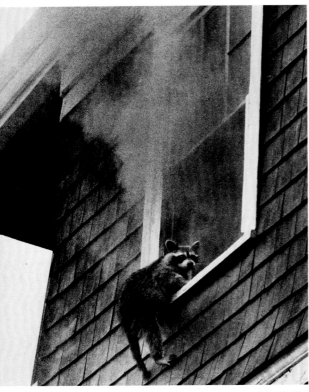

JOE RUNCI (4)

For thirty-three years, *Globe* photographer Joe Runci took life one frame at a time. All that changed on June 11, 1983.

Runci was leaving a routine assignment in Hyde Park when he heard the fire-alarm call come over his scanner: 698 Walk Hill Avenue, Mattapan, Massachusetts. He was in a good position, safely behind a responding ladder truck. The chief's driver, usually the first vehicle at the scene, came on the air. "Fire showing, abandoned building," he said.

"When I heard the words 'abandoned building' I was just getting out of the car," Runci said. "Usually I'd get right back in and leave, but this time I had a hunch."

A woman ran toward Runci telling him there was a raccoon in the window on the third floor. "He came to the window a couple of times when the heat and smoke got bad. Once he tried to walk down the shingles but he thought better of it and came back to the window. I had never ever used a motor-driven camera before, having been brought up on the old Speed Graphic philosophy of making just one frame count. In fact I had this Nikon over a year and had never even switched the motor on. But I was sure he was going to jump so I switched my motor drive on to 'C,' set my shutter speed at 1/500 second, and got ready," Runci said. C on a Nikon motor-driven camera means continuous firing of up to four frames of film per second.

Nearby, Richard Doyle, Fire Chief of District 12, directed his men. "I thought about getting a ladder up to get the raccoon down, but I was afraid one of my men might get bitten."

"It all happened so quickly," Runci recalls. He had time for only a one-second motor burst. His 105-mm lens caught this dramatic four-shot sequence. Runci's pictures were used worldwide and earned him a first place in the United Press International New England photo contest. The raccoon, unhurt and unimpressed, was unavailable for comment.

210

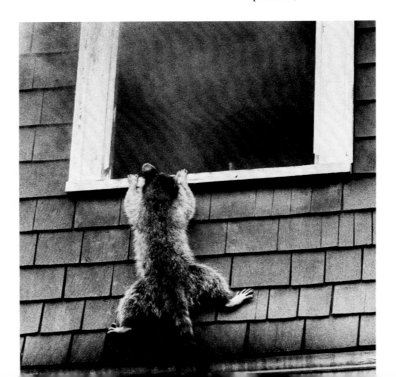

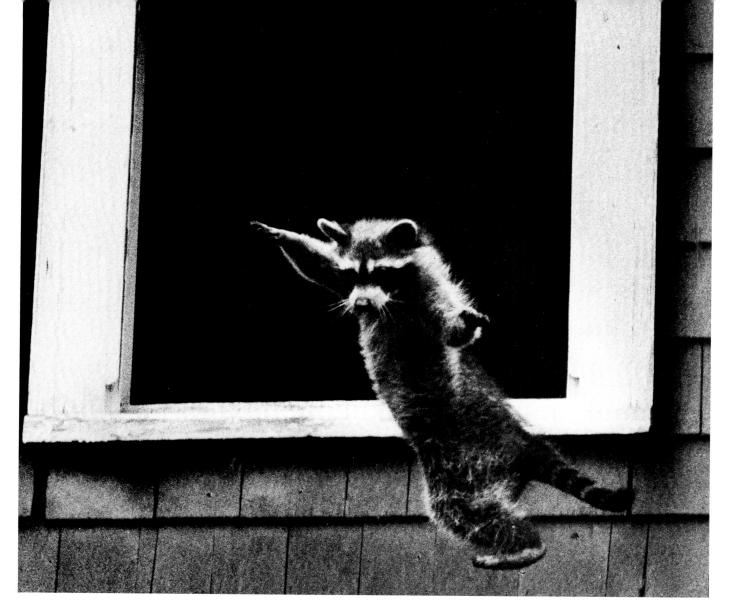

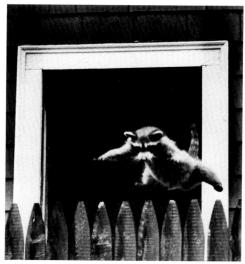

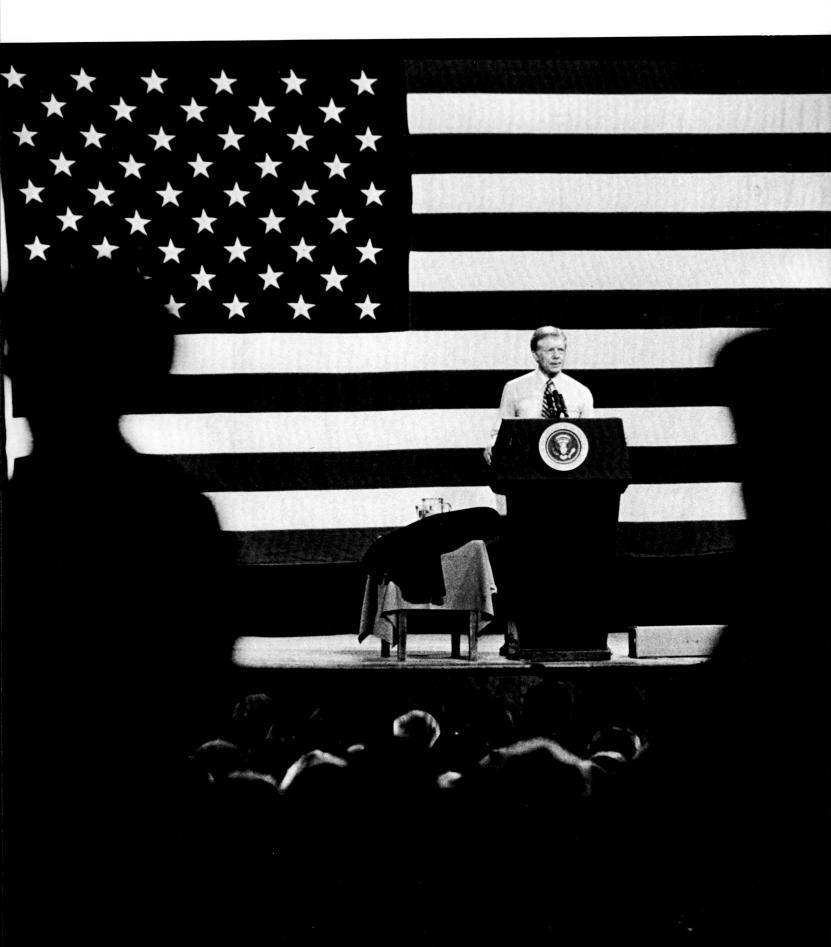

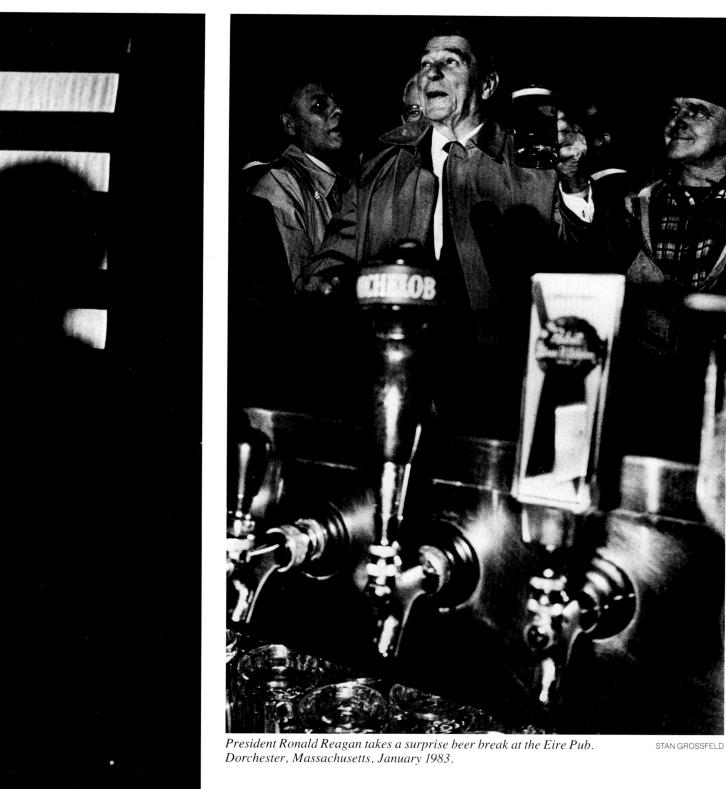

President Ronald Reagan takes a surprise beer break at the Eire Pub.
Dorchester, Massachusetts, January 1983.

STAN GROSSFELD

Opposite: President Jimmy Carter addresses an audience
at Portsmouth High School. New Hamsphire, April 1979.

TOM LANDERS

213

This is the story of three cats who were saved by a whisker.

Puffs of white smoke were pumping out of the windows at Princeton and Meridian streets in East Boston, when George Rizer arrived at the fire. Rizer is a spark, someone who enjoys going to fires. Any spark knows that white smoke means that a fire is either pretty much out, or just starting to cook. Black smoke means a fire is gathering strength. Rizer parked his car on a street perpendicular to the fire site so he wouldn't get boxed in by fire apparatus responding to a multiple alarm. No matter how good a picture is, it won't make edition unless the photographer gets it back. Residents were milling about talking to firefighters when they started bringing the lifeless cats out of the building.

"First they brought out a marmalade and then a tabby stripe, then perhaps an angora, then a mongrel," Rizer said. "Cats are like children; when there's a fire they hide in the closet."

With a touch both delicate and caring, two firefighters laid the cats down on the sidewalk. None of them was breathing. Lynn Bradley, the cats' owner, came home and was very upset. She asked the firefighters to give her cats oxygen. While they were getting ready, Bradley, a nurse, started thumping the cats' chests. Nothing. She got down on her hands and knees and gave one of the cats mouth-to-mouth resuscitation. The cat stirred.

Rizer put on a 35-mm lens and found the best angle, smack dab in the middle of a puddle. He squatted down to keep the background as uncluttered as possible. Fortunately for him it was a cloudy day, so the light was soft and even. He exposed his film at f/5.6 at 1/500 second. The nurse and a firefighter managed to revive all the cats, except for the marmalade.

The next day's paper used the photo spread on pages one and two. Rizer, Lynn Bradley, and the firefighters all received letters from cat lovers across the country. "It never struck me as unique," said Rizer. "I own a cat and I'd do the same thing myself."

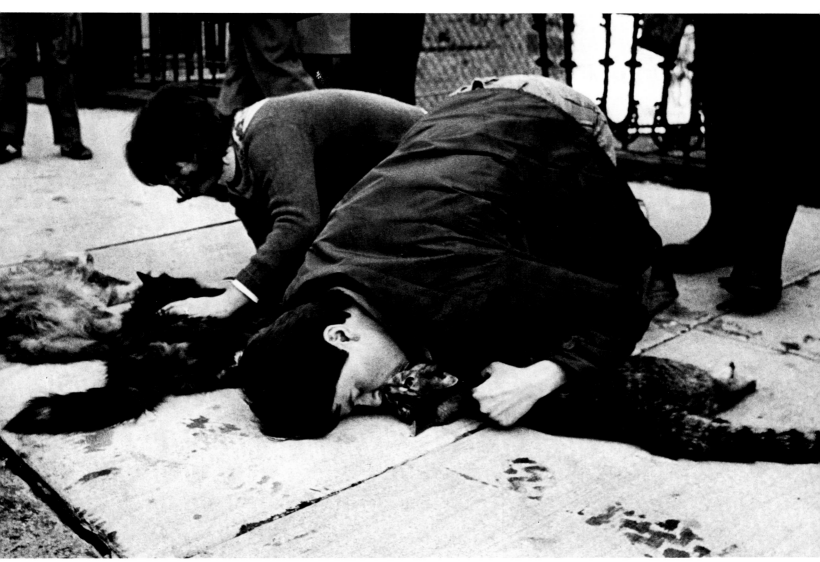

GEORGE RIZER (3)

215

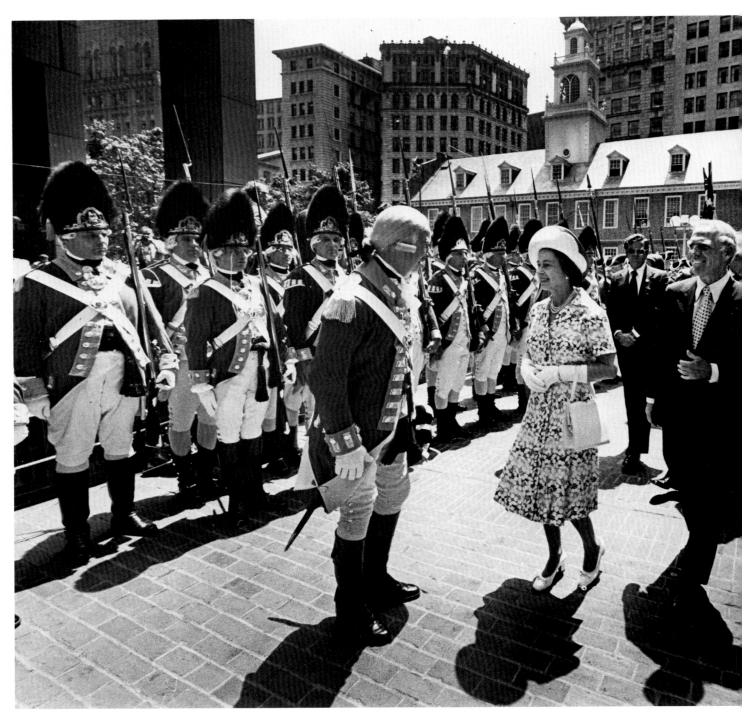

Mayor Kevin White escorts Queen Elizabeth around town during her Bicentennial visit. Boston, 1976.

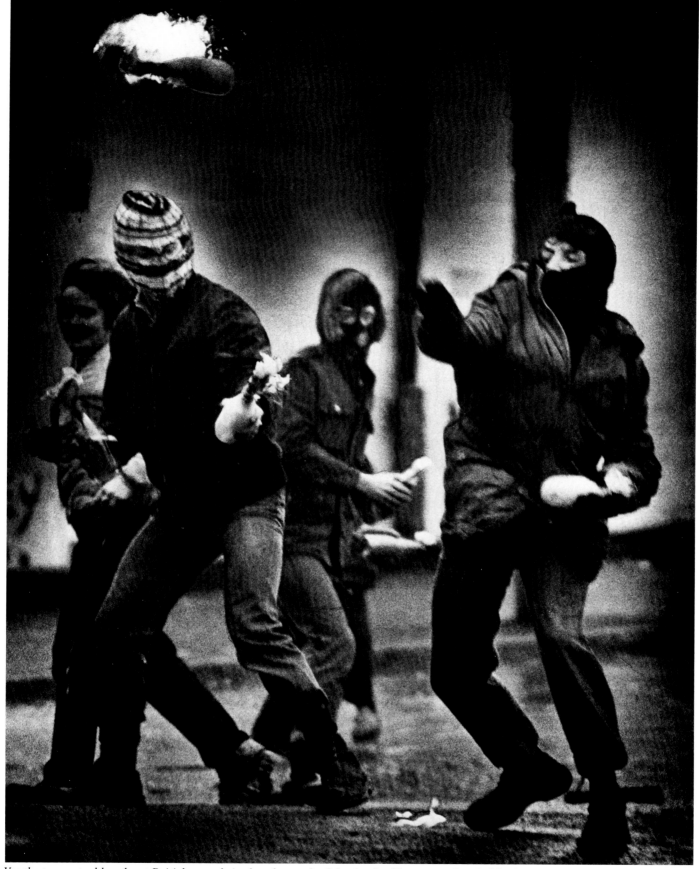

Youths toss petrol bombs at British patrols in the aftermath of the death of hunger striker Bobby Sands of the Irish Republican Army. Belfast, Northern Ireland, December 1981.

STAN GROSSFELD

217

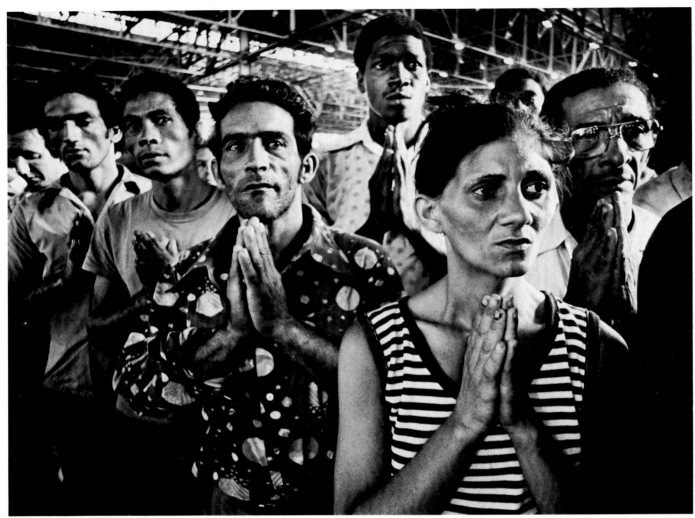

Cuban refugees pray after arriving in the United States on the Freedom Flotilla. Key West, Florida, May 1980. Stan Grossfeld

Opposite: An Ethiopian mother comforts her son in a refugee camp on the Sudan-Ethiopia border.
The child died that same day. November 1984. Stan Grossfeld

218

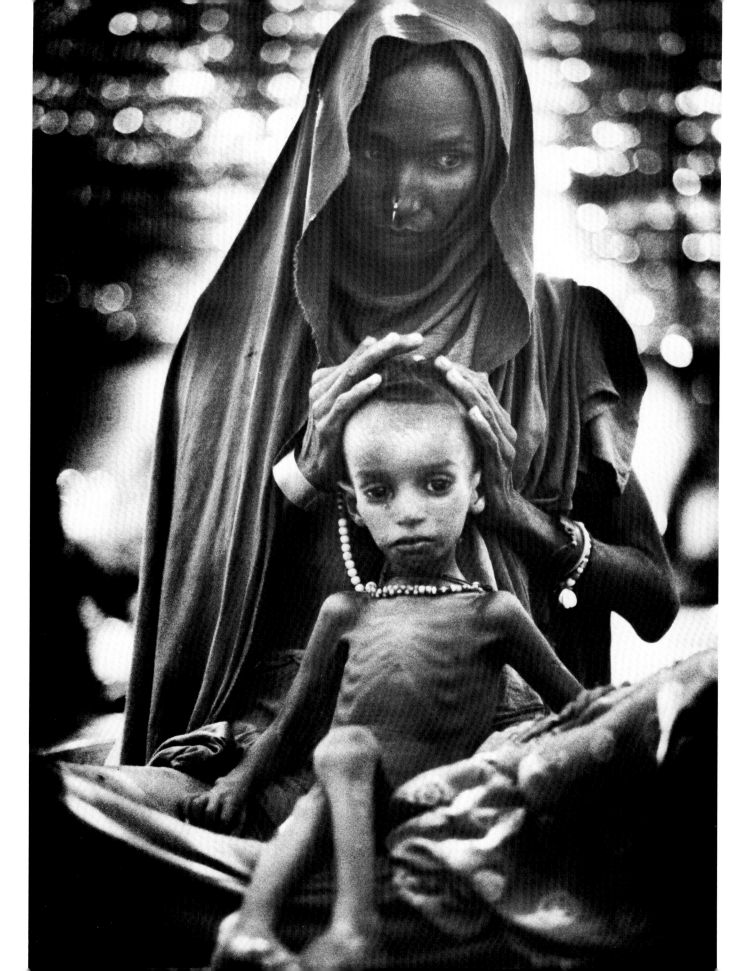

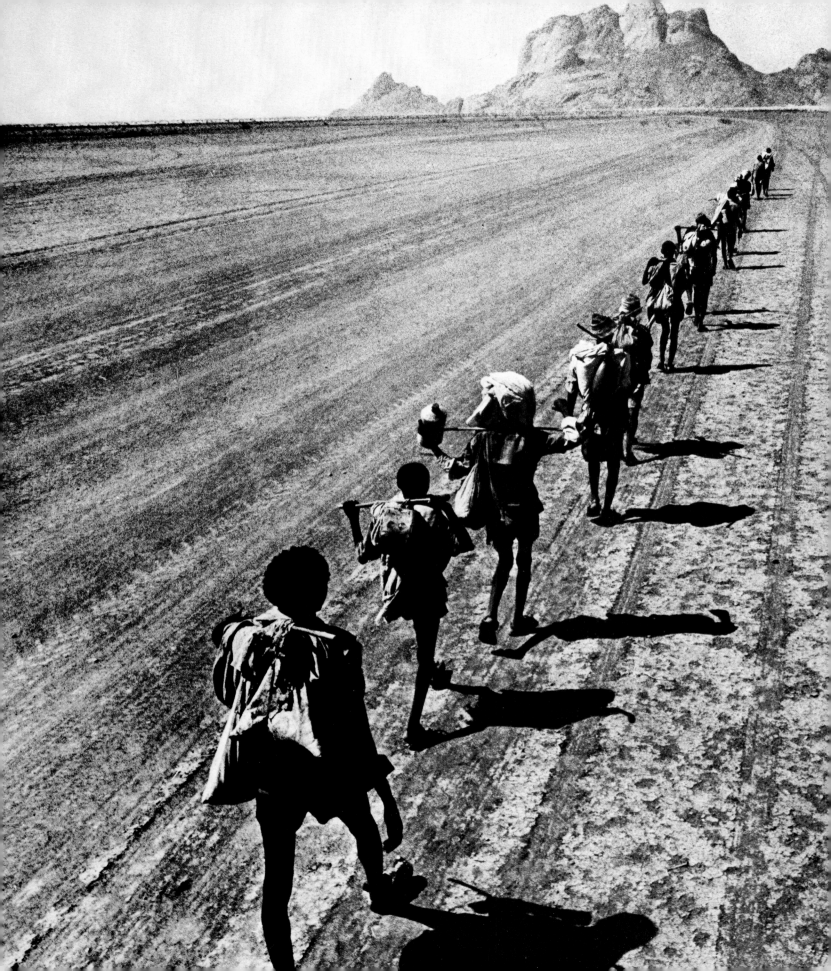

Ethiopians crossing into the Sudan to a refugee camp 180 miles from their town. Western relief officials say that up to 7 million people in Ethiopia are "at risk of starvation." November 1984. STAN GROSSFELD

221

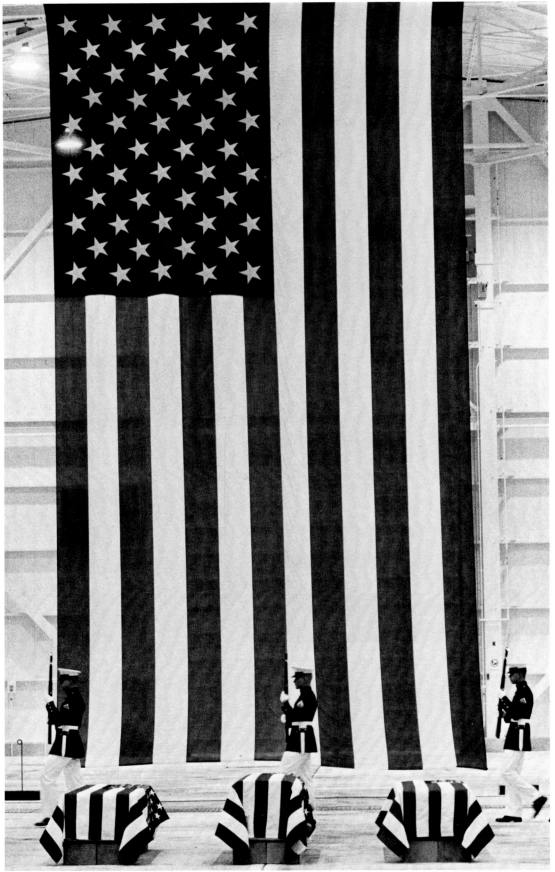

U.S. Marines honor those killed in Beirut. Dover Air Force Base, Delaware, October 1983. JIM WILSON

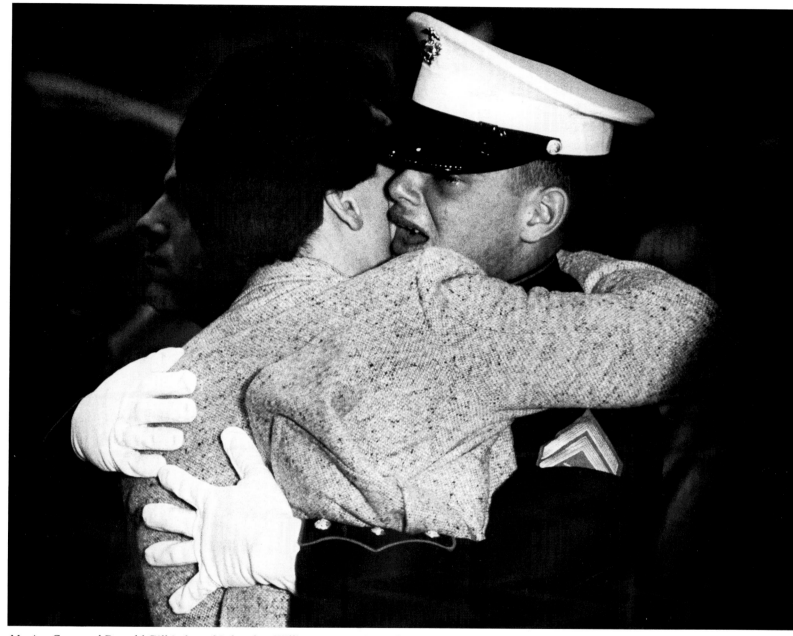

Marine Corporal Donald Gilbin hugs his brother William at a service in Dover, Delaware, for those killed in Beirut, including their brother Timothy. October 1983.

The jet nosed down to the Beirut Airport when the steward smiled and said we would land "if they're not shelling the airport."

From the window we could see a small fire burning in what I later learned were the Shouf Mountains. Behind me, *Globe* reporter Curtis Wilkie, a Middle East veteran, guzzled a full glass of cognac. I was scared. Who wanted to die in Lebanon? Especially since I had lied to my mother. My last phone call in the states had been to her. I'd told her I was on my way to Lebanon, New Hampshire.

The airport terminal windows were blown out. If the soft Mediterranean breeze blew the wrong way near the airport you could get a whiff of dead Marines. Some of the bodies were still trapped in the wreckage of the headquarters blown up by a terrorist truck bomb.

Rebecca Trounson, the *Globe*'s Beirut correspondent, met the plane. She took us through this once-elegant city to the Commodore Hotel, where the foreign press hangs out. We debated whether to get the rooms on the side of the building where you had to worry about car bombs exploding, or the side that could leave you vulnerable to rocket fire. A year earlier Trounson's living room had been hit by an artillery shell; some Beirut dwellers use pieces of shrapnel as ashtrays and umbrella stands.

Near the Commodore Bar a parrot whistled a morbid imitation of incoming artillery shells. T-shirts offered slogans like "Begin and the Jets' Spring Tour 1982." Curfew was 8:00 p.m. for everyone but the press. Even if you were press, there was no place to go. The streets were dark. Electricity ran only six hours out of twenty-four. It was a movie set for the end of the world.

Midway between downtown Beirut and the U.S. Marines' airport headquarters are the Sabra and Shatilla refugee camps. The graves of those massacred there were marked only by a black flag near a field where a worn wreath lay tangled in some brush.

In a ramshackle hut, a woman muttered softly in Arabic as she showed me photographs of her husband and eldest son, killed when Christian Phalangist militiamen went on a three-day rampage in September, 1982. They killed at least three hundred refugees. As the woman talked, her surviving son clutched her leg in fear. She feared the Phalangists would return when the French and Italian multinational forces pulled out of the camps.

In the dusty red Lebanese soil, two emaciated roosters battled, egged on by a small group of refugees who drowned their misery in the newfound suffering of the fighting cocks. There was the obscene chatter of small-arms fire in the distance. Judging from the faces of those entranced by the cockfight, the firing could safely be ignored.

One of the men stepped between the tiring birds and scooped up the rooster that had taken the worst of the battle. He placed it over the winning rooster's neck and let it peck, peck, peck. It was sickening, but that's the lesson of Lebanon. Even the guy who wins, loses. The gunfire in the distance died out as abruptly as it began. Nobody else seemed to notice.

When the war instensified between pro-Arafat PLO fighters and Syrian-backed guerrillas in Tripoli, Wilkie and I took a two-hour cab ride to the front. It sounds crazy that you have to take a taxi to the war, but that was how a lot of journalists commuted to the fighting. It was expensive, but you needed a driver to speak Arabic and get through the

checkpoints with minimum hassle.

You had to run a gauntlet of checkpoints, maybe a dozen each way, manned variously by the French, a Communist splinter group, Syrians in their bumblebee yellow uniforms, PLO fighters, and different Lebanese militias. Each trip was a trip.

In Tripoli we stopped outside the Islamic hospital. The city had been hit by rockets probably meant for the pro-PLO camp at Baddawi. Many civilians had died. One man grabbed me. Speaking excitedly in Arabic, he took me up the hospital driveway to a set of double doors barred by a wooden fencepost. A crowd gathered. My escort unbolted the door, and the crowd surged forward. I squeezed off a frame on instinct before I realized what lay before me. For one paranoid moment I thought they were going to throw me into what I realized was a makeshift morgue. The room held dead bodies, and pieces of bodies. Chunks of ice melted on the floor.

The crowd was angry, but not at me or Wilkie. They wanted visitors from the outside world to see what this dreadful shelling was doing to children. The first thing I saw was the body of a little girl, maybe four years old. She looked as if she might have been playing in a sandbox, lying there in a dress, dirt or dried blood on her face. To this day I have only to shut my eyes and I can call up that girl's face.

The stench was overwhelming. Someone gave me a paper mask. Those who didn't have masks to cover their faces held their noses. That was the picture my instincts told me to shoot. But to get that shot, in relation to the bodies, meant I had to climb over or around the dead.

Revolted by what I saw, nauseated by what I smelled, I forced myself to think of f-stops and shutter speeds. I decided

on the ultra-wide-angle 18-mm lens. It would emphasize the foreground. I tried to think in terms of what they teach you in photography classes: "dominant foreground," even if the foreground is a pile of corpses. I needed depth of field to get everything sharp. F/11 would give me enough depth. I would have to hand-hold a 1/8-second exposure time. That meant having to hold the camera rock-steady while the shutter yawned open. I cleared my mind of the horror inside the viewfinder, took a deep breath and squeezed off a few frames. That night I started having trouble sleeping.

The next day two carloads of journalists went into Tripoli. Should we try to go to Baddawi under siege and search for PLO Chairman Yasser Arafat? Our car voted to go for it, the other turned back. The sound of Katusha rockets, voomvoom, going outbound from a clump of orange groves toward the Syrian-held hills, made us nervous. An oil refinery just outside Baddawi burned out of control, casting a brooding sky over the camp.

We spotted Arafat in a white Land Rover, trailed by a stream of journalists. We tagged along. Wilkie was used to a gaggle of journalists following a politician; he'd covered the Carter White House. Nor is he intimidated by big shots; he once collided with President-elect Carter in a softball game while going for an infield fly in Plains, Georgia.

We jostled for prime position in front of Arafat, whose bodyguards are slightly more physical than the U.S. Secret Service. In the ensuing scuffles to get pictures, my Red Sox baseball cap fell to the ground. Arafat's entourage walked all over it. Wilkie, a longtime Bosox fan, got it back for me.

Later that day, we were watching outgoing rocket fire. A man ran to me,

drawn by the cap. "Zee Red Sox," he said in a French accent. "Zee Red Sox, zay do not have zee pitching. Zis Eckersley" The man's voice was drowned out by the sound that might have been home runs rocketing out of Fenway.

It's a small world. A man in Tripoli bemoans the Red Sox pitching, and the next day my sister Sandy back in New York sees television network film of my flat feet running down the street in Tripoli chasing Arafat.

She called the *Globe*, demanding to know where I was. They followed my what-to-do-if-relatives-call ruse; he's still in New Hampshire. Sensing fraud, she went to the out-of-town newsstand in Times Square. The credit line under the *Globe*'s front-page photograph gave me away. When I got back to the Commodore that night there was a note waiting: "The jig is up." Next day I went to Baddawi for the last time.

It was raining, which was good. Rain meant less shelling. There was supposedly a cease-fire. Associated Press photographer Don Mell and reporter Arlene Powell, six armed PLO fighters, and I entered the camp the PLO had first lost and then recaptured. Women and children huddled in candlelit basement shelters. Ten-year-old boys carried Soviet-made rifles as casually as if they were ice cream cones. The rain stopped; the shelling resumed. We were in the middle. Syrian-backed rebels were in front of us, shelling mostly in the direction of Tripoli. And Tripoli fired back. Unfortunately, many of the shells were falling short. I wanted out. Shoot and scoot. Arlene wanted out. Mell wanted to stay.

The shelling got closer. My throat was parched. I saw an open door and a counter with some lollipops. I put down a

Lebanese pound for the shopkeeper and took two cherry lollipops. A shell exploded well behind us as I scampered back onto the street. Now I really wanted out.

The woman from the shop ran after me, yelling in Arabic. She handed me a third lollipop. Something in Lebanon finally made sense—three lollipops for a pound.

Another shell exploded, maybe a little closer. Armed PLO fighters carrying suitcases in one hand and rifles in the other were on their way out. They were in no mood to be photographed. One PLO gunman pulled out a big rusty knife, looked at us, and slowly passed the blade close to his throat. I smiled, preferring my Good News Gillettes to his Bad News Blades. Paranoia set in. We had to leave at once.

It was chancy to walk the last hundred yards out of Baddawi because there were no buildings or shelters, just a muddy hill. I thought about Ollie Noonan. I never knew him, only his work. I thought of how he had died in Vietnam, and the wire story: ". . . the fog lifted when they buried Ollie Noonan." None of that for me, thank you. His parents on Campobello Island had welcomed me like a son. His father told me later how he'd wakened one night in a cold sweat, worrying about me.

An old man wailed the Islamic call to prayer. Bang, photo by instinct. "Hey, Ollie," I said to myself. "Sure could use a little rain." With the refinery fire burning for days, you couldn't tell whether the sky was black with rain clouds or smoke. I checked my camera to see how many frames I had left out of the roll of thirty-six. A raindrop skidded across the face of the skylight filter protecting my 18-mm lens. Another one went splat. Then it poured.

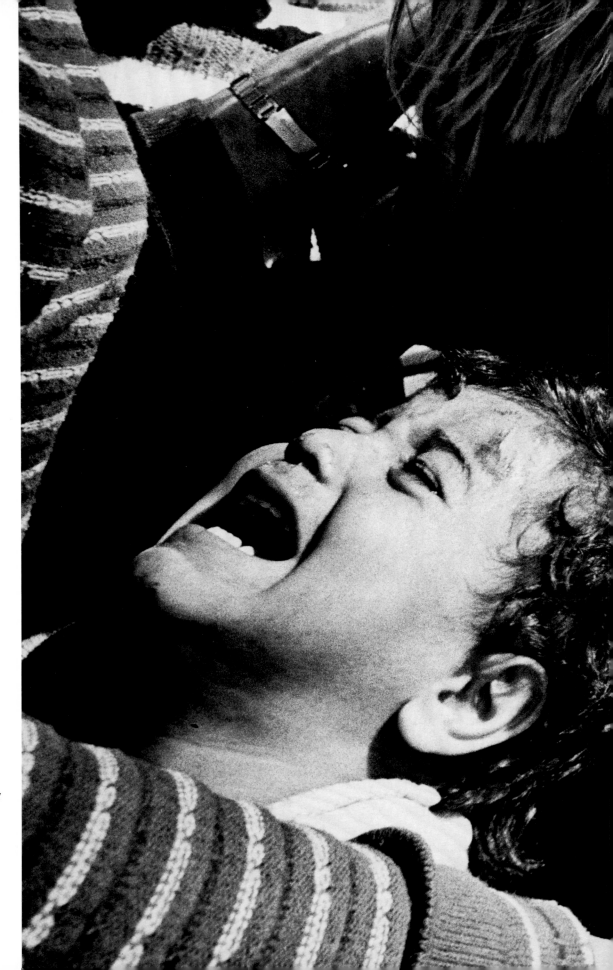

*Palestinian children
frightened by shelling
are evacuated
into trucks.
Tripoli, Lebanon,
October 1983.*
STAN GROSSFELD

226

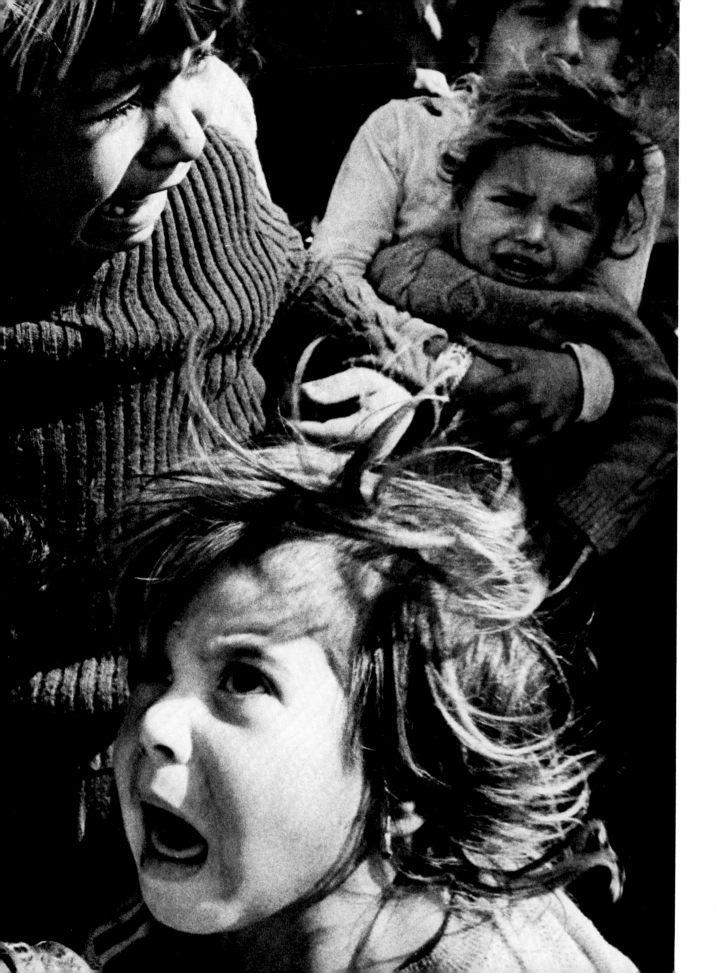

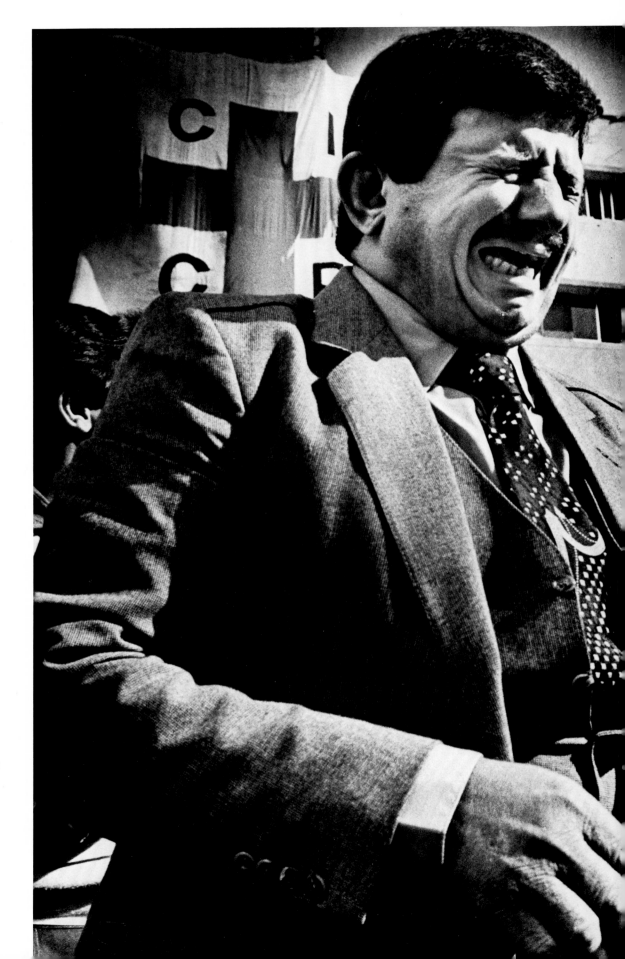

*Man weeps
moments after
identifying the body
of his wife.
Her coffin is
atop his car.
Tripoli, Lebanon,
November 1983.*
STAN GROSSFELD

228

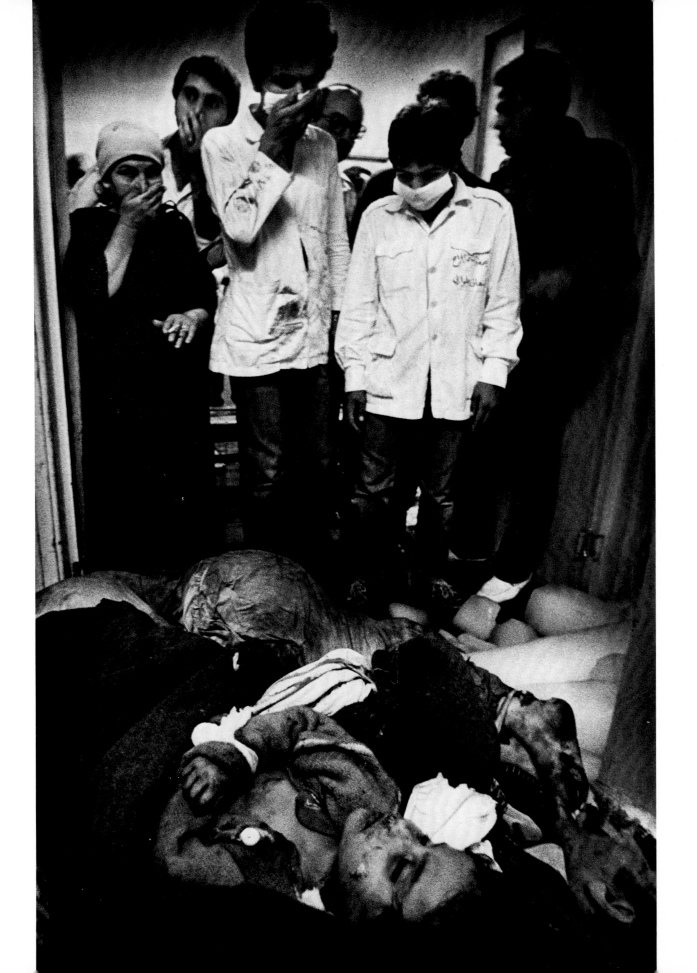

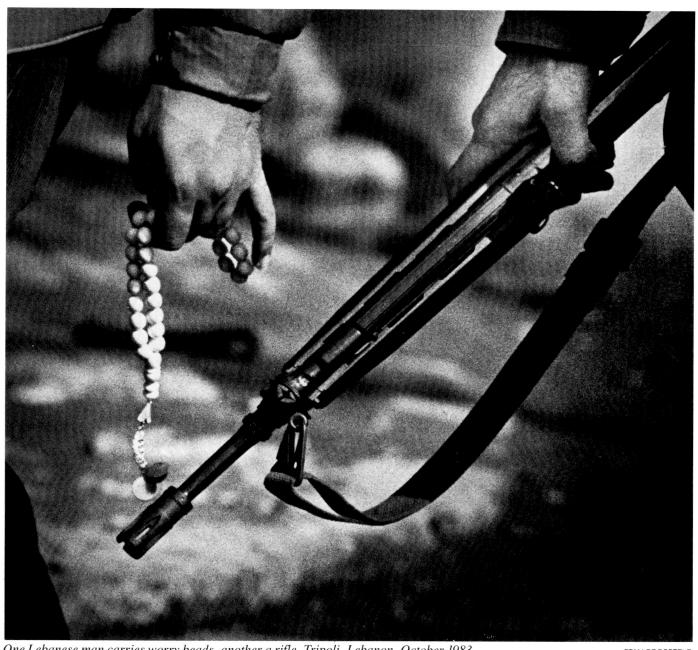

One Lebanese man carries worry beads, another a rifle. Tripoli, Lebanon, October 1983. STAN GROSSFELD

Opposite: Civil war victims are piled on ice in makeshift morgue. Tripoli, Lebanon, November 1983. STAN GROSSFELD

Biographies

Before he was old enough to get his driver's license, **John Blanding** used to hitchhike around his hometown of Gloucester, Massachusetts, covering photo assignments for the *Daily Times*. He attended Rochester Institute of Technology for two years before graduating from Boston University. Blanding has been on the *Globe* staff since 1979. He has covered everything and anything from busing in South Boston to manatees in southern Florida. He is an underwater photography specialist. In 1985 he received the Ramsdell Trophy for spot news photography.

William Brett was born in Dorchester, Massachusetts. He is a graduate of Boston Technical High School and Franklin Institute of Photography.

He started as a newsboy hawking *Boston Globes* on a Dorchester street corner. He started working part-time at the *Globe* when he was 17, and he joined the staff a year later. In 1977, Brett became chief photographer, and in 1983, Director of Photography. During this time he won numerous first-place awards from the Boston Press Photographers Association, United Press International (UPI), and Associated Press (AP).

Bill lives in Hingham, Massachusetts, with his wife, Ginny, and four children, Kerri, Megan, Timothy, and Erin.

Jim Bulman joined the *Globe* staff in 1981 as a darkroom technician, after working part-time at the *Globe* for two years. Driving to work his first week on the job, he heard a call for an explosion in Holbrook, Massachusetts, and his pictures landed on page one the next day.

Jim works nights and is able to handle lots of assignments in time to meet the 9:00 p.m. first edition deadline. Says Jim, "It can be a lot of pressure and frustration, but in the end everything works out okay."

Charles B. Carey, who covered the Brink's robbery in 1950, says he was afraid to put his camera bag on the money-strewn floor for fear the police would get the wrong idea and arrest him. He joined the *Globe* in 1946 and has won many honors, including the *Look Magazine* Award for Sports Photography. Carey retired from the *Globe* in 1978 and currently is building a log cabin in Amherst, New Hampshire.

Paul Connell started at the *Globe* in 1937 as an errand boy making $10.50 a week. He became hooked on photography while accompanying *Globe* photographer Paul Maguire to baseball games at Fenway Park on his free time. The *Globe* publisher at that time, William Davis Taylor, was struck by Connell's enthusiasm and loaned him the money to purchase his first 4x5 Speed Graphic. The move paid off. Connell spent 36 years as a *Globe* staff photographer until his retirement in 1982.

Paul has won over one hundred awards, including numerous UPI and AP awards. He has won the Boston Press Photographers Association's Photographer of the Year award four times. He also has won four times the Region One Photographer of the Year award from the National Press Photographers Association.

William Curtis, a Boston native, became interested in photography while he was a student at Boston University. He received his journalism degree from the University of Massachusetts at Amherst and joined the *Globe* staff in 1972. He has taught photography at the University of Massachusetts and at Cambridge (Massachusetts) Alternative Public School. He also has been an actor, a disc jockey, and a play director.

After resigning from the *Globe* in 1982, Curtis relocated to Colorado.

Bob Dean has been a staff photographer for the *Globe* since 1960, and assistant chief photographer since 1977. A Boston native, he first became interested in photography when he was working on a Boy Scout merit badge.

He started with the Associated Press as an office boy. Once he was sent to Cardinal Cushing's residence to pick up film of the Cardinal's meeting with President Truman. There was no film to pick up, however, because the meeting was closed to the press. A determined Dean walked past Secret Service agents who thought he was a theology student and right into the meeting. The President obliged his request and the wire services carried the picture and story of how an office boy scooped the national press corps. Dean worked at a Maine television station as a staff cameraman for five years before joining the *Globe*.

Bob has been named New England Photographer of the Year on two occasions and has won over twenty-six first prizes from the Boston Press Photographers Association, AP, and UPI.

In 1956 **Joe Dennehy** worked as an office boy to the publisher of *The Boston Globe*. He transferred to the photo department in 1958 as a darkroom technician. Dennehy joined the staff as a full-time photographer in 1961. As assistant chief photographer in 1973, he designed the *Globe*'s photo lab. Today, he also serves as chairman of the Board of Trustees of *The Boston Globe*'s employees' pension plan.

Charles Dixon was a staff photographer for the *Globe* from 1939 to 1979, except for four years when he served as a senior photographic officer in the European theater of World War II. Dixon currently conducts tours of the *Globe*, and at Christmas moonlights as *Globe* Santa.

Ted Dully was in the seventh grade when he sold a picture to *The Bristol Press* (Connecticut). It showed his school principal moving into a new building. When Ted was in high school, the publisher of the *Press* would call the school and request that Ted be excused to take pictures for the paper. The publisher was also chairman of the Board of Education. Sensing a good thing, Ted has been in photography ever since.

After a stint in the Navy, Ted returned to *The Bristol Press* and worked there nine years before moving to the *Globe*. He has been a regional winner of the National Press Photographers' clip contest seven years in a row.

Danny Goshtigian joined the *Globe* in 1940 after a stint at the Associated Press. His specialty was sports but his first love was golf. Despite winning many awards for his photos, Goshtigian believes his best shot was a hole-in-one using a three-iron on the fifth hole at Hillview Country Club in North Reading, Massachusetts, in 1960. Following his retirement from the *Globe* in 1976, Goshtigian returned to the fairways.

Stan Grossfeld received consecutive Pulitzer Prizes in 1984 and 1985 for his work in Ethiopia, at the United States–Mexican border, and in Lebanon. He won two consecutive Overseas Press Club awards, first for best photographic reporting from abroad, then for "human compassion" for his work in Ethiopia. Grossfeld, now the *Globe*'s Director of Photography, started with the *Star-Ledger* (Newark, N.J.) in 1973. Since joining the *Globe* in 1975, he has been named New England Photographer of the Year five times. He is the author of *Nantucket: The Other Season,* published by The Globe Pequot Press.

John Ioven started working part-time at the *Globe* in 1977. He joined the staff as darkroom technician a year later. He attended Malden public schools, Bunker Hill Community College, and Northeastern University, where he worked on the school newspaper for a year. His specialty is erecting portable darkrooms to transmit photos back to the *Globe* from out-of-town.

Ed Jenner joined the *Globe* staff in 1959 after working at the *Framingham News*. In 1960 he won the Graflex award — a diamond-studded pin — for spot news. In the early Sixties Jenner ran the *Globe*'s Cape Cod bureau, taking photographs and writing stories. He resigned from the *Globe* in 1979 to pursue a career as a licensed commercial pilot.

Ed Kelley was a photographer's mate in the Navy from 1943 to 1945. He joined the *Globe* in 1948 and worked until 1980. President Kennedy requested and received several Kelley photographs. The last time Kelley sent prints to the White House he made an extra print and asked Kennedy to sign it for him.

"It was November, 1963, and the President was in Dallas."

For her eighth birthday **Janet Knott** got a Brownie box camera. She loved to run around her neighborhood, photographing her friends.

A 1974 graduate of Barnard College with a degree in English Literature, Knott got her start at the *Beverly Times* (Massachusetts) when she arrived unannounced with pictures from a 1975 Rolling Stones concert that she had managed to sneak into. The *Times* didn't use the pictures, but they were impressed enough to offer her a part-time photographer's job. She joined the *Globe* staff in 1976 as a darkroom technician. Two years later she became a staff photographer.

Knott has consistently won awards from the Boston Press Photographers Association for her work.

Tom Landers comes from a photo family. His father worked at the *Globe* for thirty-eight years and his brother has worked for the *Boston Herald* for over thirty years. Landers has been a staff photographer at the *Globe* since 1966. Prior to that, he was with United Press International in Boston for four years.

During his career at the *Globe* and UPI, he has won more than twenty awards in UPI, AP, and Boston Press Photographers Association photo contests. He has covered events ranging from the 1967 and 1975 World Series and national political conventions to riots, Presidential visits, and the Tall Ships at Newport, Rhode Island.

Wendy Maeda joined the *Globe* in 1979. She worked previously at *The Winchester Star* and *The Arlington Advocate*. A 1974 graduate of Boston University, where she majored in photography, Maeda was the first woman to win the Boston Press Photographers Association's Ramsdell Trophy for spot news. The four-foot-high trophy came up to her neck.

Maeda was the only photographer to get on the runway at Boston's Logan International Airport when World Airways Flight 30 plunged into Boston Harbor. She eluded state and local police while exposing two rolls of Tri-X. All other photographers were kept

from the scene for three hours.

Sam Masotta started at the *Globe* in 1951. After working many years in different departments at the *Globe*, Sam transferred to the photo department in the early Sixties. In 1983 Sam was appointed an assistant chief photographer. His voice is familiar to anyone who listens to the *Globe*'s radio frequency.

Frank O'Brien likes to point out to his fellow workers how far he has come. O'Brien was born in St. Margaret's Hospital in Dorchester, Massachusetts, which can be seen from the windows of the city room.

He began work at the *Globe* full-time in 1958, two weeks after graduating from high school. He started as a messenger in the advertising department, later served as assistant route cashier, supply clerk, wire room chief, and then as darkroom technician. He had spent only two weeks as an inside man learning photography when he was sent out on an emergency assignment. It was February, 1964, and O'Brien has been on the street ever since.

O'Brien specialized in sports full-time, from the Red Sox Impossible Dream year of 1967 until 1983, when he returned to the tranquility of general assignment work. During that time he covered the Stanley Cup finals, the World Championships, the Olympics, and the NBA finals.

He has won many photographic awards from AP, UPI, and the Boston Press Photographers Association. In 1980 Boston University awarded O'Brien the Scarlet Quill for outstanding contribution to sports.

Of all the Boston newspaper staff photographers, **Jack O'Connell** has the most longevity. He began working for the *Globe* in 1943, while he was a junior in high school. Jack enlisted in the United States Navy in 1944, and served in the battle of Okinawa. Discharged in 1946, he joined the *Globe* full-time at the tender age of 20. He is a two-time winner of the *Look Magazine* award for Sports Photography, and winner of the AP and UPI sports contests. Jack also served as president of the Boston Press Photographers Association.

George Rizer was a summer photography intern in 1970 while he attended Boston College. Impressed by his hard work and his news sense, the *Globe* hired Rizer full-time in 1973.

Rizer has won numerous awards from the Boston Firefighters Association and the Boston Press Photographers Association. He covered Pope John Paul II's visit to Boston, the 1975 World Series, and the Great Chelsea Fire, among other assignments. He has completed the Boston City Hospital Emergency Medical Technician course. Who does he admire most? "Firefighters, cops, and EMTs."

Joe Runci has been with the *Globe* since 1949. He has won numerous awards, including first place in the Boston Press Photographers Association competition. In 1966, Joe covered the Vietnam War for the *Globe*; in addition to photographing combat, he wrote stories on the conflict.

Joe lives in the city during the week and escapes to his country farm on weekends. He is the father of two children.

David L. Ryan remembers being eight years old and crouching down low in his father's car as they responded to an armed robbery. His dad, Leroy, put in fifty years as a news photographer, and young David tagged along and changed those hot flash bulbs for him. Ryan says he learned a lot about photography "just by looking through the discarded prints in the *Globe* darkroom."

As a teenager, Ryan worked as a copy boy in the *Globe*'s sports department. His earliest published work was enterprise pictures for the financial pages that most photographers didn't want to shoot. In 1975 he covered his own college graduation from Boston College. "I didn't have time to receive my diploma. They had to mail it to me later because I had to leave for another assignment at the State House."

Ryan has been named Photographer of the Year and also has won the National Headliners Award along with AP and UPI awards.

Bill Ryerson, a *Globe* photographer since 1967, started his career in 1952 with the *Woburn Daily Times*. He was also a staff photog-

rapher for *The Winchester Star* and operated his own commercial photography business before beginning at the *Globe*.

Bill has won several awards from the Boston Press Photographers Association and the New England Press Photographers Association.

Jack Sheahan began his photography career in 1935 free-lancing for the *Globe* and three other Boston dailies. He impressed the *Globe* photo editor with an exclusive picture story of a Medfield High School girl trying out for the school's football team, and earned himself a staff position. His specialty was people pictures, and his portraits earned him many awards. He retired from the *Globe* in 1975.

Dan Sheehan began his photography career at the *Boston Post* in 1945 after four years of service with the United States Army in New Guinea and the Philippines. He won his first Ramsdell trophy for Spot News with a picture of children crying as their injured mother is assisted after being involved in a car accident. After the *Post* folded, Dan moved to the *Boston Daily Record* where he won another Ramsdell trophy before joining the *Globe* in 1960.

About his *Globe* position, Dan says, "I always told people I'd finally made it to Heaven." He has spent twenty-two of his twenty-four years at the *Globe* on the midnight shift, earning the title "Captain Midnight." He has covered everything from floods and fires to Presidential train tours and the Brink's robbery. Dan says, "When I look back over the years and think of all the friends I've made and stories I've covered, I know that life could never be more interesting." Sheehan retired in 1984 to his ocean-front villa in Scituate.

John Tlumacki caught the photo bug early in life from his father, John Sr., who'd taken thousands of slides of him and his family. In high school he worked for the Bishop Fenwick High School yearbook. He graduated *magna cum laude* from Boston University (BU), earning a B.S. in communications. While at BU he started working part-time at his hometown paper, the *Beverly Times* (Mas-

sachusetts). John also worked on political campaigns, traveling across the country to photograph political candidates. Following graduation, he became United States Senator Edward Brooke's personal photographer.

In 1978 he joined United Press International as a stringer. In 1981 he started working part-time at the *Globe*. He joined the staff a year later and has won numerous photography awards since then.

Ulrike Welsch came to the United States from her native Germany in 1964. She spent her first two years in America at a camera store where she learned the English language. In 1966 she became the first female staff newspaper photographer in Boston at the *Herald Traveler*. After five and a half years, she joined the *Globe* staff, where she spent an intensive nine years.

Ulrike now enjoys extensive travel and has produced several books, including *The World I Love to See,* published by The Globe Pequot Press. In 1981, Ulrike ventured for the first time into Southeast Asia to photograph the Royal Family of Thailand aiding the hill tribes. She also took photographs within a Cambodian refugee camp. Ulrike photographs for *Time, Yankee,* and *The Yacht.*

In 1974 **Jim Wilson** borrowed his father's camera, leaned out his bedroom window, and made a picture of a tree. Although Cyril Wilson wanted his son to be a doctor, the damage was done. While studying chemistry at Salem State College, Jim became more interested in his part-time job working for the *Sunday Post* in Lynn, Massachusetts. He mixed that job with a part-time position at United Press International for a few years before landing a job at the Lynn *Daily Evening Item*. The highlight of Wilson's five-year stay was the Great Lynn fire of 1981 that he covered from the first alarm through the cleanup process. A book was later produced that featured many of Wilson's photos. Wilson joined the *Globe* staff in 1982.

In his twenty-five year *Globe* career, **Gil Friedberg** wrote a camera column entitled Camera Eye plus won many awards .

Technical Appendix

This is going to make you feel good. Even the pros make mistakes.

In October, 1948, Joe Runci got a tip that United States Speaker of the House, John McCormack, would be paying a late-night call to President Harry S Truman, who was staying in a special railroad car at South Station in Boston.

Truman's press secretary was the only one outside the President's car at the rear of the train when Runci arrived. He demanded that Runci leave "because the President is already in his pajamas and not to be disturbed." Just then House Speaker McCormack arrived and knocked on Truman's door.

"I'll be right out," Truman said.

The door opened, revealing the President of the United States in pinstriped pajamas. Runci spun around and fired his mighty 4x5 Speed Graphic. The flashbulb lit up the night. Runci left the station faster than a speeding locomotive, eluding the irate secretary. Following procedure, he stopped at the first phone available and called in to the office.

When he returned, his editors were "drooling" for the exclusive photograph. The Associated Press and United Press International also were waiting.

Runci went into the darkroom. He took out the film-holder that slipped into the 4x5. It was empty. The camera had not been loaded. His exclusive photo was to remain exclusive.

Joe Dennehy was assigned to photograph the flooded banks of the Charles River in Watertown, Massachusetts, from a helicopter. Dennehy preferred that the helicopter door be taken off before going up, because it afforded him more maneuverability and meant fewer obstacles in making the aerials. He had the pilot bank the chopper several times over the flooded area, then returned to the heliport on the *Globe's* roof with a fine set of pictures. Two hours later a man walked into the *Globe* with a small tangle of metal. It had been Joe's 500-mm lens before it had rolled out of the helicopter.

Ted Dully was covering a submarine launching when he leaned overboard to get a dramatic wide-angle photograph. Dully's $1200 walkie-talkie popped out of its belt holster and splashed into Boston Harbor. The divers retrieved it and Dully ran home, rinsed off the saltwater, and put the walkie-talkie in the oven. It melted.

Photographers jockey for position as the Kennedy family break ground for the John F. Kennedy Library in Dorchester, Massachusetts, June 1977. GEORGE RIZER

236

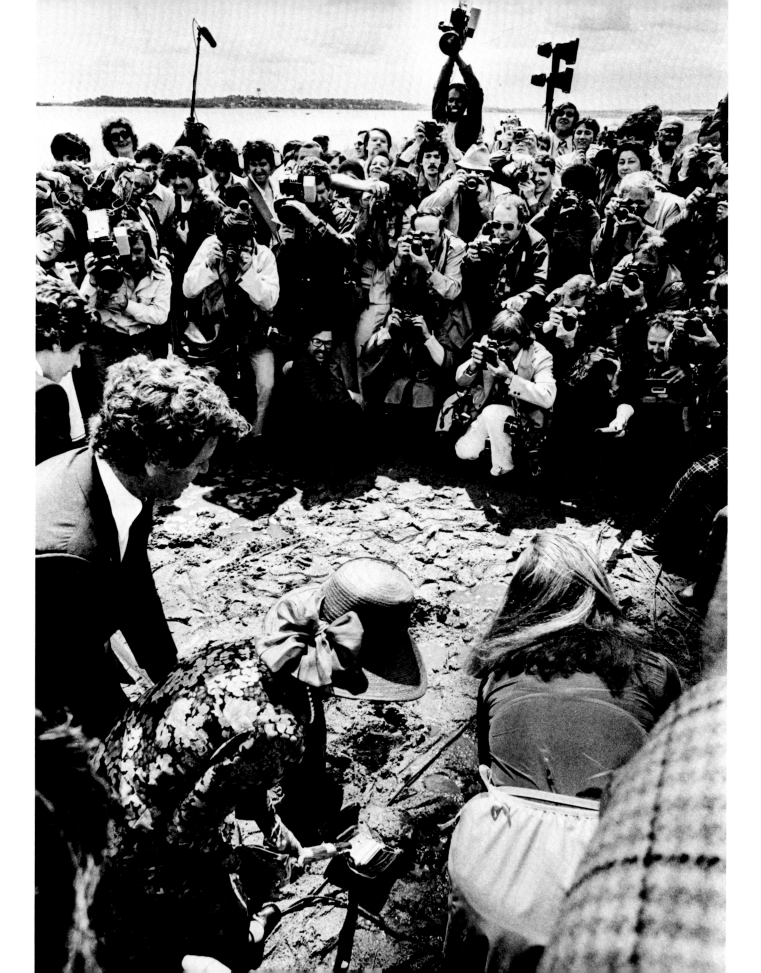

Cover: See page 10

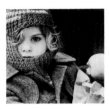

Photographer: Janet Knott
Page: 1
see page 82 for technical information

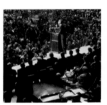

Photographer: Ed Kelly
Pages: 8-9
4x5 Speed Graphic
f/5.6 at 1/100 second

Photographer: David L. Ryan
Page: 10
18-mm lens f/22 at 1/250 second

"The statue doesn't seem very big when you get close," says Ryan, who had to get a $1 million insurance policy before being allowed to photograph the restoration of the 151-foot Statue of Liberty from angles usually left to the birds. "You take an elevator to the wrist of the upraised arm and walk down flights of stairs to the face level. What's amazing is the detail: the veins on the arm, the dimples in the elbow, the eyelids. It seems so real." The scaffold, says Ryan, "shook some in the wind." Scary? "Not bad at all. I've been on worse."

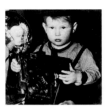

Photographer: Ollie Noonan, Sr.
Page: 12
4x5 Speed Graphic 135-mm lens
 f/11 at 1/200 second

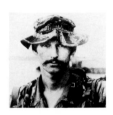

Photographer: Unknown
Page: 14
Technical information not available.

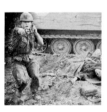

Photographer: Ollie Noonan, Jr.
Pages: 14-15
Technical information not available.

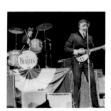

Photographer: Bob Dean
Page: 16
85-mm lens f/5.6 at 1/250 second
Dean: "In those days you were welcomed at concerts. You could move

anywhere you wanted backstage, frontstage, onstage." Today, news photographers usually are allowed to photograph only the first three songs of a big name concert. The fans shooting from decent seats actually have better opportunity to make pictures. The problem is that they usually shoot all their film duing the moody blue and red low-light songs instead of waiting for the bright white spotlights, which would allow them to shoot at f/5.6 at 1/250 second.

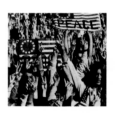

Photographer: Bob Dean
Page: 17
35-mm lens f/8 at 1/60 second with
 straight flash

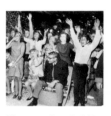

Photographer: Paul Connell
Page: 18
35-mm lens f/5.6 at 1/125 second

Photographer: Ollie Noonan, Jr.
Page: 19
Technical information not available.

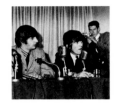

Photographer: Bob Dean
Page: 20
28-mm lens f/5.8 at 1/60 second

Photographer: Stan Grossfeld
Page: 20
85-mm lens f/1.4 at 1/15 second
 ASA 1600
The light source is a streetlight.

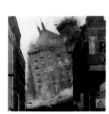

Photographer: Jim Wilson
Page: 21
85-mm lens f/11 at 1/500 second
 ASA 800

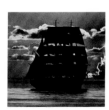

Photographer: Ulrike Welsch
Pages: 22-23
400-mm lens f/8 at 1/250 second
The camera was set on a tripod.

Photographer: John Blanding
Page: 24
24-mm lens f/16 at 1/500 second

Photographer: Stan Grossfeld
Page: 28
180-mm lens f/11 at 1/500 second

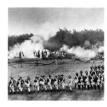

Photographer: David L. Ryan
Page: 30
300-mm lens f/5.6 at 1/1000 second

Photographer: John Tlumacki
Page: 34
500-mm mirror lens f/8 at 1/500 second

Photographer: Ted Dully
Page: 25
24-mm lens f/11 at 1/500 second

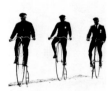

Photographer: Stan Grossfeld
Page: 29
180-mm lens f/5.6 at 1/250 second
In the darkroom, Grossfeld printed the full frame on grade 5 paper.

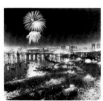

Photographer: Ted Dully
Page: 31
35-mm lens f/8 at 10 seconds
Dully set his tripod atop a Beacon Street rooftop.

Photographer: Ulrike Welsch
Page: 35
105-mm lens f/8 at 1/500 second

Photographer: Ulrike Welsch
Page: 26
180-mm lens f/2.8 at 1/250 second

Photographer: David L. Ryan
Page: 30
20-mm lens f/8 at 1/60 second
Ryan set up two strobes. One, attached to the camera with a synch cord, was aimed upward and bounced off the low ceiling. The diffuse soft light served as fill-in. The other strobe, eight feet off the camera's right, was aimed directly at the subject and served as the main light. A "slave unit," which has light detecting cells and responds to the camera-triggered strobe, was placed on the main light and made sure both strobes fired in unison.

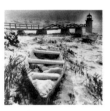

Photographer: Joe Dennehy
Page: 32
24-mm lens f/16 at 1/250

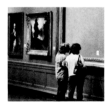

Photographer: David L. Ryan
Page: 36
85-mm lens f/2 at 1/125 second

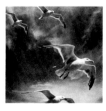

Photographer: John Blanding
Page: 27
20-mm lens f/11 at 1/500 second
A yellow filter darkened the blue sky.

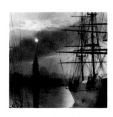

Photographer: Joe Dennehy
Page: 33
105-mm lens f/16 at 1/125 second

Photographer: Stan Grossfeld
Page: 37
18-mm lens f/4 at 1/15 second

239

Photographer: Janet Knott
Page: 38
180-mm lens f/5.6 at 1/500 second

Photographer: John Blanding
Page: 39
20-mm lens f/11 at 1/60 second
Blanding, a certified diver, climbed into the underwater tank at the New England Aquarium to make this picture. He used a Nikonos III underwater camera with a Novatek 20-mm lens adaptor mounted on his 35-mm lens. For light he used a Vivitar 283 strobe in an Ikelite waterproof plexiglas housing. He diffused the light further through a handkerchief held outside the housing. "My biggest problem was the turtles who like to nuzzle up to you," Blanding says. "I kept pushing them away but they kept coming back. Once I pushed one without looking and it turned out to be a shark."

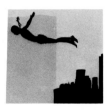

Photographer: David L. Ryan
Pages: 40-41
180-mm lens f/8 at 1/1000 second
High humidity and haze produced a flat negative. Ryan printed the picture on high contrast grade 5 paper.

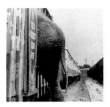

Photographer: John Tlumacki
Page: 42
300-mm lens f/11 at 1/60 second
The camera was set on a tripod. Tlumacki exposed for the buildings, and in the darkroom had to darken or burn in the overexposed moon for his final print.

Photographer: Stan Grossfeld
Page: 43
300-mm lens f/8 at 1/250 second

Photographer: Janet Knott
Pages: 44-45
135-mm lens f/5.6 at 1/500 second

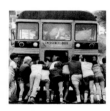

Photographer: David L. Ryan
Page: 46
24-mm lens f/11 at 1/250 second

Photographer: Joe Dennehy
Page: 47
135-mm lens f/8 at 1/500 second

Photographer: Ulrike Welsch
Page: 48
90-mm lens f/11 at 1/125 second

Photographer: Ulrike Welsch
Page: 49
200-mm lens f/8 at 1/500 second

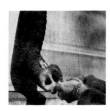

Photographer: Ulrike Welsch
Page: 50
200-mm lens f/5.6 at 1/500 second
Welsch spent extra time in the darkroom darkening, or burning in, the child's sleeve and face in the final print.

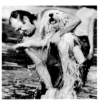

Photographer: Stan Grossfeld
Page: 51
400-mm lens f/11 at 1/250 second

Photographer: Stan Grossfeld
Page: 52
400-mm lens f/8 at 1/1000 second
In the darkroom Grossfeld printed the full frame, including the black border, on grade 5 paper for high contrast.

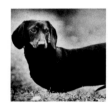

Photographer: Stan Grossfeld
Page: 53
300-mm lens f/5.6 at 1/250 second
The low camera angle created a plain and simple background.

240

Photographer: David L. Ryan
Pages: 54-55
55-mm lens f/8 at 1/500 second
Ryan chose a low angle because a silhouette works best with a clear background. An exposure reading was taken of the sky that underexposed the faces of the chimney sweeps and rendered them as silhouettes. This gave Ryan the dramatic effect he was seeking. He made his final print on high contrast paper.

Photographer: David L. Ryan
Page: 56
180-mm lens f/2.8 at 1/250 second ASA 1600
Ryan deliberately overexposed his film by one f-stop so that he could separate Kermit's black cap and gown from the black background.

Photographer: Tom Landers
Page: 57
300-mm lens f/4.5 at 1/125 second ASA 1600
Landers found some humor while most photographers were making boring head-shots of politicians.

Photographer: Ted Dully
Pages: 58-59
16-mm lens f/16 at 1/125 second
Dully prefocused his 16-mm lens and then leaned out the 58th-floor window as far as he dared, extended his arm as far as it would go, and squeezed off several frames.

Photographer: Ulrike Welsch
Page: 60
200-mm lens f/11 at 1/500 second

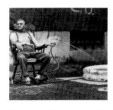

Photographer: Janet Knott
Page: 61
180-mm lens f/11 at 1/250 second

Photographer: Stan Grossfeld
Page: 62
300-mm lens f/8 at 1/500 second
The picture was shot from ground, looking up. A red filter was used to give strong cloud and sky contrast.

Photographer: Wendy Maeda
Page: 63
400-mm lens f/11 at 1/500 second
In her final print, Maeda darkened the wooded area for greater impact.

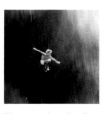

Photographer: Joe Dennehy
Page: 64
85-mm lens f/4 at 1/30 second
By panning his camera with the boy who was jumping into the quarry, Dennehy was able to blur the background while keeping the youngster's image sharp.

Photographer: Stan Grossfeld
Pages: 64-65
18-mm lens f/4 at 1/30 second
Grossfeld darkened the floor area in the final print to make the lone prisoner stand out more.

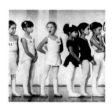

Photographer: Janet Knott
Page: 66
85-mm lens f/2 at 1/125 second

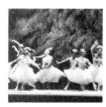

Photographer: David L. Ryan
Page: 67
180-mm lens on monopod f/4 at 1/30 second ASA 1600

Photographer: Wendy Maeda
Page: 68
18-mm lens f/16 at 1/500 second

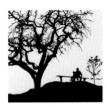

Photographer: Ted Dully
Page: 69
135-mm lens f/15 at 1/500 second
Dully took his normally exposed negative, put it in the enlarger and projected it on a 4x5 sheet of Kodalith Ortho film to build extreme contrast and obtain a positive image. He returned to the darkroom and sandwiched that positive image with another piece of Kodalith to give him a Kodalith negative. He printed the high-contrast negative normally. The Kodalith film can be safely handled under a red safelight. It drops out the midtones so you get either whites or blacks.

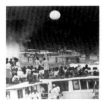

Photographer: Janet Knott
Page: 70
180-mm lens f/2.8 at 1/250 second ASA 1600

Photographer: George Rizer
Page: 71
35-mm lens f/5.6 at 1/125 second ASA 1600

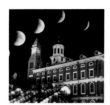

Photographer: John Tlumacki
Page: 73
See description on page 72.

Photographer: Ulrike Welsch
Pages: 74-75
28-mm lens f/5.6 at 1/60 second

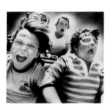

Photographer: Stan Grossfeld
Pages: 76-77
18-mm lens f/16 at 1/250 second
The photo was made riding backwards on the roller coaster with a motor-driven camera and wide-angle lens prefocused at 2 1/2 feet. Grossfeld fired a burst of film as he went down the big hill, holding on for dear life. The results: First frame—sky, second frame—Grossfeld's left leg, third frame—scared kids.

Photographer: Janet Knott
Page: 78
180-mm lens f/5.6 at 1/125 second ASA 1600

Photographer: John Tlumacki
Page: 78
135-mm lens f/5.6 at 1/250 second

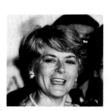

Photographer: David L. Ryan
Page: 78
180-mm lens f/4 at 1/125 second

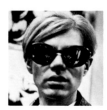

Photographer: Gil Friedberg
Page: 78
50-mm lens f/4 at 1/60 second

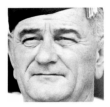

Photographer: Ollie Noonan, Jr.
Page: 79
Technical information not available.

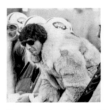

Photographer: Frank O'Brien
Page: 79
300-mm lens f/5.6 at 1/500 second

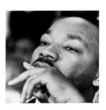

Photographer: Bob Dean
Page: 79
180-mm lens f/2.8 at 1/250 second

Photographer: Janet Knott
Page: 79
85-mm lens f/2.8 at 1/250 second

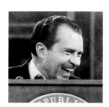

Photographer: Paul Connell
Page: 80
135-mm lens f/2.8 at 1/500 second

Photographer: Ulrike Welsch
Page: 84
20-mm lens f/8 at 1/250 second

Photographer: Jim Wilson
Page: 87
85-mm lens f/2.8 at 1/15 second
 ASA 1600

Photographer: David L. Ryan
Page: 92
85-mm lens f/4 at 1/125 second
 ASA 800

Photographer: Paul Connell
Page: 81
35-mm lens f/5.6 at 1/250 second

Photographer: Ted Dully
Page: 85
55-mm macro lens f/11 at
 1/250 second

The queen bee was placed on the
woman's face, and the whole colony
followed her scent. The woman was
not stung, but Dully, inching closer to
fill the frame, was.

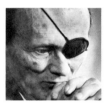

Photographer: George Rizer
Page: 88
180-mm lens f/4 at 1/250 second
By filling the frame, Rizer produced
this dramatic candid portrait.

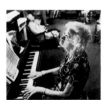

Photographer: David L. Ryan
Page: 93
24-mm lens f/4 at 1/125 second
 ASA 1600

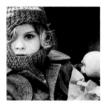

Photographer: Janet Knott
Page: 82
180-mm lens f/5.6 at 1/250 second

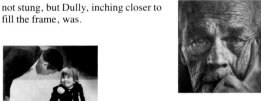

Photographer: George Rizer
Page: 86
180-mm lens f/2.8 at 1/250 second

Photographer: Janet Knott
Page: 89
85-mm lens f/1.4 at 1/60 second
 ASA 1600

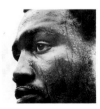

Photographer: Paul Connell
Page: 94
500-mm lens f/8 at 1/250 second

Photographer: Stan Grossfeld
Page: 83
135-mm lens f/8 at 1/125 second

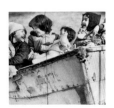

Photographer: Stan Grossfeld
Pages: 90-91
300-mm lens f/16 at 1/250 second

Photographer: Jack Sheahan
Page: 95
135-mm lens f/11 at 1/250 second

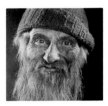

Photographer: Janet Knott
Page: 96
24-mm lens f/5.6 at 1/500 second
In making the print, Knott darkened the sky area by about 300 percent to obtain good tonality and detail in the bright colors.

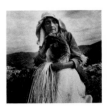

Photographer: Ulrike Welsch
Page: 97
90-mm lens f/5.6 at 1/125 second

Photographer: Ulrike Welsch
Page: 98
105-mm lens f/11 at 1/500 second
Welsch climbed a wooden plank onto a low roof to gain elevation. The 105-mm lens gave her just the right composition. In the original negative there was a car parked on the street, above the sculpture's head. Welsch dramatically darkened the final print to eliminate the distracting elements.

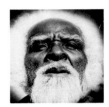

Photographer: Paul Connell
Page: 99
105-mm lens f/8 at 1/250 second

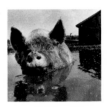

Photographer: David L. Ryan
Page: 100
24-mm lens f/5.6 at 1/500 second
On a hot July day, David Ryan used a 24-mm lens and a long blade of grass to tease the pig into camera range.

Photographer: Stan Grossfeld
Page: 101
80-mm lens f/5.6 at 1/250 second
The photograph was made in open shade.

Photographer: Frank O'Brien
Page: 103
300-mm lens f/5.6 at 1/500 second
 ASA 1600
Frank O'Brien tries to "yank the guts

out of a picture." He shot the 1980 victory of the United States Olympic hockey team over the Soviets with a 300-mm lens from high above center ice. U.S. goalie Jim Craig kept the Russians from scoring any points in the last 37 minutes of the game, thus preserving the 4-3 score.

As the final siren sounded, O'Brien spied defenseman Jack O'Callahan of Boston's Charlestown section celebrating the Cold War victory atop teammate Mike Ramsey. The Associated Press processed O'Brien's film on deadline and transmitted an uncropped horizontal print as its lead jubilation picture. O'Brien recropped the picture vertically as it appears on page 103.

Photographer: Paul Connell
Page: 104
135-mm lens f/8 at 1/500 second

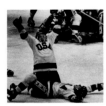

Photographer: Paul Connell
Page: 105
35-mm lens f/16 at 1/250 second

Photographer: Frank O'Brien
Page: 106
300-mm lens f/2.8 at 1/500 second
 ASA 1600

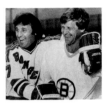

Photographer: Frank O'Brien
Page: 107
85-mm lens f/5.6 at 1/250 second
 ASA 800

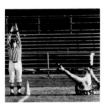

Photographer: John Blanding
Pages: 108-109
300-mm lens f/8 at 1/1000 second
Another photographer walked in front of Blanding just as the touchdown pass was caught. This picture is the frame after.

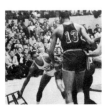

Photographer: Paul Connell
Page: 110
50-mm lens f/2.8 at 1/500 second
 ASA 1600

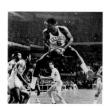

Photographer: Dan Goshtigian
Page: 111
35-mm lens f/4 at 1/500 second
 ASA 1600

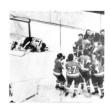

Photographer: Frank O'Brien
Pages: 114-115
180-mm lens f/4 at 1/500 second
 ASA 1600

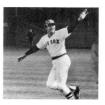

Photographer: Frank O'Brien
Page: 120
180-mm lens f/4 at 1/500 second
 ASA 1600
O'Brien resisted the temptation to fol-
low the ball and made a motor-driven
series of the Red Sox catcher "direct-
ing" the ball into fair territory.

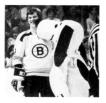

Photographer: Frank O'Brien
Page: 123
180-mm lens f/2.8 at 1/500 second
 ASA 1600

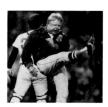

Photographer: Frank O'Brien
Page: 112
300-mm lens f/2.8 at 1/1000
 second ASA 1600

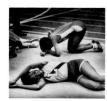

Photographer: John Tlumacki
Page: 116
85-mm lens f/2.8 at 1/250 second
 ASA 1600

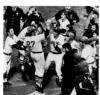

Photographer: Tom Landers
Page: 121
300-mm lens f/4.5 at 1/500 second
 ASA 1600

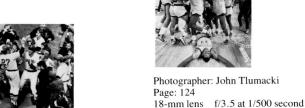

Photographer: John Tlumacki
Page: 124
18-mm lens f/3.5 at 1/500 second

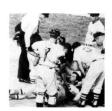

Photographer: Charlie Carey
Page: 113
200-mm lens f/5.6 at 1/500 second

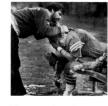

Photographer: Janet Knott
Page: 117
180-mm lens f/2.8 at 1/250 second

Photographer: Frank O'Brien
Page: 122
180-mm lens f/5.6 at 1/500 second
Sometimes the best picture in sports is
not action. O'Brien used a telephoto
lens to condense the snowflakes. He
printed the negative full frame.

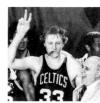

Photographer: Frank O'Brien
Page: 125
180-mm lens f/8 at 1/500 second
 ASA 1600

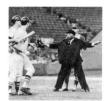

Photographer: Dan Gostigian
Page: 113
200-mm lens f/11 at 1/500 second

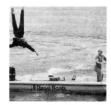

Photographer: John Tlumacki
Pages: 118-119
300-mm lens f/5.6 at 1/1000
 second

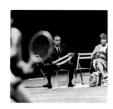

Photographer: Paul Connell
Page: 126
105-mm lens f/2.8 at 1/250 second

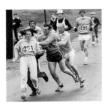

Photographer: Paul Connell
Page: 127
135-mm lens f/5.6 at 1/250 second
Editor's note: Kathy Switzer, 20, became the first woman to run "officially" in the Boston Marathon in 1967. She had a college friend take the physical and enter her in the race as K. Switzer of the Syracuse Striders. She finished the course in 4 hours 20 minutes, but officials refused to place her in the standings. In 1972, the Amateur Athletic Union sanctioned marathons with both men and women, and by 1973 the Boston Marathon was open to women.

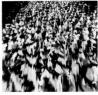

Photographer: Stan Grossfeld
Page: 128
24-mm lens f/22 at 1/30 second
The picture was taken from a cherry picker hovering twelve feet above the road. The background of lawns and trees was darkened in printing for impact.

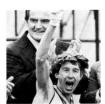

Photographer: Bill Brett
Page: 128
400-mm lens f/11 at 1/500 second

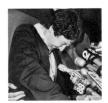

Photographer: Stan Grossfeld
Page: 129
28-mm lens f/8 at 1/60 second
Press conferences are usually well lighted by television lights, but when Rosie Ruiz sobbed into the microphones her face was in deep shadow. Grossfeld was ready with a small strobe.

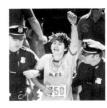

Photographer: Bill Brett
Page: 129
180-mm lens f/11 at 1/500 second

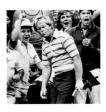

Photographer: John Blanding
Pages: 130-131
80–200-mm lens f/5.6 at
 1/1000 second

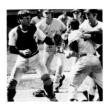

Photographer: Dan Gostigian
Pages: 132-133
200-mm lens f/11 at 1/500 second

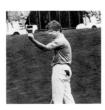

Photographer: Paul Connell
Page: 134
135-mm lens f/8 at 1/1000 second

Photographer: Stan Grossfeld
Page: 135
300-mm lens f/11 at 1/500 second
The cardinal rule of photographing golf is to wait until the golfer makes contact; anything after that is fair game.

Photographer: Frank O'Brien
Page: 136
180-mm lens f/2.8 at 1/250 second
 ASA 1600
Most photographers shot from ring-side, but O'Brien went to a balcony overlooking the ring because he wanted to get both the fighters and the diners.

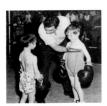

Photographer: Paul Connell
Page: 137
50-mm lens f/8 at 1/60 second
 straight flash

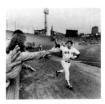

Photographer: Bill Brett
Pages: 138-139
18-mm lens f/11 at 1/250 second
 ASA 800
The secret to successfully using an 18-mm lens is having a dominant foreground. Bill Brett got a tip that Yaz would run around the track at Fenway Park following the ceremonies to honor him. A long lens would give him a tight shot, but no ballpark atmosphere. Brett gambled and decided to go halfway down the left-field line, put on his ultra-wide-angle lens, and wait. The fans reaching out to wave goodbye to their hero gave Brett the lines of direction and strong foreground that he needed.

Photographer: Jim Wilson
Page: 140
400-mm lens f/8 at 1/500 second
 ASA 800

Photographer: John Tlumacki
Page: 141
400-mm lens f/8 at 1/1000 second

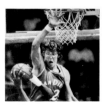

Photographer: Jim Wilson
Page: 142
300-mm lens f/2.8 at 1/500 second

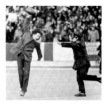

Photographer: Frank O'Brien
Page: 143
300-mm lens f/4.5 at 1/500 second
 ASA 1600

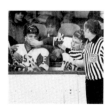

Photographer: Frank O'Brien
Page: 144
300-mm lens f/4.5 at 1/500 second
 ASA 1600

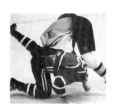

Photographer: John Tlumacki
Page: 145
300-mm lens f/4 at 1/500 second
 ASA 1600

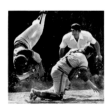

Photographer: Frank O'Brien
Page: 146
400-mm lens f/5.6 at 1/1000
 second ASA 800
The problem with shooting sports is
that the players often get lost in a sea
of spectators. O'Brien chose a differ-
ent angle to eliminate the grandstand
and create a simple black background.

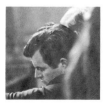

Photographer: David L. Ryan
Page: 147
180-mm lens f/4 at 1/500 second
Ryan watched the horses approach the
jump. The horses that approached
from the left had little trouble clearing
the jump; those coming from the right
had a tougher landing. The jump was
in deep shade so Ryan rated his film at
ASA 1600 so that he could use a shut-
ter speed of 1/500 second to freeze the
action. He knew Amy Shoemaker was
going to fall because "she approached
from the right and was going like
mad. She fell right in front of me — I
thought she was dead." With his mo-
torized camera he got off several
frames using a 180-mm lens set at f/4.
"It happens so quickly you don't
know whether you've got it or not."

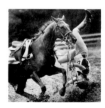

Photographer: Paul Connell
Pages: 148-149
28-mm lens f/11 at 1/500 second

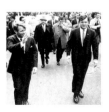

Photographer: Paul Connell
Page: 150
180-mm lens f/2.8 at 1/125 second

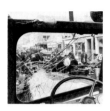

Photographer: Joe Dennehy
Page: 151
80-300-mm zoom lens f/4.5 at
 1/15 second
Dennehy made one frame before be-
ing stopped by Secret Service agents.

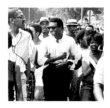

Photographer: Bob Dean
Page: 152
24-mm lens f/16 at 1/15 second
Dean chose a slow shutter speed that
allowed him to shoot the picture at
f/16 for maximum depth of field. The
firefighters were met with a barrage of
rocks and bottles and withdrew from
the racially tense area. Dean, also un-
der attack, jumped on the back of a
moving fire truck. He still has a scar
on his left arm from being hit by flying
glass during the ride to safety.

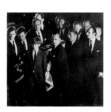

Photographer: Ollie Noonan, Jr.
Page: 153
Technical information not available.

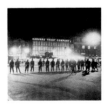

Photographer: Bill Brett
Pages: 154-155
50-mm lens f/1.4 at 1/30 second
 ASA 1600
Brett chose a fast lens and an available streetlight for a mood shot of riot police.

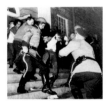

Photographer: Dan Sheehan
Page: 154
35-mm lens f/11 at 1/250 second

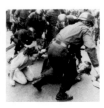

Photographer: Dan Sheehan
Page: 155
35-mm lens f/5.6 at 1/125 second

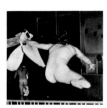

Photographer: Stan Grossfeld
Page: 156
50-mm lens f/8 at 1/60 second
 straight flash

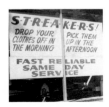

Photographer: Sam Masotta
Page: 156
50-mm lens f/8 at 1/125 second

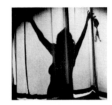

Photographer: Joe Dennehy
Page: 157
24-mm lens f/2.8 at 1/125 second

Photographer: Charles Dixon
Page: 158
200-mm lens f/4 at 1/125 second
 ASA 1600

Photographer: Stan Grossfeld
Page: 159
18-mm lens f/16 at 1/250 second
Grossfeld selected the 18-mm wide-angle lens because it afforded him great depth of field. At f/16, focused at three feet, the image is sharp

from 1¹/₂ feet to infinity. For this reason some photographers depend on this lens when they are suffering from hangovers.

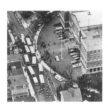

Photographer: Ted Dully
Pages: 160-161
85-mm lens f/8 at 1/250 second

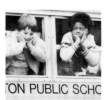

Photographer: Tom Landers
Page: 162
85-mm lens f/8 at 1/500 second
This picture was made from a heli-copter.

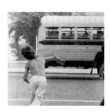

Photographer: Bob Dean
Page: 162
135-mm lens f/5.6 at 1/250 second

Photographer: Paul Connell
Page: 163
105-mm lens f/8 at 1/250 second

Photographer: John Blanding
Pages: 164-165
105-mm lens f/5.6 at 1/250 second

Photographer: George Rizer
Page: 166
35-mm lens f/5.6 at 1/60 second

Photographer: Dan Sheehan
Page: 167
35-mm lens f/8 at 1/60 second
 straight flash

Photographer: Bill Brett
Page: 169
2¼ camera f/8 at 1/250 second
 straight flash

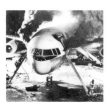

Photographer: George Rizer
Pages: 170-171
35-mm lens f/5.6 at 1/4 second
Acting on a tip to the *Globe* city desk
from a janitor at Logan Airport, Rizer
rushed to the scene. Upon arrival he
was threatened with arrest by a state
trooper at the scene. Rather than
waste time arguing about his first
amendment rights, Rizer ran upstairs
to the observatory. He braced the
camera on a railing because of the
slow shutter speed, and made several
frames using the available light com-
bined with his flash for fill-in light.

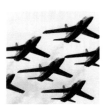

Photographer: John O'Connell
Page: 171
105-mm lens f/11 at 1/1000
 second

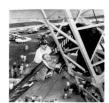

Photographer: Bob Dean
Page: 172
127-mm lens (standard 4x5 lens)
 f/8 at 1/200 second
"The crane was next to a building
under construction. I climbed up the
scaffolding five floors lugging my
trusty 4x5 Crown Graphic, eight hold-
ers and a supply of number 5 bulbs.
My exposure was 1/200 second at f/8
on Super Panco Press Type B film. I
used the number 5 bulbs in the flash
gun to give me some fill-in light on the
man's face."

Photographer: Dan Sheehan
Page: 173
50-mm lens f/8 at 1/60 second
 straight flash

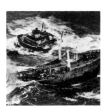

Photographer: Ed Jenner
Pages: 174-175
80–200 zoom lens f/8 at 1/1000
 second from helicopter

Photographer: Tom Landers
Page: 176
85-mm lens f/8 at 1/500 second
Landers shot this scene from a heli-
copter.

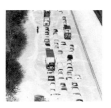

Photographer: Bob Dean
Page: 177
24-mm lens f/5.6 at 1/500 second
Dean shot this picture from a helicop-
ter on fine grain Plus-X film.

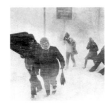

Photographer: Bill Brett
Pages: 178-179
85-mm lens f/8 at 1/500 second
Brett shot this picture with a motor-
driven camera.

Photographer: John Blanding
Page: 180
35-mm lens f/11 at 1/60 second

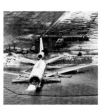

Photographer: David L. Ryan
Page: 181
200-mm lens f/8 at 1/1000 second
Ryan took a light reading from the
palm of his hand in the shade because
he knew that taking a reflected read-
ing from a predominately white scene
results in underexposure. He also
could have used an incident light read-
ing that reads the light falling on a
subject.

Photographer: Tom Landers
Page: 182-183
28-mm lens f/5.6 at 1/500 second

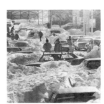

Photographer: Dan Sheehan
Page: 184
300-mm lens f/8 at 1/250 second

Photographer: Bill Ryerson
Pages: 186-187
300-mm lens f/11 at 1/250 second
 yellow filter

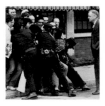

Photographer: Paul Connell
Page: 193
50-mm lens f/11 at 1/500 second

Photographer: Dan Sheehan
Page: 197
105-mm lens f/11 at 1/125 second

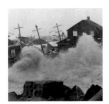

Photographer: Bill Brett
Page: 184
85-mm lens f/11 at 1/500 second
This photo was shot from a helicopter.

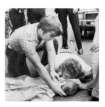

Photographer: Ulrike Welsch
Pages: 188-189
50-mm lens f/8 at 1/60 second
 ASA 1600
Welsch used a Leica M3 rangefinder
camera because it is quieter than a
single lens reflex camera.

Photographer: Bill Brett
Page: 194
35-mm lens f/11 at 1/250 second

Photographer: Bill Curtis
Pages: 198-199
300-mm lens f/5.6 at 1/500 second

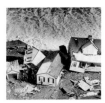

Photographer: Dan Sheehan
Page: 185
300-mm lens f/4.5 at 1/125 second
 ASA 1600

Photographer: Tom Landers
Pages: 190-191
300-mm lens f/8 at 1/500 second

Photographer: Wendy Maeda
Page: 195
85-mm lens f/8 at 1/90 second
 straight flash

Photographer: Bob Dean
Page: 200
35-mm lens f/8 at 1/500 second

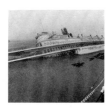

Photographer: David L. Ryan
Page: 185
24-mm lens f/2.8 at 1/125
 second ASA 1600

Photographer: Tom Landers
Page: 192
35-mm lens f/5.6 at 1/500 second

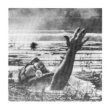

Photographer: John Blanding
Page: 196
80–200 zoom lens f/8 at 1/500
 second

Photographer: Bob Dean
Page: 201
24-mm lens f/8 at 1/500 second
 ASA 800

Photographer: John Blanding
Page: 202
24-mm lens f/8 at 1/60 second
Blanding used a bare tube strobe.

Photographer: Wendy Maeda
Page: 203
180-mm lens f/4 at 1/250 second
 ASA 1600

Photographer: Joe Dennehy
Page: 205
24-mm lens f/2.8 at 1/250 second
Dennehy shot this photo through a
telescope.

Photographer: Stan Grossfeld
Page: 206
300-mm lens f/4.5 at 1/125 second

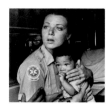

Photographer: Stan Grossfeld
Page: 207
18-mm lens f/5.6 at 1/125 second
 ASA 1600

Photographer: John Tlumacki
Page: 208
135-mm lens f/8 at 1/60 second
It was dawn and the police scanner
was quiet. Tlumacki was taking a nap
in the *Globe* cruiser in a parking lot on
Dorchester Avenue in South Boston
when he smelled smoke. He radioed
the city desk, which in turn called the
fire department. When firefighters ar-
rived, one climbed a ladder to the top
of the warehouse roof and put out
some stubborn flames by hanging
over the roof's edge. Tlumacki saw
the juxtaposition of the happy bill-
board face and the exhausted fire-
fighter and used a medium telephoto
lens set at f/8 to sharply render both
the billboard and the firefighter.

Photographer: John Tlumacki
Page: 209
35-mm lens f/8 at 1/30 second
Tlumacki set his automatic flash at f/8
and used a slow shutter speed of 1/30

second. The flash threw enough light
to freeze the action and facial expres-
sion of the fleeing firefighter. He used
a 35-mm lens and could get off only
three frames before he, too, was
driven off by the heat.

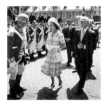

Photographer: Joe Runci
Pages: 210-211
105-mm lens f/5.6 at 1/500 second

Photographer: Tom Landers
Pages: 212-213
80-mm lens f/5.6 at 1/125 second

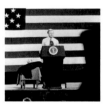

Photographer: Stan Grossfeld
Page: 213
18-mm lens f/8 at 1/90 second
 direct wide angle flash

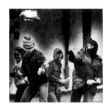

Photographer: George Rizer
Pages: 214-215
35-mm lens f/5.6 at 1/1000 second

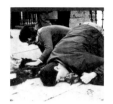

Photographer: David L. Ryan
Page: 216
15-mm lens f/5.6 at 1/500 second

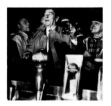

Photographer: Stan Grossfeld
Page: 217
300-mm lens f/4.5 at 1/250 second
 ASA 1600
Grossfeld earlier had made the mis-
take of photographing unmasked Bel-
fast youths tossing petrol bombs at
British patrols. The youths, angry at
the possibility of being identified,
chased him. Grossfeld, adrenaline
pumping, made it easily to his rented
car, turned, and flipped the petrol
bombers the bird. He unlocked the car
door, got in, and noticed something
was missing. In Ireland, the steering
wheel is on the right. He barely
scrambled over the gear stick in time
to start the car and escape.
 For this picture he played it safe
and hid behind a telephone pole. The
youths never saw him.

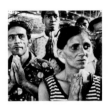

Photographer: Stan Grossfeld
Page: 218
18-mm lens f/8 at 1/8 second
 ASA 1600
The Cubans were praying in an old dark airport hangar. Grossfeld selected a very slow shutter speed and simply stopped breathing when he squeezed the trigger. The slow shutter speed allowed him to use a smaller aperture to gain more depth. It is recommended to use a tripod or at least brace the camera when using shutter speeds slower than 1/30 second.

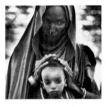

Photographer: Stan Grossfeld
Page: 219
80-mm lens f/1.4 at 1/4 second
 ASA 1600

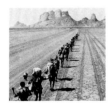

Photographer: Stan Grossfeld
Pages: 220-221
24-mm lens f/22 at 1/500 second

Photographer: Jim Wilson
Page: 222
85-mm lens f/5.6 at 1/125 second
 ASA 1600

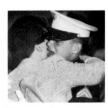

Photographer: Janet Knott
Page: 223
300-mm lens f/4.5 at 1/60 second
 ASA 1600

Photographer: Stan Grossfeld
Pages: 226-227
18-mm lens f/8 at 1/500 second

Photographer: Stan Grossfeld
Pages: 228-229
28-mm lens f/11 at 1/125 second

Photographer: Stan Grossfeld
Page: 230
18-mm lens f/11 at 1/8 second

Photographer: Stan Grossfeld
Page: 231
180-mm lens f/5.6 at 1/250 second
The negative was cropped and enlarged for impact.

Photographer: Stan Grossfeld
Page: 233
300-mm lens f/11 at 1/250 second

Photographer: George Rizer
Page: 237
24-mm lens f/11 at 1/125 second

Photographer: John Tlumacki
Page: 254
18-mm lens f/4 at 1/60 second
Tlumacki put his camera about an inch above the puddle to reflect not only the produce vendor but also Faneuil Hall.

Photographer: David L. Ryan
Backcover
180-mm lens f/16 at 1/250 second

Acknowledgments

Putting together this book was like putting out the paper; it takes a lot of work by a lot of people.

Globe editor Tom Winship is responsible for getting this book published. The Winship years produced a philosophy of good news photos and artistic feature photos unparalleled in any other major newspaper. Simply put, the man is a genius.

Globe political columnist David Nyhan, who is the best writer I have ever known for speed and quality, transferred my humble scrawlings into English by editing and rewriting the text. Nyhan was always available when needed, and his friendship and advice are unfailingly true. If I ever grow up I want to be like him.

Josephine Cappuccio researched and wrote captions for all the photographs, found long-lost photographs in library files, chased elusive photographers for information, and remained cheerful and helpful during several all-night sessions during which this book was formed. She forfeited her days off to help complete this epic without a complaint. I am grateful for her help.

Others contributing to this book are former *Boston Globe* Director of Photography Bill Brett (now Chief of Color Photography), the entire *Boston Globe* Photography Department, assistant chief photographer Bob Dean, darkroom technicians John Ioven, Jim Bulman, and Danny Gould, and *Globe* reporter Bruce Mohl. I wish to thank Shirley Jobe and the entire *Globe* library staff for their cooperation.

Barry Allen, Mark Cardwell, Kathleen Curran, Greg Derr, Ed Doherty, Vince Doria, Jack Driscoll, George Esper, Jim Franklin, Mildred Grossfeld, Sandy Grossfeld, Charles Liftman, Tom Mulvoy, Peter Mancusi, Bob Ryan, Linda Selaya, and Bob Yaeger all made significant contributions.

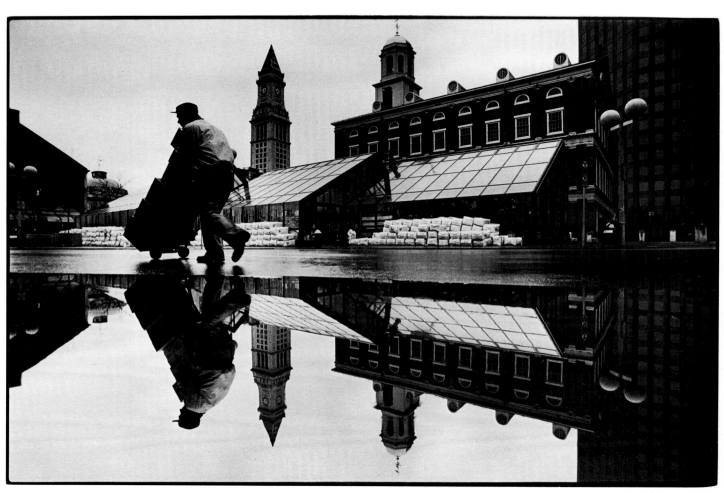

JOHN TLUMACKI